MICHELANGELO

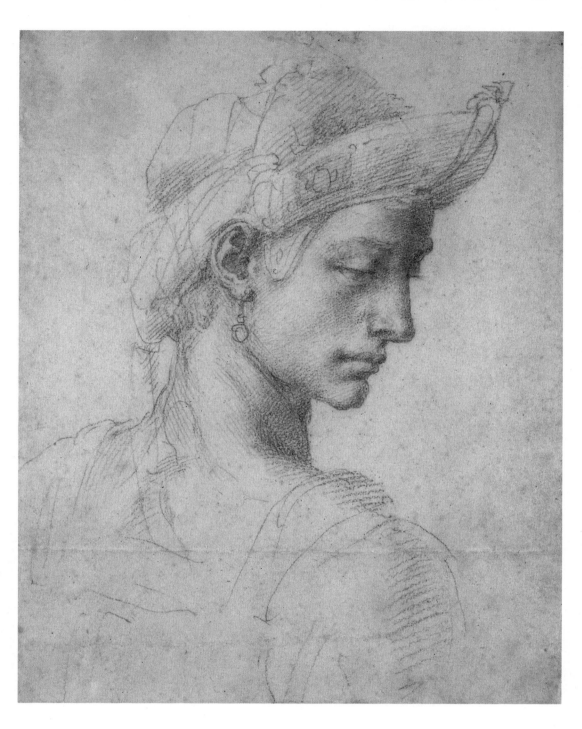

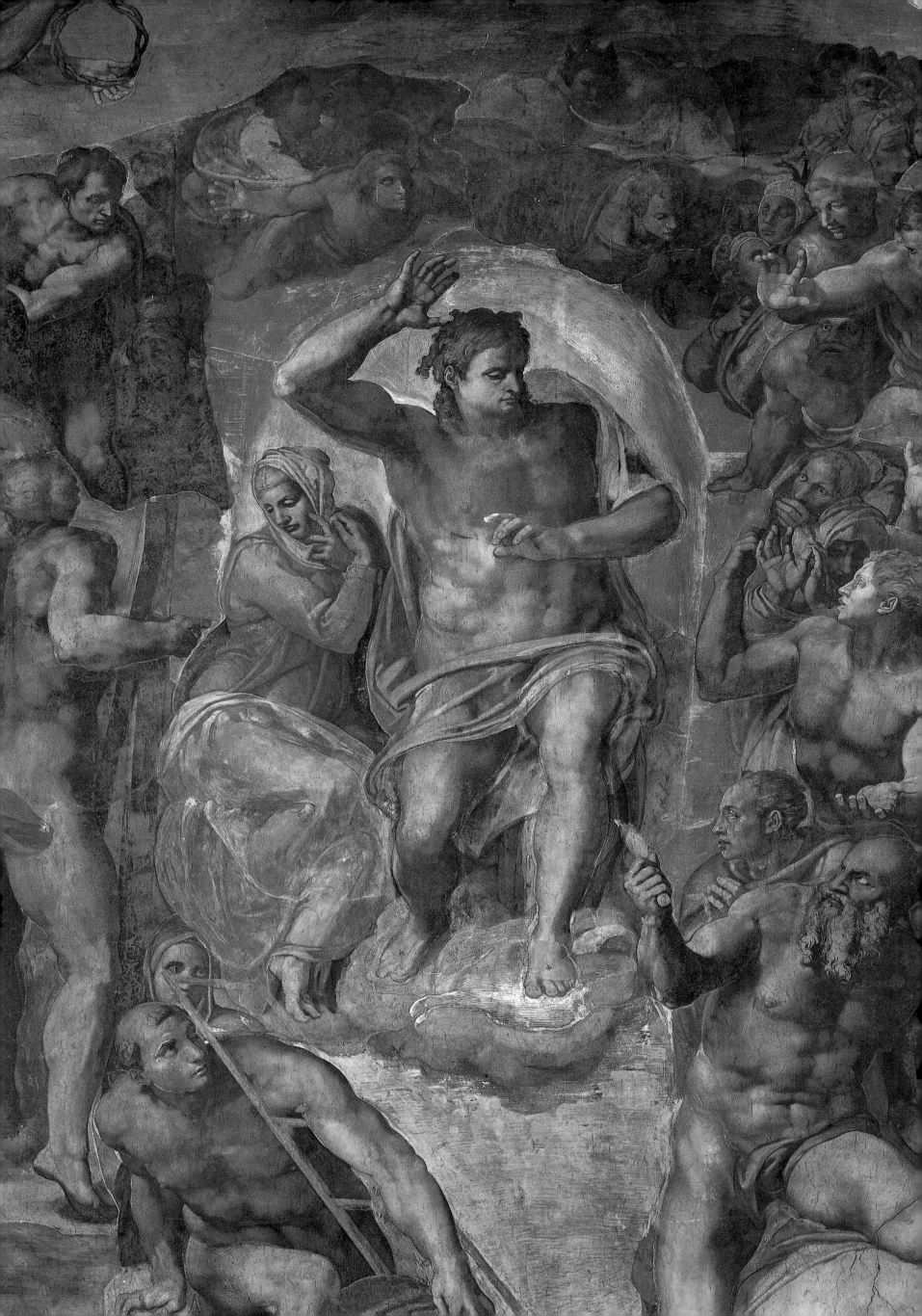

MICHELANGELO

JESSE MCDONALD

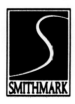

SMITHMARK

This edition published in 1994
by SMITHMARK Publishers Inc.,
16 East 32nd Street,
New York, New York 10016.

SMITHMARK books are available for bulk
purchase for sales promotion and premium
use. For details write or telephone the
Manager of Special Sales, SMITHMARK
Publishers Inc., 16 East 32nd Street, New
York, NY 10016. (212) 532-6600.

Produced by Brompton Books Corp.,
15 Sherwood Place,
Greenwich, CT 06830.

ISBN 0-8317-5789-2

Printed in China

10 9 8 7 6 5 4 3 2 1

PAGE 1: *Ideal Head*, *c.*1520, chalk, 8 × 6½ inches
(20.5 × 16.5 cm), Ashmolean Museum, Oxford.

PAGE 2: *The Last Judgment* (detail), 1534-41,
fresco, Sistine Chapel, Vatican.

RIGHT: *Apollo (David)*, *c.*1530, marble, h. 57
inches (146 cm), Museo Nazionale (Bargello),
Florence.

Contents

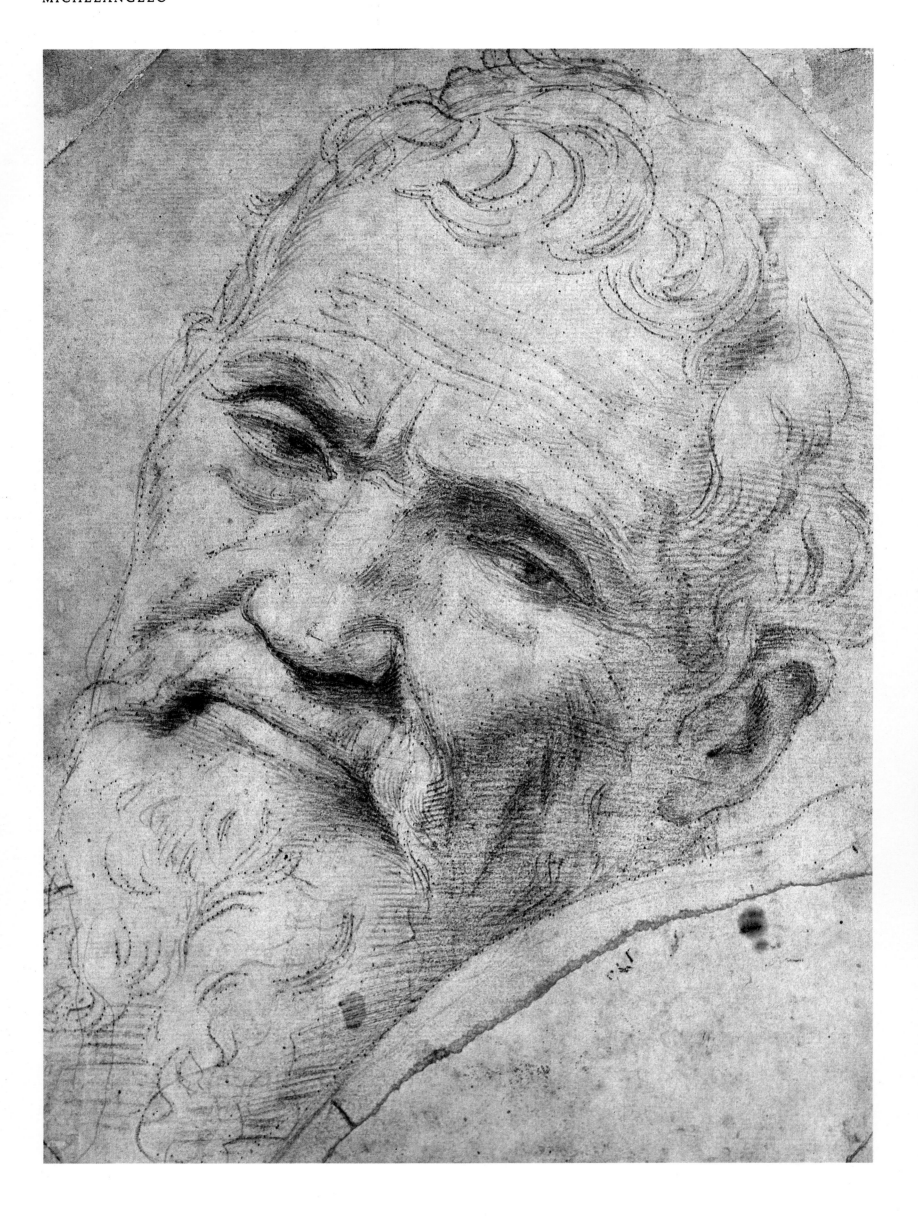

CHAPTER ONE

Sculpture: Early Years in Florence and Rome, 1475–1505

Michelangelo Buonarroti, perhaps best known today as the sculptor of *David* and the painter of the Sistine Chapel ceiling, was also an inspired and innovatory architect, a formidable draftsman and an accomplished poet. One of the greatest figures of the European Renaissance, and indeed of world art, his influence on all the arts in which he worked has been incalculable.

Born in Florence in 1475, Michelangelo benefited from the patronage of the ruling family, the Medici, in his early years, and continued to receive commissions from the Medici popes Leo X and Clement VII until the late 1520s. Although he trained as a fresco painter, almost all his early work was sculptural, culminating in the *Pietà* he carved in Rome between 1497 and 1500 and the monumental Florentine *David* (1501-04). In 1505 he was summoned to Rome by Pope Julius II, first to work on a vast tomb commission, which occupied him spasmodically and unsatisfactorily for nearly 40 years, and then to undertake the painting of the Sistine ceiling, a huge and daunting project which he completed in an extraordinary four years. It was Pope Leo X who introduced him to architecture, with the commission first for a design for a church façade, and then for a Medici memorial chapel, and yet another pope, Paul III, who involved him in the project that was to dominate his last decades, the rebuilding of St Peter's in Rome.

The influential role played by Michelangelo's patrons in his artistic development raises an important point. Even in his relative youth Michelangelo was hailed as an unparalleled master, and this instant and unchallenged recognition, the iconic status accorded to *David* or the *Creation of Adam*, has tended to remove their creator from his historical context. He is seen as the archetypal artist, single-minded, tormented, rarely satisfied with his own achievements – hence the large number of works he left unfinished. The cult of the artist as individual genius, rather than craftsman employed for a specific commission, owes its development to Michelangelo and his older contemporary and rival, Leonardo. And yet an artist still needed patrons, was vulnerable to political and religious upheaval, and was inevitably influenced by his artistic milieu. Some understanding of the major changes that took place in all these spheres during Michelangelo's long lifetime is essential to a full appreciation of his art.

By the time of Michelangelo's birth in 1475, the artistic revival that we know as the Renaissance, based on antique models and the desire for fidelity to natural form, was well established in northern Italy, and above all in Florence. The highest achievements of the early Renaissance are represented by the painting of Tommaso Masaccio (1401-28) and his successors Fra Angelico, Filippo Lippi and Piera della Francesca, the sculpture of Donatello (1386-1466), and the architecture of Filippo Brunelleschi (1377-1446). The High Renaissance is the term used of the brief period between about 1500 and 1520 when the aims and innovations of the earlier Renaissance masters, the classical canons of harmony and proportion, found their fullest and freest expression in the work of three superlative artists: Raphael (1483-1520), Leonardo (1452-1519) and Michelangelo himself. As early as 1508, in his Sistine paintings, however, Michelangelo's work

contains idiosyncratic non-classical qualities that have come to be described as Mannerist. The term Mannerism is now used as a generic label to describe the period of Italian art between the High Renaissance and the Baroque, roughly 1520-1600. It was originally coined by the sixteenth-century Italian biographer Giorgio Vasari to denote the qualities of poise, elegance and sophistication that he identified in the art of his own time, but subsequent critics found the art of Vasari's period inferior to that of the High Renaissance, and so the term came to signify an exaggerated, superficial and facile style. Mannerist art has now been largely rescued from this wholesale condemnation; it is associated with tension, emotion, exaggerated poses, unusual effects of scale or lighting, and Michelangelo's formative influence is clear.

Political and religious changes were equally momentous. Late fifteenth-century Italy was a world of small city states, constantly vying with each other for influence and territory, but ensuring by their very number a degree of economic and political stability, with the Church holding the ultimate sanction of excommunication or interdict. From 1494, when the French first invaded, Italy was overrun repeatedly by foreign armies, culminating in the final defeat of the French in 1525, the sack of Rome by an uncontrolled Spanish army in 1527, and effective Spanish overlordship thereafter, which in turn led to economic stagnation and social rigidity. At much the same time the effect of the Reformation – sparked off by Martin Luther, but in fact a much more long-term and slow-burning rejection of clerical and papal opulence, intransigence, incompetence and corruption – was to remove large tracts of Europe from the control of the Roman Church. In reaction, the Church retreated into pessimism and rigid orthodoxy, notably in the rulings of the reforming Council of Trent, which imposed a new religious iconography on the

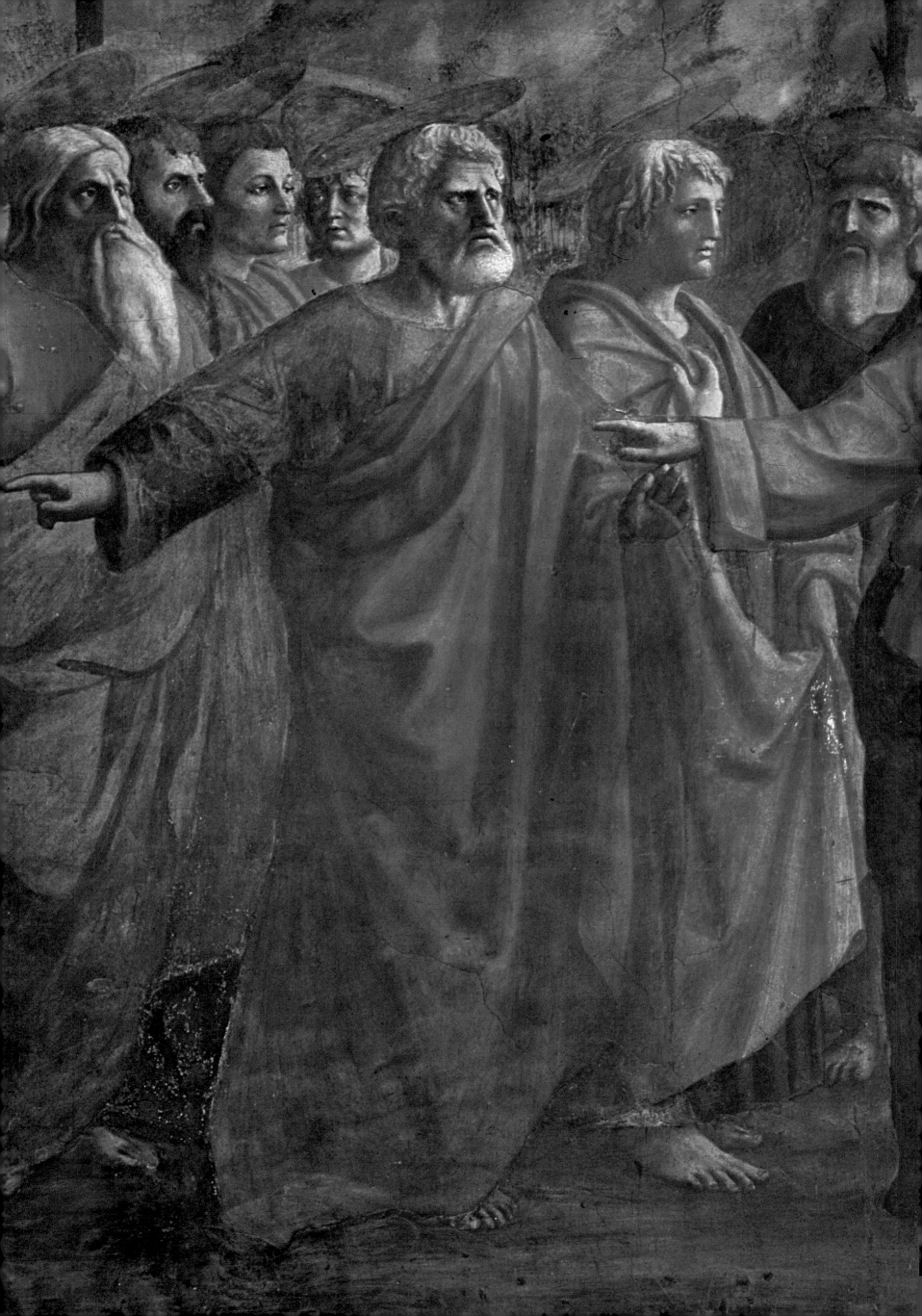

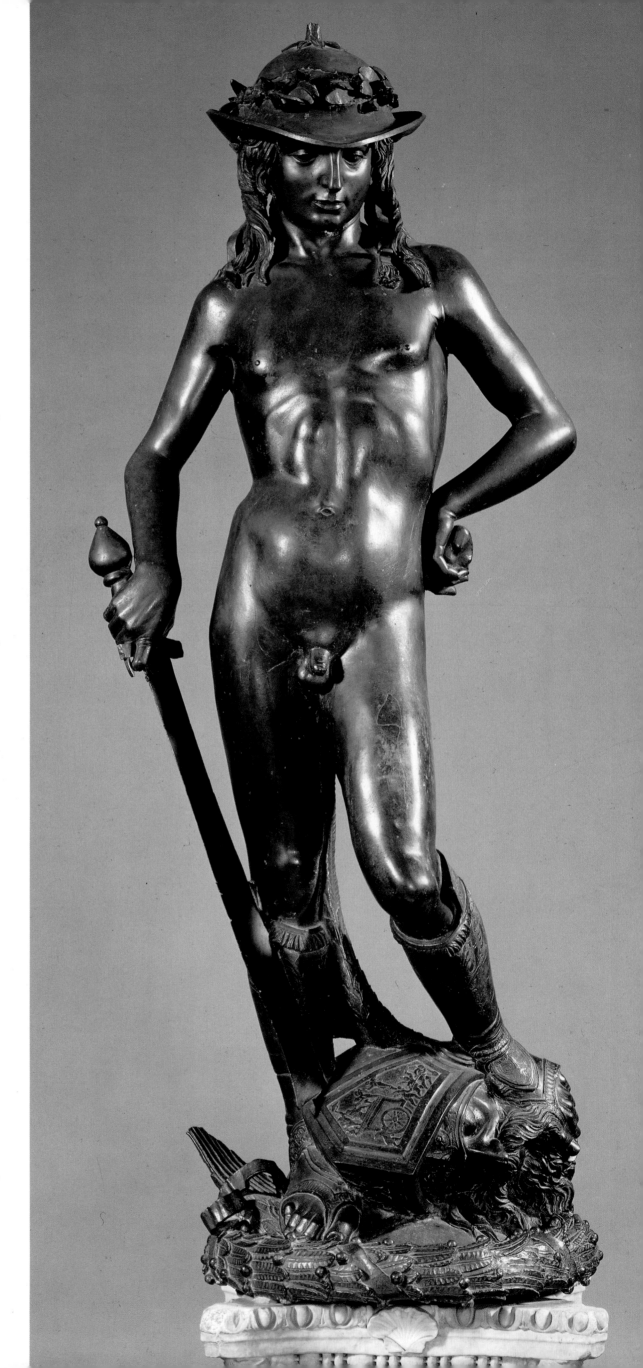

LEFT: Masaccio, *The Tribute Money* (detail of St Peter), 1425-26, fresco, Brancacci Chapel, S Maria del Carmine, Florence. Michelangelo's early drawing style was influenced more by the solid sculptural quality of Masaccio's painting than by the more decorative, descriptive work of his own teacher, Ghirlandaio.

RIGHT: Donatello, *David*, 1450s, bronze, h. 61¾ inches (158 cm), Museo Nazionale (Bargello), Florence. The first nude figure cast in bronze since classical times, this *David* has a smooth, serene, almost sentimental tenderness, which is far removed from the powerful intensity of Michelangelo's version 60 years later.

faithful and virtually banned the use of the nude in religious art. All these changes exerted an inevitable influence on Michelangelo's continuing development as painter, sculptor and architect.

Michelangelo's background was unusual for an artist of his time. He was the second son of an established Florentine family, whose rise in the thirteenth century had been linked with the Guelphs, then the ruling group in Florence. At the time of his birth in 1475, his father Lodovico was nearing the end of his term of office as *podestà* or mayor of Caprese, a small town near Arezzo. When the boy was barely a month old, the family returned to Florence, where three more sons were born, and Ludovico lived an idle life in increasingly poverty-stricken gentility. The family retained the expectations of the minor aristocracy, however, and there was considerable resistance to Michelangelo's early expressed intention of becoming an artist. Even toward the end of the fifteenth century, art was still regarded as manual work unsuitable for a gentleman. While most of his artist contemporaries became workshop apprentices at an early age, Michelangelo was given a more extended formal education, remaining at school until he was about 14. His own claims that he successfully evaded schooling, and was frequently punished for drawing rather than learning his grammar, are contradicted by the literary subtlety and skill displayed in his letters and poetry.

This question of Michelangelo's education at once raises one of the difficulties in writing about him. Well before the end of his extended life, he had established a pre-eminent position among his contemporaries; the first biographical account was published in 1527, when Michelangelo was 52, and our main sources of information about him are the lives by his assistant Ascanio Condivi, published in 1553, and fellow artist Giorgio Vasari. Vasari's *Lives of the Most Excellent Painters, Sculptors and Architects*, first

RIGHT: Façade of S Maria della Pace, Rome, by Pietro da Cortona, 1656-57. This typically baroque creation, with its convex central and concave outer sections and broken pediment, owes much to Michelangelo's outstandingly original architecture.

BELOW: *Four Grotesque Masks*, mid-1520s, black and red chalk, 9¾ × 13½ inches (25 × 53 cm), British Museum, London. These may well be preliminary drawings for some of the more macabre animal masks which feature on the tombs in the Medici Chapel, Florence (see pages 79-81).

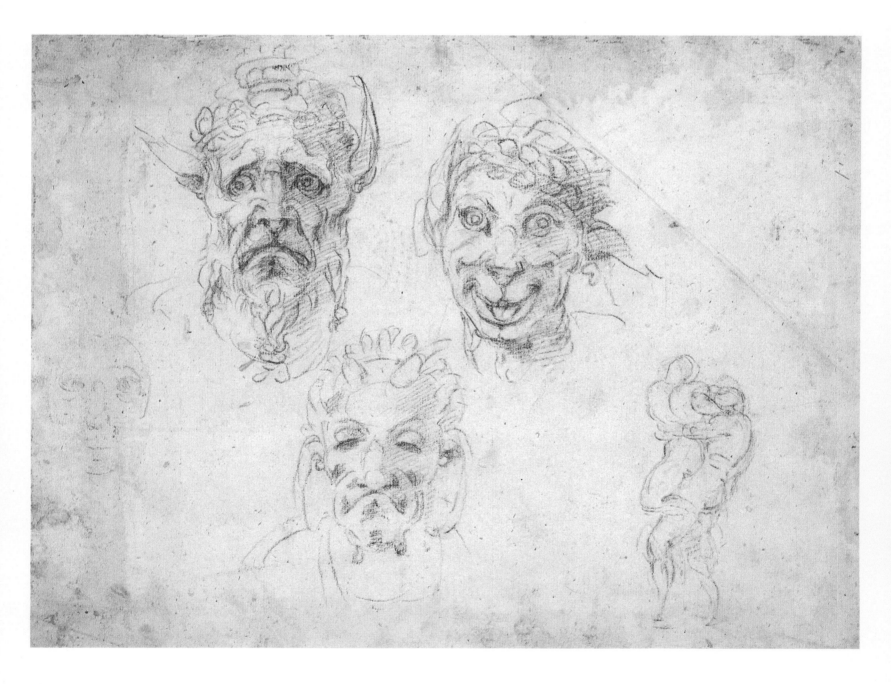

published in 1550 and expanded in 1568, is a fundamental source for the art of the Cinquecento, the sixteenth century in Italy, and was written with the specific intention of raising the status of the visual arts. It was also intended to demonstrate the superiority of the Central Italian artistic tradition, of which Michelangelo was regarded as the master.

In later life Michelangelo himself denied that he had any formal training in the arts, preferring to imply that his genius was unique and God-given, owing nothing to any mortal teacher. Condivi echoes this, but Vasari produces evidence of Michelangelo's apprenticeship in 1488 to the Florentine artist Domenico Ghirlandaio (c.1449-94). Although he stayed only a year, it was during this period that he learned the technique of fresco-painting, which he was to use so stunningly on the ceiling of the Sistine Chapel. One of the principal elements in an artistic training was the copying of work by established masters, and it is significant that Michelangelo chose to copy the monumental works of such early Renaissance masters as Giotto and Masaccio, rather than adopting Ghirlandaio's more decorative style. The earliest surviving drawings, dating from this time, already show his superb draftsmanship as well developed; the modeling of forms by means of cross-hatching rather than extended line suggests a sculptural approach to the depiction of volume.

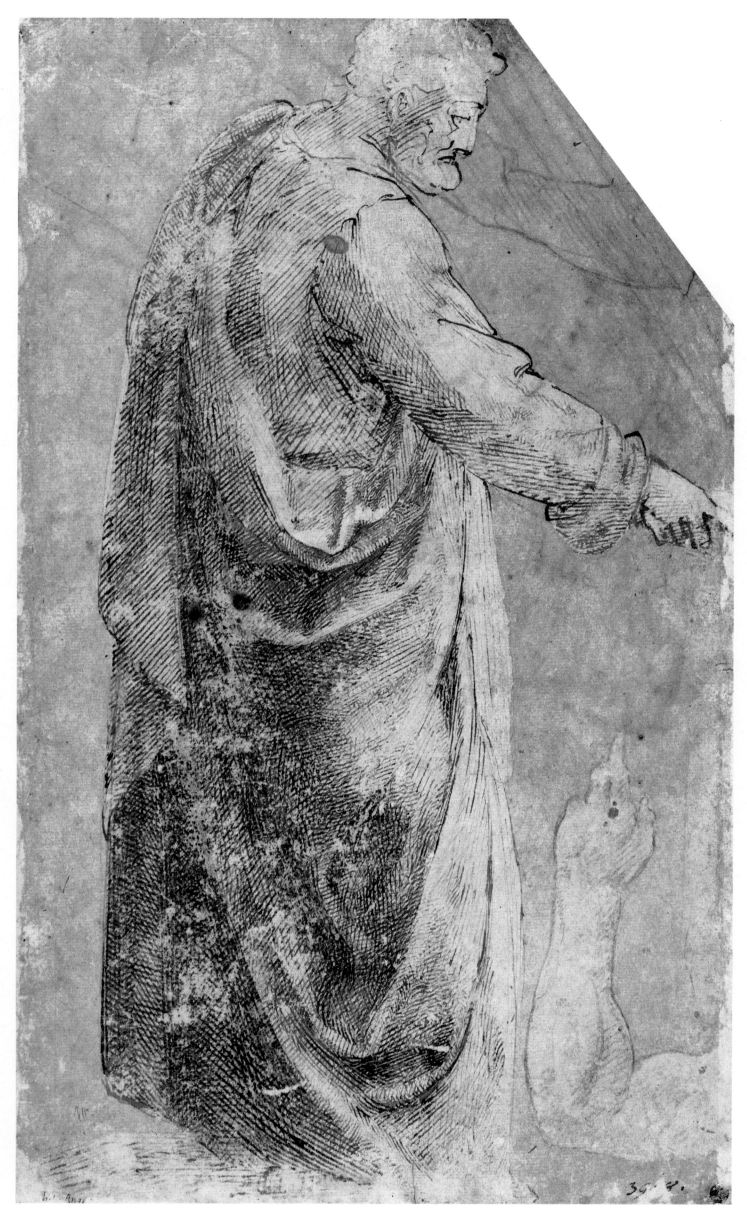

LEFT: *St Peter*, c.1490, pen and red chalk, 12 × 7 inches (31 × 18.5 cm), Staatliche Graphische Sammlung, Munich. One of Michelangelo's earliest surviving drawings, this figure is copied from Masaccio's fresco *The Tribute Money* (page 8).

BELOW: Domenico Ghirlandaio, *The Birth of the Virgin*, 1485-90, fresco, Tornabuoni Chapel, S Maria Novella, Florence. Part of the fresco series on which Ghirlandaio was engaged during the period of Michelangelo's apprenticeship with him, this demonstrates the older artist's concern with contemporary, rather than biblical, mores, and with decorative detail.

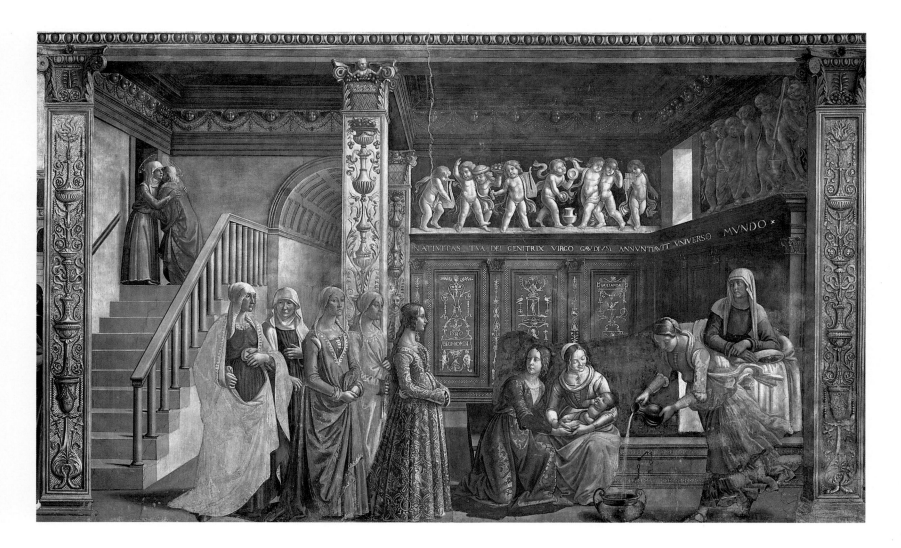

By the late 1480s Medici power in Florence was openly established, and Cosimo's grandson Lorenzo was the acknowledged ruler of the city. Through his lavish patronage, Lorenzo played a major role in the artistic renaissance taking place in Florence, earning himself the title 'the Magnificent.' In response to the contemporary interest in all things classical, Lorenzo assembled a collection of fragments of antique sculpture, which was kept in a house and garden near the monastery of San Marco, and which promising artists were permitted to study. It is unclear how Michelangelo first came to Lorenzo's attention, but after about a year with Ghirlandaio, Michelangelo moved on to work in the Medici sculpture garden, under the supervision of the aged sculptor Bertoldo di Giovanni (c.1420-91), who was himself a pupil of the great fifteenth-century sculptor Donatello and, like his master, worked in bronze.

It was in this harmonious setting that Michelangelo first began to experiment with sculpture. According to Condivi, he begged a piece of marble from masons working on the Medici library and made a copy of an antique faun's head in the garden. This so impressed Lorenzo that he offered to take the boy into his household to be educated with his own sons under the tuition of the humanist poet Agnese Poliziano. Thus at the age of 14 Michelangelo found himself at the heart of one of the greatest and richest centers of artistic and intellectual endeavor in Italy, at a time of extraordinary creative ferment. Visitors to the Medici court included the scholar Cristoforo Landino, specialist in Dante and Virgil, and the philosophers Pico della Mirandola and Marsilio Ficino, who were both concerned to harmonize the writings of Plato with Christian thought. Neoplatonism saw intellectual discipline as the key to man's redemption from original sin, art as an imperfect reflection of God's original vision: ideas which became central to Michelangelo's credo as an artist. Treated as the familiar of scholars and patrons, he also gained the confidence to insist on the integrity of his artistic vision, even at the expense of a patron's preferences: a rare quality in an era when it was still the patron who normally determined the subject and

RIGHT: *The Madonna of the Steps*, c.1491, marble, 21½ × 15½ inches (55.5 × 40 cm), Casa Buonarroti, Florence. The background motif which gave the work its name, a staircase with a figure leaning over it, echoes another Donatello, the *Feast of Herod*, now in Lille. The remote gaze of Michelangelo's Madonna, as she abstractedly nurses her muscular baby, is very different from the enclosed intensity of Donatello's *Pazzi Madonna* (left).

BELOW: Donatello, *Pazzi Madonna*, c.1430, marble, Staatliche Museen, Berlin. Michelangelo adopted the extremely shallow relief (*rilievo schiacciato*, literally 'squashed relief') and the figure style of Donatello's work in one of his own earliest sculptures, *The Madonna of the Steps*.

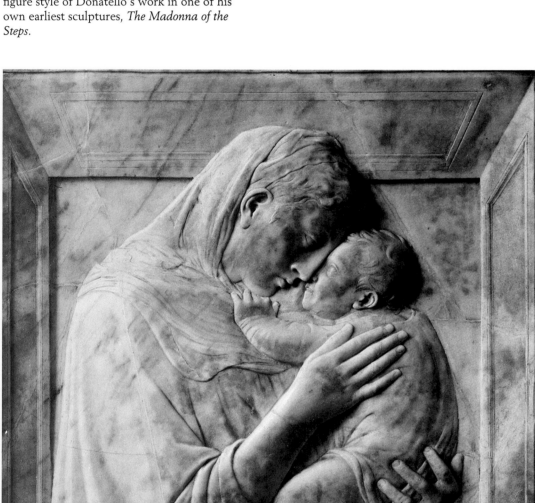

appearance of a work of art, but also one which contributed to Michelangelo's difficulties with his patrons, and his tendency to leave work unfinished.

The two surviving works which are generally agreed to date from Michelangelo's sojourn in the Medici palace are both reliefs carved in marble, the *Madonna of the Steps* and the *Battle of the Centaurs*. The first is a small work, in golden marble and the very shallow relief adopted by Donatello. Although there is evidence of inexperience in the clumsy handling of the child's right arm and the Madonna's feet, the work already has a

power and monumentality that distinguishes it from the softness and sentimentality that many contemporary artists brought to this popular theme. Although small in scale, the figures fill the frame and are expressed in simple massive shapes reminiscent of Masaccio. The influence of the classical art to which Michelangelo was so much exposed at this time can be seen both in the seated profile position of the Madonna, like a mourning figure on a Greek grave stela, and in the massively muscular figure of the child, firmly turning his back on the faithful. Like so many of Michelangelo's

works, the *Madonna of the Steps* is unfinished; the two principal figures are carved in some detail but the setting and the background figures are only cursorily outlined.

The *Battle of the Centaurs* is a larger piece, carved from a block of creamy marble in a distinctly different style from the *Madonna*. It also introduces for the first time a subject that was to preoccupy Michelangelo throughout his life: the male nude. The theme, possibly suggested by Poliziano, and a popular one in classical Greek art, is taken from Ovid's *Metamorphoses*: at the wedding feast of the king of the Lapiths, the Centaurs among the guests, inflamed with wine, tried to carry off the bride and her attendants. In Michelangelo's version, the female figures, other wedding guests, background, and even the Centaurs' equine lower halves, have all been eliminated, so that he can concentrate on the tangled mass of bodies, some in low relief and some in the round. Again, the work is unfinished. It seems that Michelangelo began it immediately before the death of Lorenzo de' Medici in April 1492, when he returned to his father's house, and he may have abandoned it at this time, although it remained in his possession until his death.

The death of Lorenzo marked a turning point in the fortunes of Florence. The reforming friar, Girolamo Savonarola (1452-98), appointed prior of San Marco in 1491, rapidly came to dominate the city through his fervent and apocalyptic denunciations of contemporary vice and frivolity, and abuses in Church and State. The political maneuverings of Lorenzo's successor Piero also contributed indirectly to the invasion of Italy by Charles VIII of France in September 1494. Piero was driven out of the city, ending the Medicis' 60-year rule, the Medici Palace was sacked, and in November the French entered Florence.

Michelangelo had long since fled, first to Venice and then to Bologna, where he

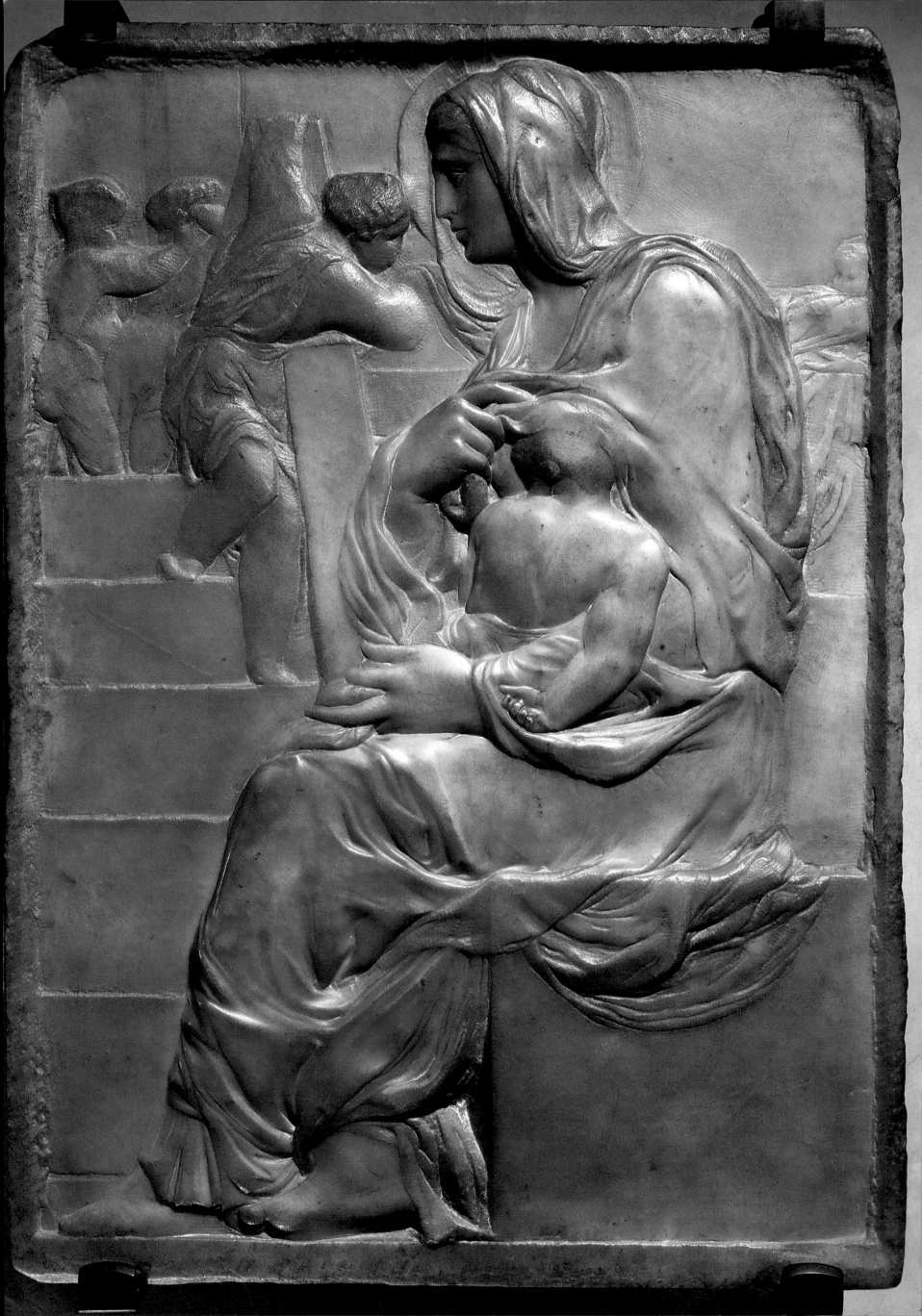

BELOW: *Battle of the Centaurs*, 1491-92, marble,
33 × 35½ inches (84.5 × 90.5 cm), Casa
Buonarroti, Florence. This was a popular theme
in classical sculpture, notably the friezes on the
Parthenon and the temple of Apollo at Bassae in
southern Greece. Michelangelo's treatment of
the subject already shows many of the qualities
characteristic of his mature work. There is no
indication of background or context, no
perspective, no costume; instead the whole
block is occupied with a tangled mass of nude
bodies.

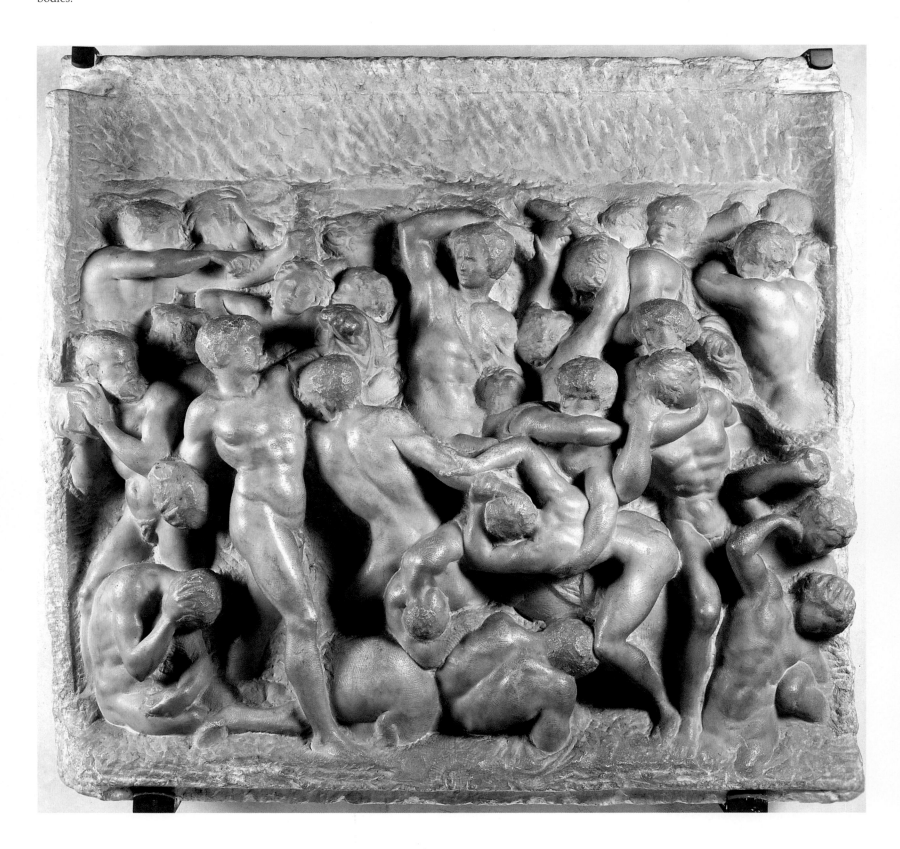

BELOW: *Crucifix, c.*1492, polychromed wood, h. 52½ inches (134.5 cm), Casa Buonarroti, Florence. This was somewhat controversially identified in 1964 as the wooden crucifix which Condivi reports Michelangelo as carving for the high altar of S Spirito in Florence, in gratitude for the prior's providing him with corpses to dissect. Many scholars accept the identification, but some object that the body is too slender, the musculature inaccurate, and the forms too elongated, to be by Michelangelo.

gained a commission to make three figures for the shrine of St Dominic in the church dedicated to him. This elaborate freestanding tomb had been begun by the thirteenth-century sculptor Nicola Pisano, and left incomplete on the death of Niccolo dell' Arca in March 1494. Michelangelo's contribution included two local saints, *Saint Petronius* and *Saint Proculus,* and a kneeling angel holding a candlestick. Although small – about two feet, whereas the tomb is nearly 20 feet tall – the figures give an impression of monumentality reminiscent of the *Madonna of the Steps,* and are also strikingly different from each other in technique. The angel is carved with a soft, almost waxen, and yet sturdy quality which contrasts strongly with Niccolo dell'Arco's detailed tomb decoration. The two saints, however, show a detailed realism which has been linked with the style of painters popular in Bologna at this time, such as Ercole de' Roberti. *St Proculus* in particular, with his short tunic, his muscular legs and tense stance, his furrowed brow and concentrated gaze, has an intensity and individuality that stands out against the calm, elegant articulation of the rest of the shrine.

After a year or so in Bologna, Michelangelo returned to Florence in 1495/96, by which time the French invasion had petered out and Savonarola was in firm control. There was little opportunity for a sculptor under a religious dictatorship which condemned material wealth, the nude, and the legacy of antiquity, and by June 1496 Michelangelo was in Rome for the first time. With the political decline of Florence and the resurgent power of the papacy, Rome had in turn become a center of artistic patronage, with major building programs under way. Michelangelo arrived with a letter of introduction to the patron and connoisseur Cardinal Riario, although it is unclear whether he commissioned either of the two statues Michelangelo is known to have completed in Rome at this time.

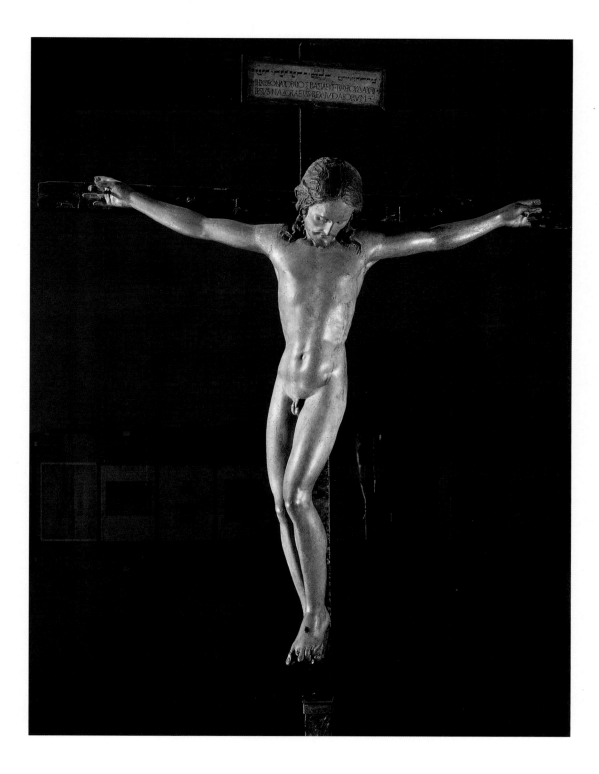

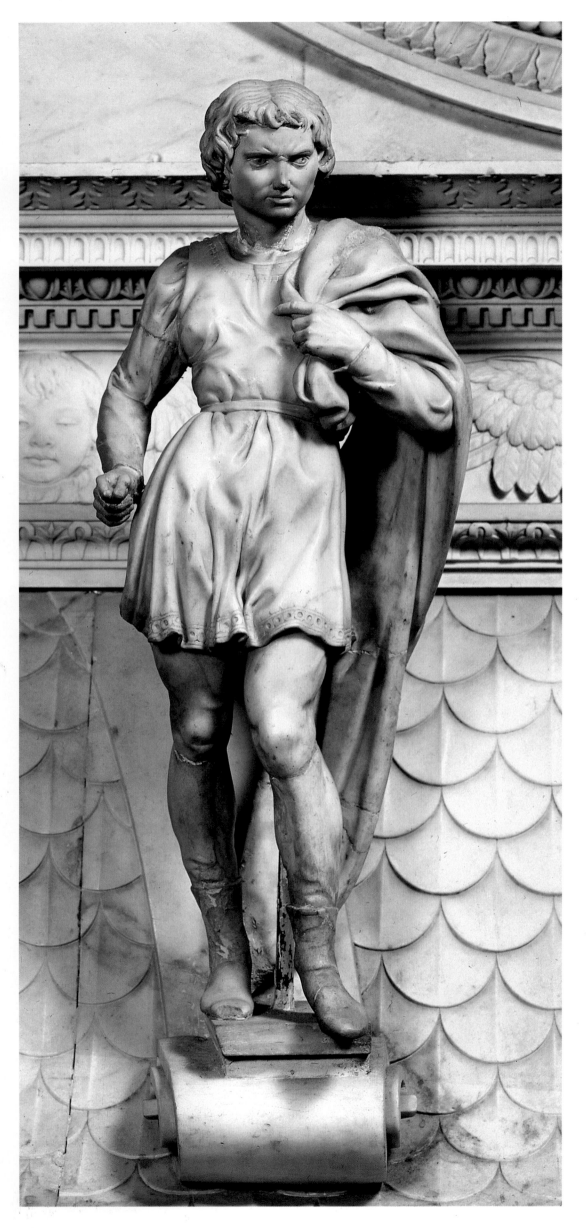

LEFT: *St Proculus*, 1495, marble, h. 22¾ inches (58.5 cm), S Domenico, Bologna. One of three figures that Michelangelo carved for the tomb of St Dominic during his brief stay in Bologna, this has been proposed as a self-portrait of the artist because of the striking intensity of its expression, anticipating the similar mood of *David* (page 24).

RIGHT: *Angel Bearing a Candlestick*, 1495, marble, h. 22 inches (56.5 cm), S Domenico, Bologna. This is a rare example of a winged angel by Michelangelo; the wings were obligatory, to match the figure's angel partner, carved by the leading Bolognese sculptor Niccolo dell' Arca in the 1490s.

Both these works, an *Eros* (now lost) and a *Bacchus*, were owned by the banker Jacopo Galli, and the *Bacchus*, the first of two major works which established Michelangelo's reputation as a sculptor, is shown in a drawing of the 1530s standing in Galli's garden among his collection of antique statues and reliefs. It is lifesized, the first surviving work on this scale (although there is evidence that Michelangelo carved a *Hercules* on a similar scale during the period of confusion in Florence following Lorenzo de' Medici's death). The god of wine is shown as a smooth-fleshed, languid young man, his nudity emphasized by his garland of grapes and vine leaves, his eyes glazed and his stance unsteady as he raises a wine-cup to his fleshy lips. While the representation of the male nude is fully in the antique tradition, there is a moral element in Michelangelo's creation that is very much of his time; this *Bacchus* is the essence of the unregenerate soul trapped within the prison of the body by animal desires.

The personal mood of this work is echoed in Michelangelo's second major Roman commission, the *Pietà* he carved for the French Cardinal Jean Bilhères de Lagraulas, which is now in St Peter's. Although sculpture groups of the *Pietà* were common in Germany and France, and painted examples existed in Italy, this is one of the earliest sculptural renderings of the theme in Italy. With characteristic strength of purpose, Michelangelo succeeds in retaining the tenderness and pathos of the northern version, while triumphantly solving the problem of how to render convincingly the body of one adult lying in the lap of another. This is one of the most highly finished of all Michelangelo's works, the major forms modeled with anatomical precision, the minor forms of head and face delicate and clear-cut, and the whole imbued with a powerful sense both of idealized beauty and of a calm acquiescence to suffering and God's will.

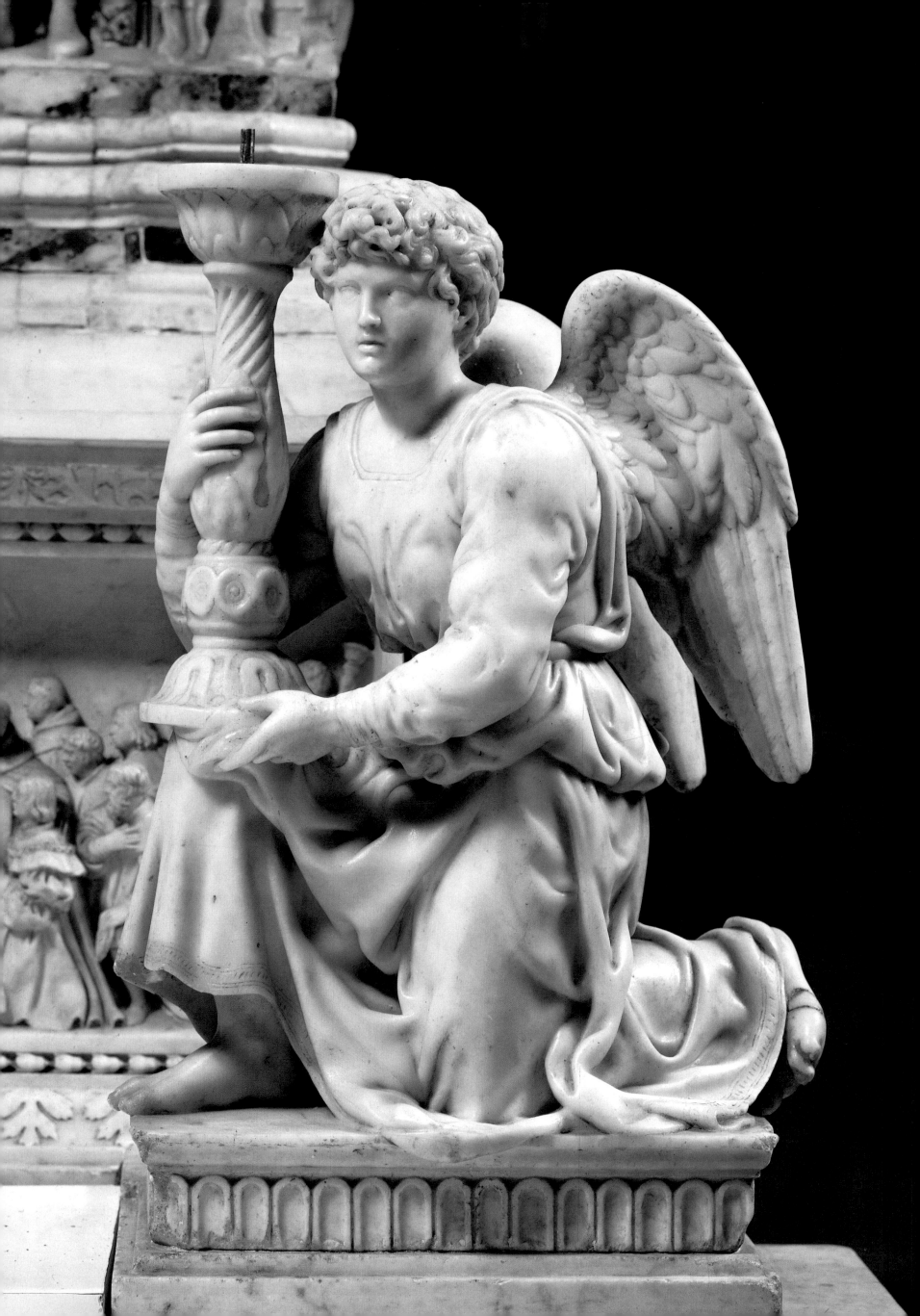

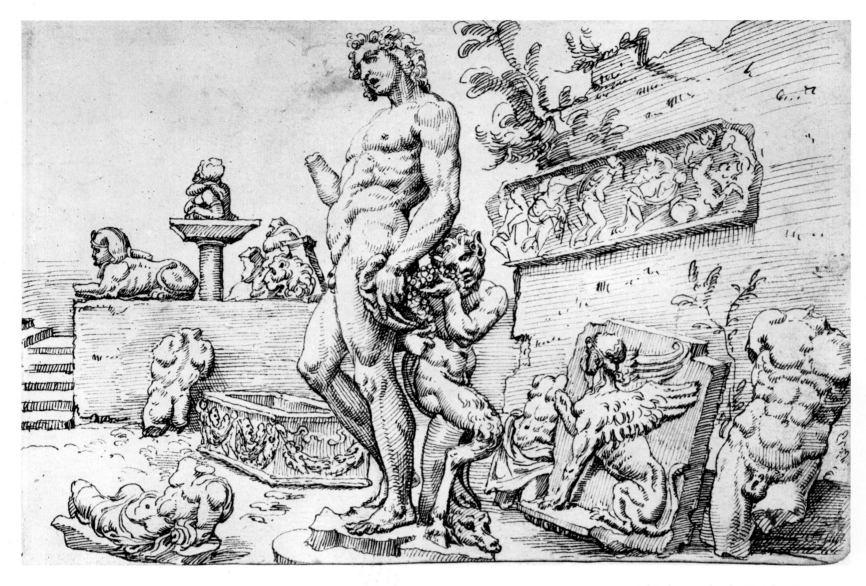

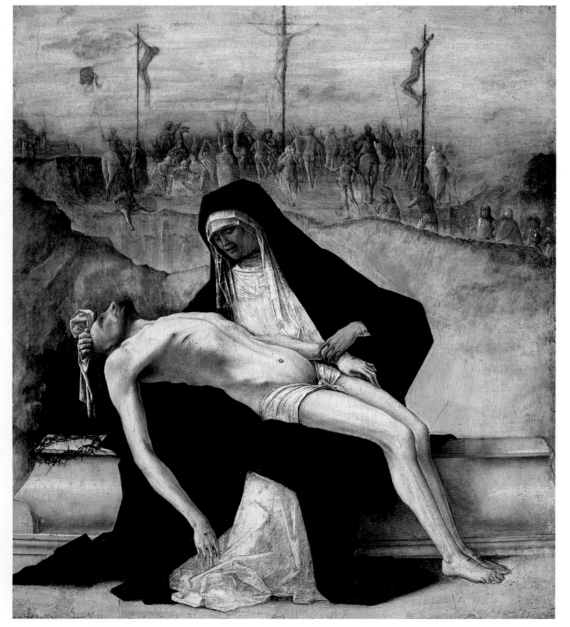

ABOVE: This drawing by the Dutch artist Maerten van Heemskerck, made during his visit to Rome in 1532-35, shows Michelangelo's *Bacchus* displayed in the sculpture garden of Jacopo Galli. The right forearm holding the drinking cup has been broken off, possibly to make the work look more convincingly classical, as Galli's principal interest was in antique sculpture. It may have been Michelangelo himself who restored the statue to its original form.

LEFT: Ercole de' Roberti (d.1496), *Pietà*, predella panel, oil on wood, 13¼ × 12¼ inches (34.3 × 31.3 cm). One of the few Italian versions of the Pietà to predate Michelangelo's sculpture (page 22), this adopts the device of shrouding the Virgin in heavy draperies in order to create a lap large enough to accommodate the dead Christ.

RIGHT: *Bacchus*, *c*.1497, marble, h. 79 inches (202.5 cm), Museo Nazionale (Bargello), Florence. The precarious pose of Michelangelo's decadent god of wine reinforces the imminent loss of balance and restraint which is the theme of the work. The resulting subversion of the dignity of the classical nude has been hailed as the first example of Mannerist sculpture.

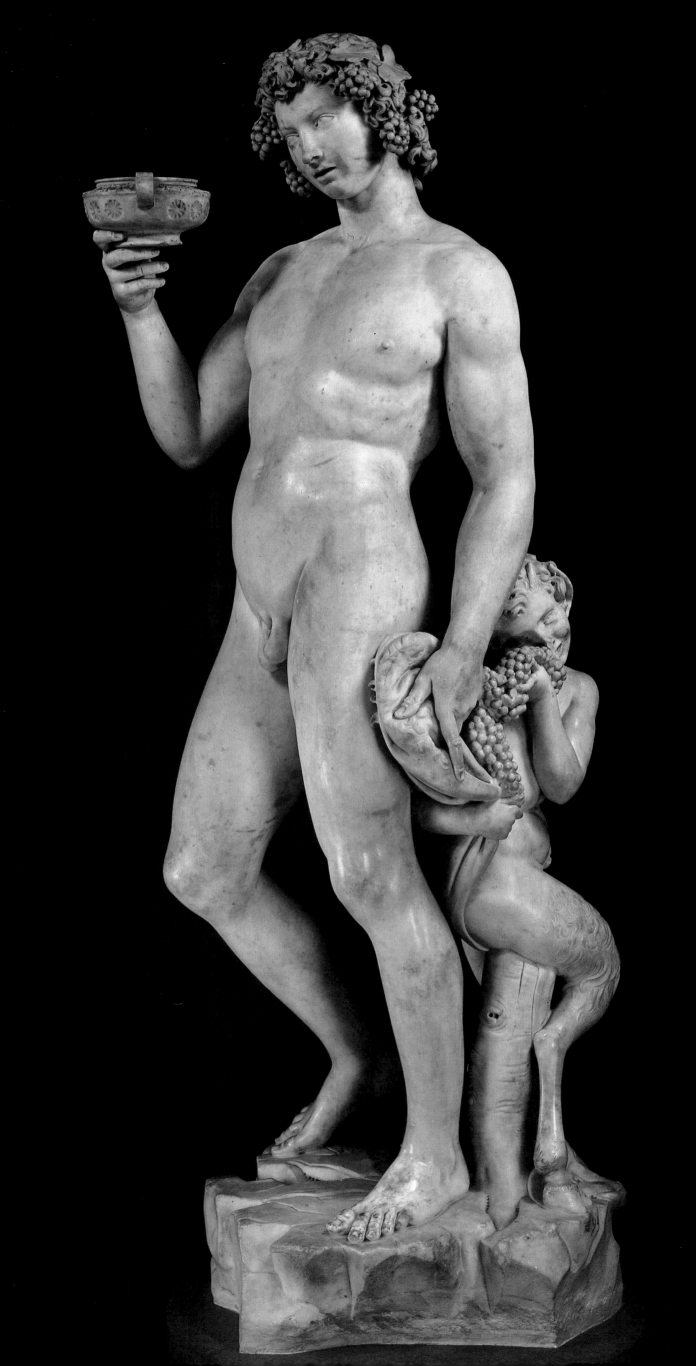

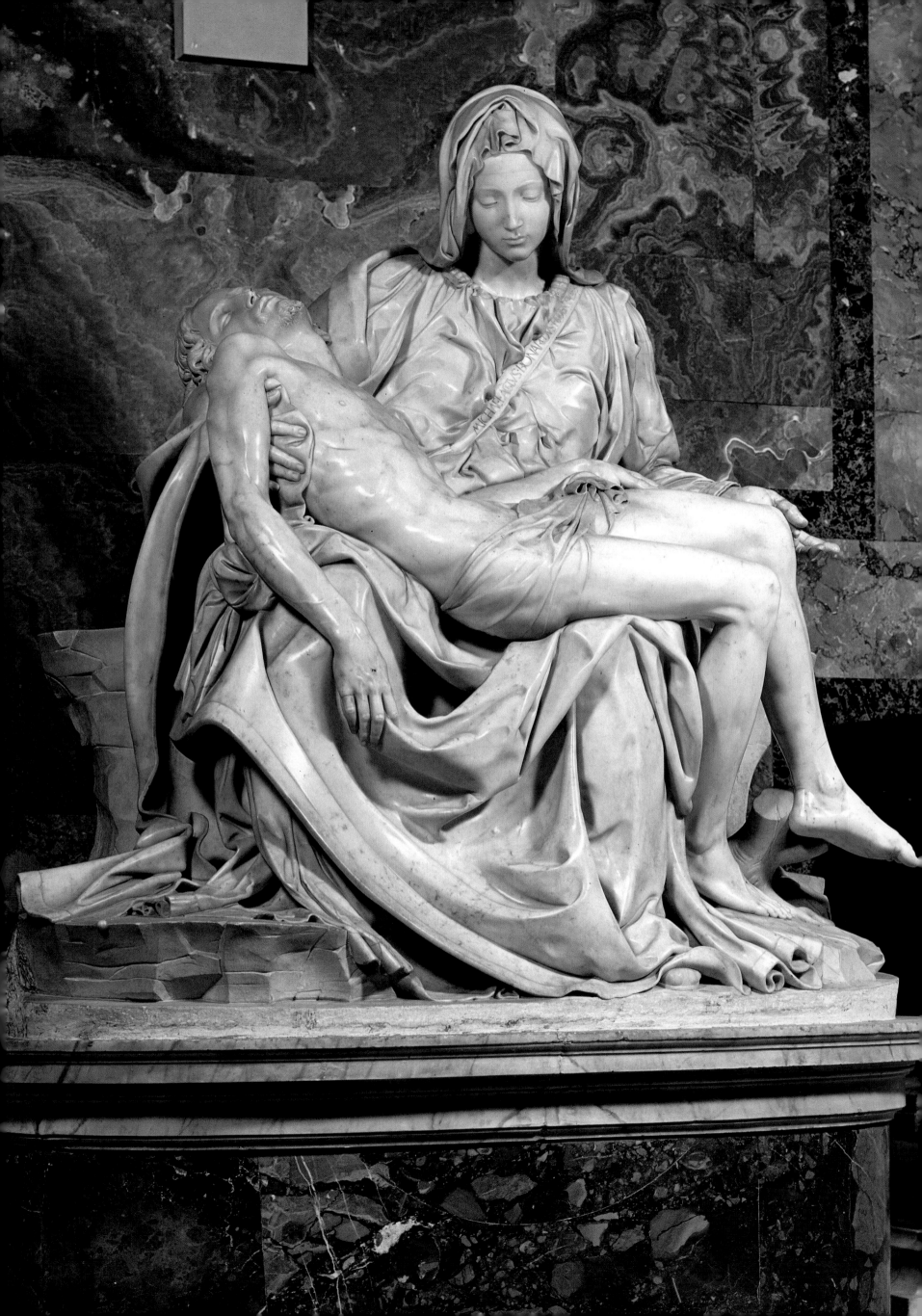

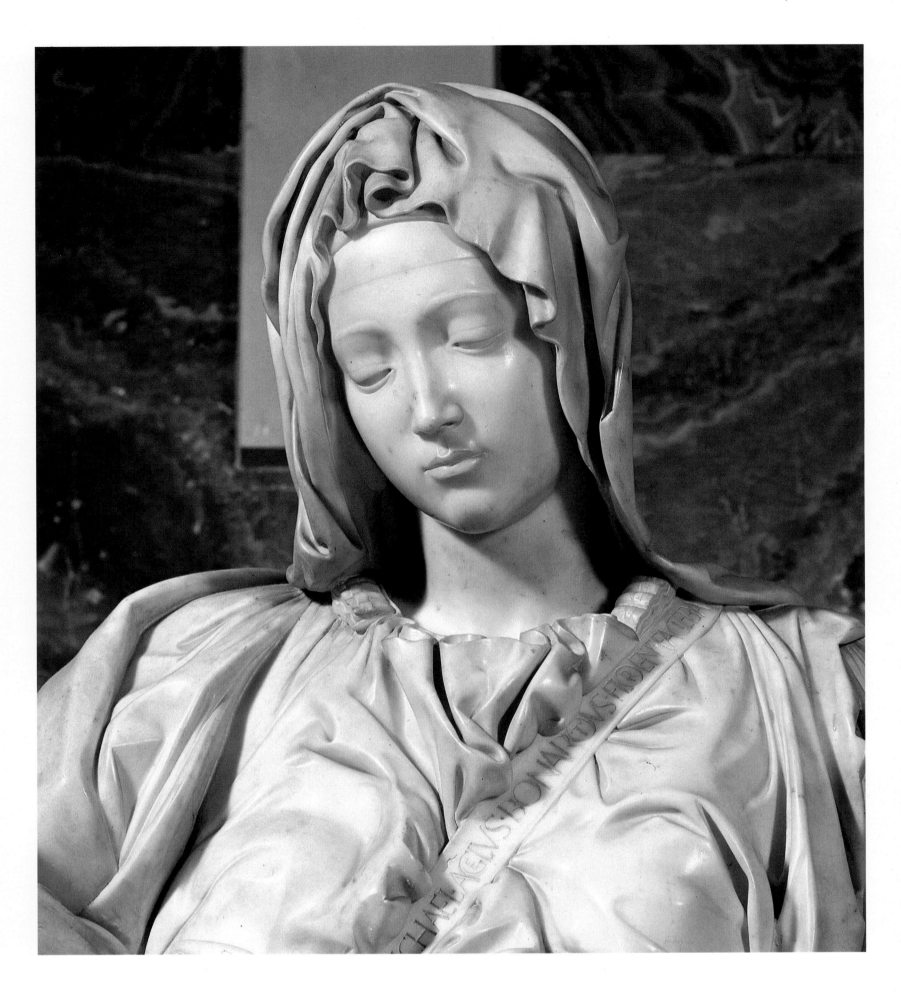

LEFT and ABOVE: *Pietà*, 1497-1500, marble, 68 × 76 inches (174 × 195 cm), St Peter's, Rome. Described by Vasari as 'a miracle wrought from a once shapeless stone,' this was Michelangelo's first major religious commission; its contemplative mood and stable pyramidal composition present a striking contrast to the tipsy, pagan *Bacchus*. It is unusual among Michelangelo's works for its high degree of finish, and the artist's own pleasure in his achievement may be deduced from the fact that it is the only work that he signed; his name is carved on the band across the Virgin's breast.

The *Pietà* was immediately recognized as a turning point in Italian sculpture, the culmination of fifteenth-century attempts to reconcile images of the natural world with the classical ideal. When Michelangelo returned to Florence in 1501, he was already acknowledged as the foremost sculptor of the day and was preceded by his fame. The climate in Rome had become less favorable to artists with the advent of the politically ambitious Borgia pope, Alexander VI, while republican government and relative stability had been restored in Florence since the

fall and execution of Savonarola in 1498. Within a few months of his return, Michelangelo received a major commission from the board of works of Florence Cathedral, in the form of a huge block of marble, 14 feet high, on which Agostino di Duccio (1418-81) had begun and abandoned work in the 1460s. Before he embarked on this, however, he may have carved the mysterious *Madonna and Child* now in Bruges Cathedral, which was possibly commissioned by Cardinal Francesco Piccolomini, later Pope Pius III, for the family altar in Siena

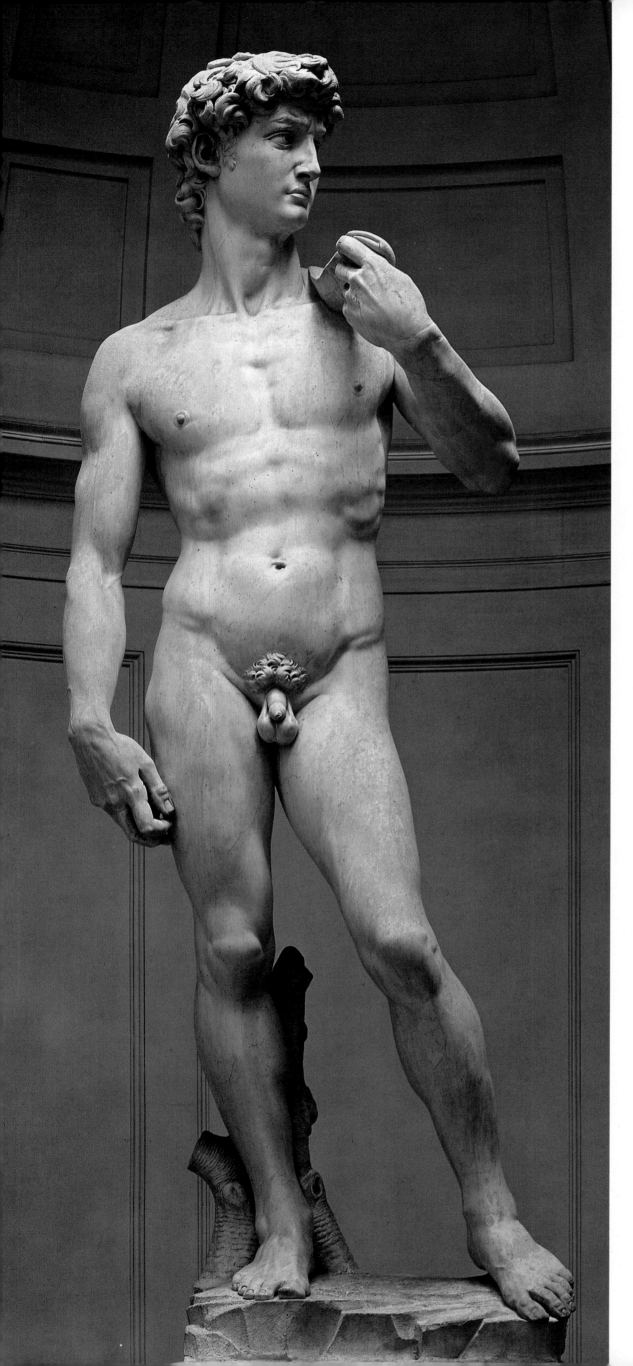

Cathedral. Both the remote gaze of the Madonna and the monumental scale of the child recall the earlier *Madonna of the Steps* relief, but the highly-finished quality of the carving, and the Madonna's face and headdress, is related stylistically to the more recent *Pietà*, while the simpler drapery and more integrated forms of the Bruges *Madonna* give the work a simplicity and compactness which is new, and show Michelangelo working toward a more coherently monumental style.

The cathedral commission gave him the opportunity to work on a correspondingly monumental scale. The statue for which Duccio's mangled block had been intended was called 'the giant', or 'David'; for the Florentines the biblical David, stoic against impossible odds, faithful to his beliefs and finally triumphant, represented the essence of civic virtue. The subject was a common one. Donatello's exquisite, almost feminine, *David* dates from the 1450s, Verrocchio's calm, triumphant warrior, from 1473/75. Both of these are worked in bronze and are shown at the moment of victory, sword in hand, and the enemy's head at their feet. In contrast, Michelangelo's *David* is a massive, huge-limbed, almost ungainly youth, body relaxed with a young man's self-confident ease, but the face wary and the brow furrowed in tense anticipation and uncertainty, an expression reminiscent of the fiercely scowling *Proculus* in Bologna. Originally intended for the Cathedral, the statue was finally erected on the steps of the Palazzo Vecchio when it was finished in 1504. Since removed to the Accademia, it has been replaced by a copy.

The political upheavals of the period influenced many contemporary artists. Leonardo da Vinci (1452-1519) had already worked in Florence for a period in the 1470s and early 1480s, but by 1483 was at the Sforza court in Milan. In 1499 Milan fell to the invading French army, and Leonardo fled via Mantua and

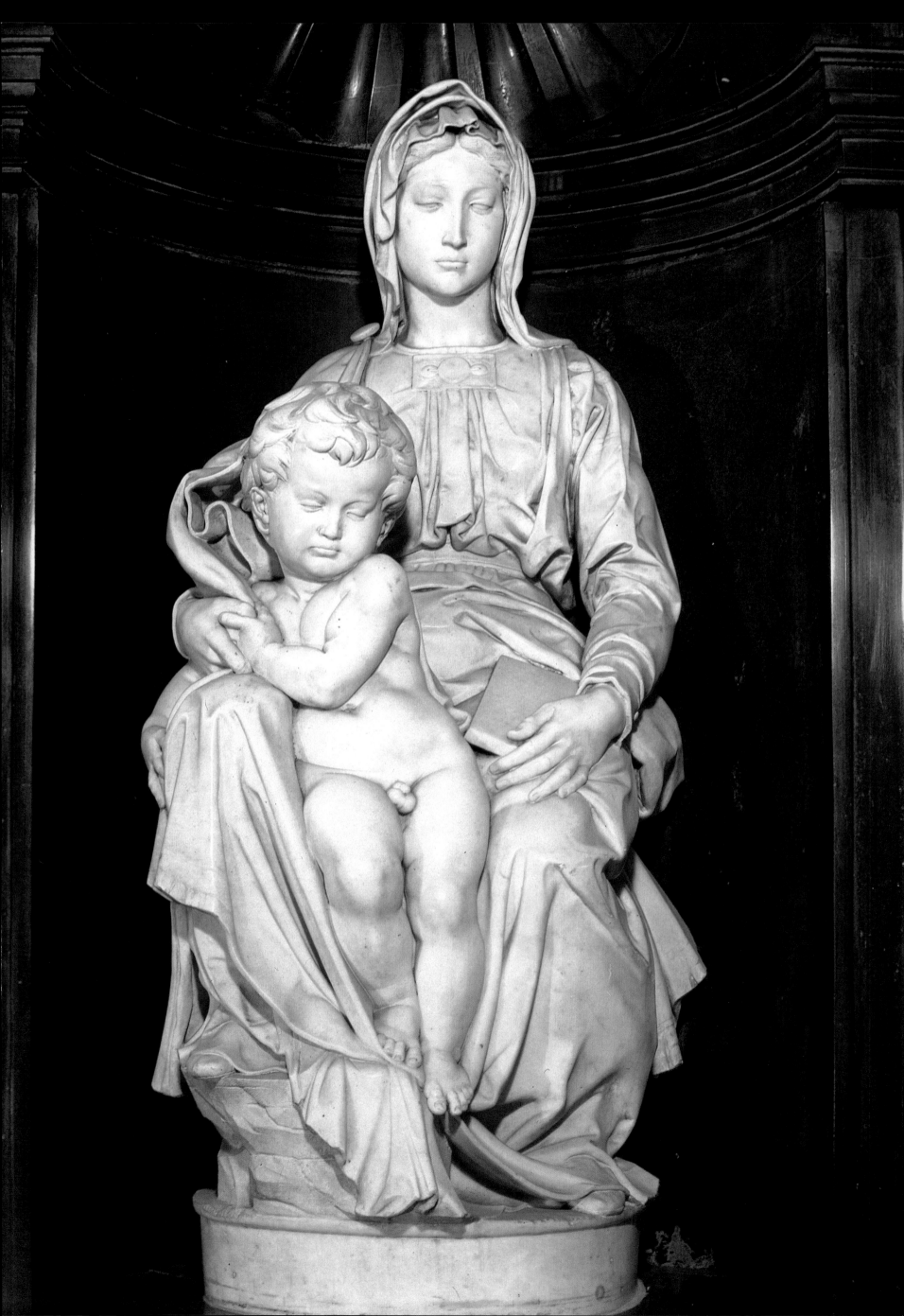

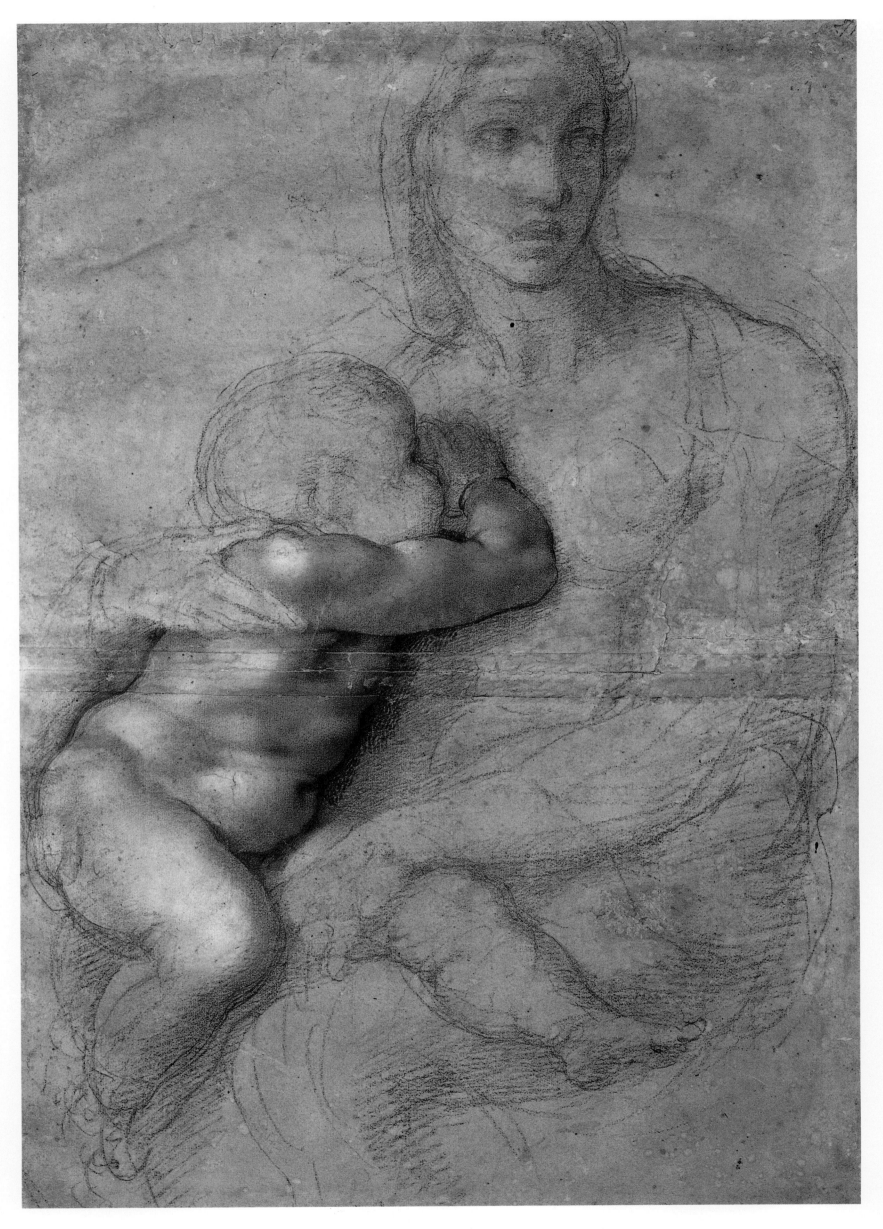

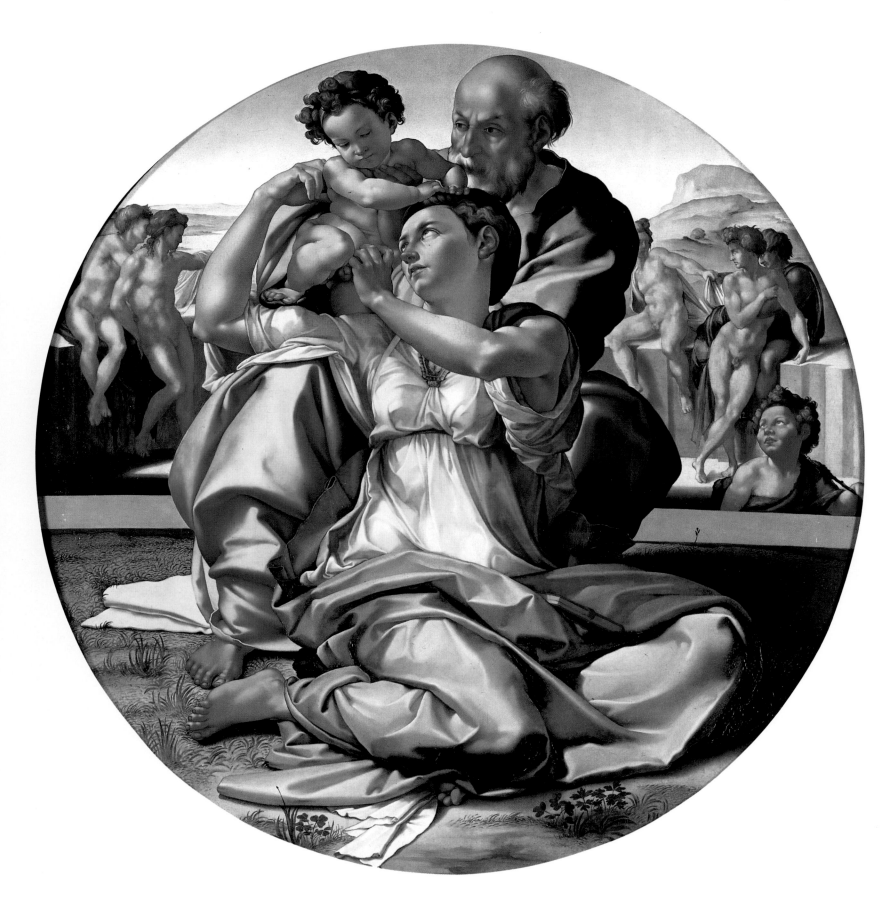

ABOVE: *Madonna and Child (Doni Tondo)*, 1503-04, tempera on panel, diam. 46¾ inches (120 cm), Uffizi Gallery, Florence. The only easel painting securely attributed to Michelangelo, this uses the traditional medium of tempera on wood panel, rather than the new technique of oil on canvas which his rival Leonardo preferred. The crispness of the picture is in part related to the choice of medium, and anticipates the brilliant color revealed by the restoration of the Sistine ceiling. The nudes in the background probably represent pagan life before the possibility of salvation through Christ.

LEFT: *Drawing for the Doni Madonna*, red chalk, Museo Buonarroti, Florence. This demonstrates Michelangelo's early mastery of the medium introduced by Leonardo.

Venice to Florence, arriving in 1500, some months before Michelangelo. Like Michelangelo, he returned, as the painter of the *Last Supper*, with his artistic reputation established, and in April 1501 exhibited a cartoon for an altarpiece of the *Virgin and Child with St Anne and St John* which caused a sensation.

It was with this stimulus that Michelangelo began again to paint. His only firmly datable painting before the Sistine ceiling is the *Madonna and Child* painted for the Doni family, probably to mark the marriage of Angelo Doni to Maddalena Strozzi in 1503. This is a round painting or *tondo*, a traditional form used particularly for domestic decoration, and which clearly shows the influence of Leonardo.

A preparatory study for the Doni Madonna is made in red chalk, a medium new to Michelangelo which Leonardo had introduced. The tondo itself is arranged in the pyramidal form advocated by Leonardo as the most satisfactory means of arranging a group of linked figures in space. And yet the clarity of definition and the brilliant color, arranged sculpturally in blocks, is far removed from the soft-focus atmospheric quality of contemporary paintings by Leonardo, such as the *Mona Lisa* (*c*.1503).

Michelangelo made two other tondi at about this time, both marble reliefs and both unfinished, perhaps because of his departure for Rome in 1505. Circular

BELOW: *Madonna and Child with the Infant Saint John (Taddei Tondo)*, 1504-05, marble, diam. 47½ inches (121.5 cm), Royal Academy of Arts, London. The theme of this circular relief recalls that of the Leonardo cartoon of the *Virgin and Child with St Anne and St John*, exhibited in Florence in 1501. Instead of the pyramidal composition favored by Leonardo and adopted by Michelangelo in the *Doni Tondo*, however, the figures here follow the curving outline of the marble. The goldfinch held by the infant Baptist, from which the Christ Child shrinks back in alarm, was regarded as a symbol of the Passion, and the Madonna's remote gaze suggests that she too can see the future.

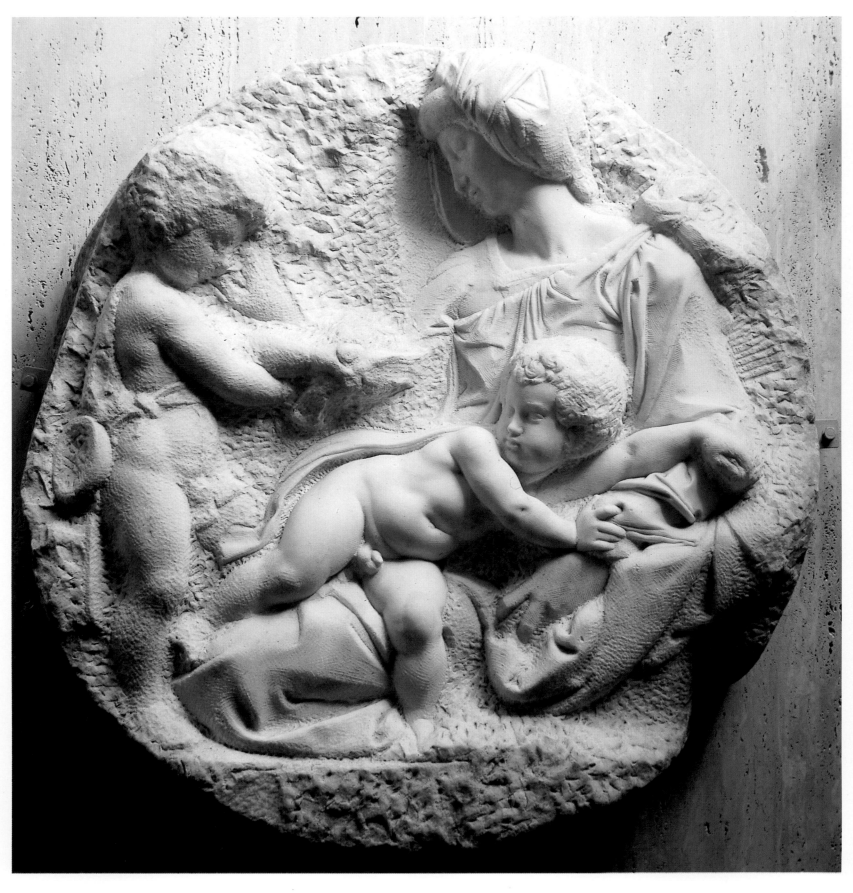

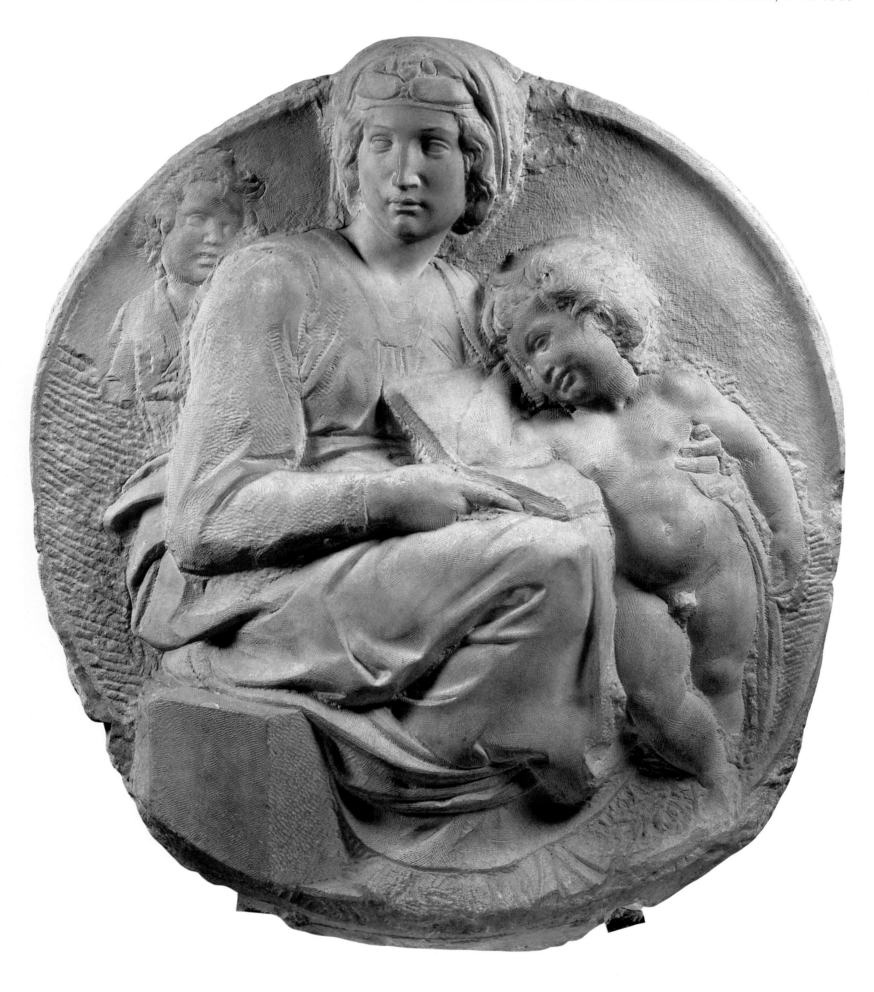

ABOVE *Madonna and Child with the Infant St John (Pitti Tondo)*, 1504-05, marble, diam. 32 inches (82 cm), Museo Nazionale (Bargello), Florence. Carved in higher relief than the Taddei Tondo, the figures in this smaller marble are arranged in a triangular composition which pushes against the constraints of the circular form and actually bursts its bounds at the top. The clear modeling of the Virgin's head and her direct gaze link her with the sibyls on the Sistine ceiling, begun four years later (page 44).

marble reliefs were often used on tombs, but these both seem to have been commissions from patrons motivated by admiration for Michelangelo's work, indicating the growing interest in art for its own sake. Both take the Madonna and Child for their subject, and have a greater softness and sense of atmosphere than the *Doni Tondo*. The *Taddei Tondo*, now in the Royal Academy, London, has a particular delicacy and tenderness which, if anything, is emphasized by its very unfinished state; only the Child, shown

lying across his mother's lap and flinching away from a bird held by the young John the Baptist, is at all fully realized. The *Pitti Tondo* is both smaller and more finished, and instead of the group being enclosed within the block, the head of the Madonna projects above the perimeter of the frame and the relief is much higher.

All three tondi show Michelangelo experimenting with the composition of a group within a circular frame. His next sculptural work, the unfinished figure of

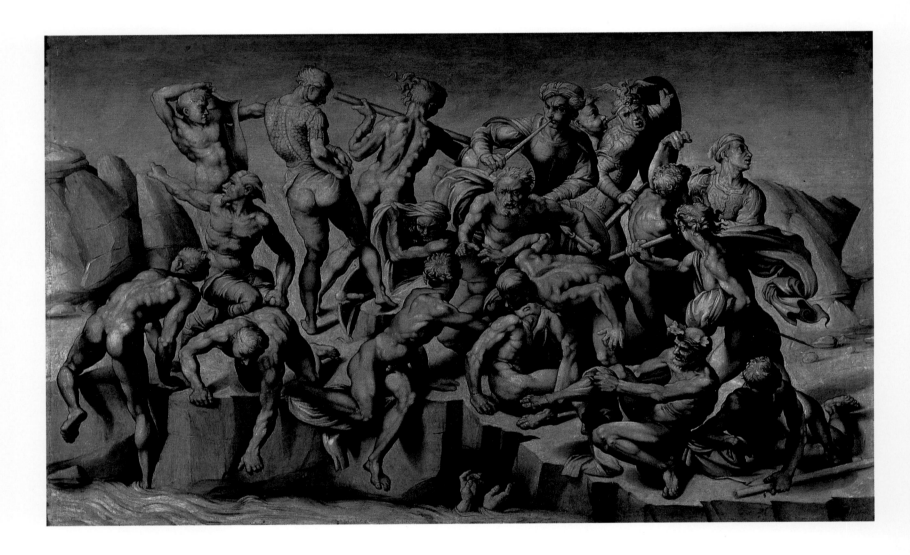

ABOVE: Aristotile da Sangallo, copy of part of
Michelangelo's *Battle of Cascina* cartoon, *c*.1542,
grisaille on panel, Viscount Coke, Holkham
Hall, Norfolk. When both Michelangelo and
Leonardo were commissioned by the new
republican government in Florence to paint
murals for the great Sala del Gran Concilio, the
rivalry between them was given an additional
edge. Leonardo's subject was the battle of
Anghiari, Michelangelo's the battle of Cascina,
with the central section, copied by Sangallo,
devoted to the moment before the battle when
Florentine troops bathing in the river were
alerted at the last moment to the approach of
Pisan forces.

St Matthew, commissioned for Florence Cathedral as one of twelve apostles, introduces a new and potent image in his work: the contorted figure struggling against some form of constraint, which was to reappear on the Sistine ceiling, in the Medici Chapel, and in some of the figures he carved for the tomb of Pope Julius II. This work was interrupted by the commission to paint a battle scene in the main hall of the Palazzo della Signoria, to which Leonardo was commissioned to paint a companion. The latter's mural was completed swiftly but, like the *Last Supper*, was painted in an experimental fresco technique which deteriorated rapidly and irreparably. Michelangelo had completed only a part of the preparatory cartoon when he was summoned to Rome by Julius II and given the tomb commission. The original is now lost, but a surviving partial copy shows that Michelangelo seized this as his first great opportunity to demonstrate his extraordinary ability to create nude figures in violent action. The cartoon was immensely influential on the next generation of artists; it was hailed as a triumph and installed in the Medici Palace.

RIGHT: *St Matthew*, 1503-08, marble, h. 105 inches (271 cm), Accademia delle Belle Arti, Florence. The only one of a planned total of twelve apostles that Michelangelo was able even to begin before the commission was interrupted by the *Battle of Cascina* project, this massive figure seems to be growing out of the block of stone, clearly illustrating Michelangelo's method of working the block from the front.

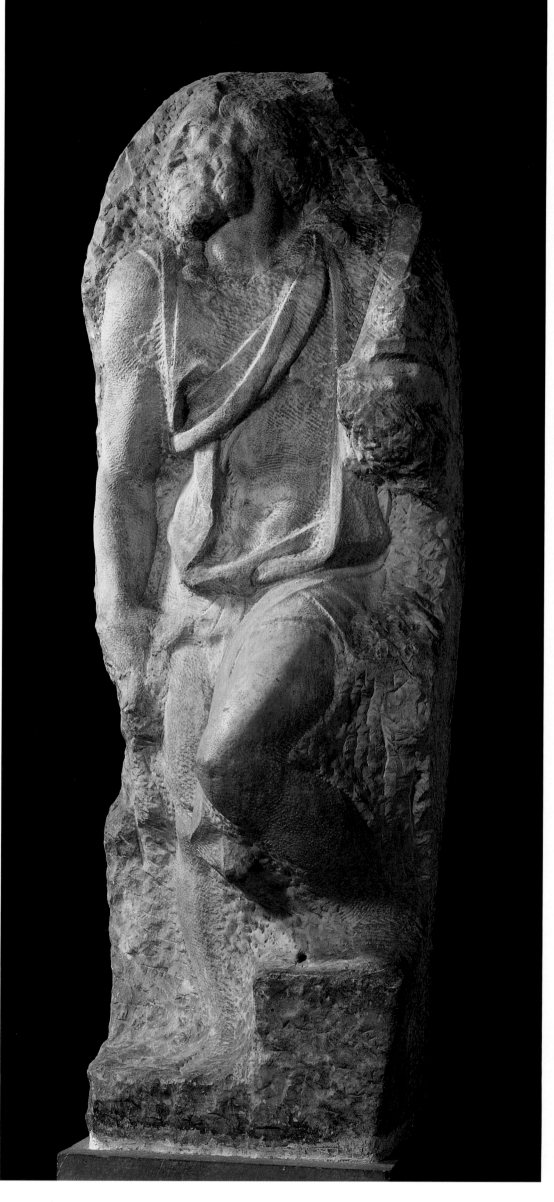

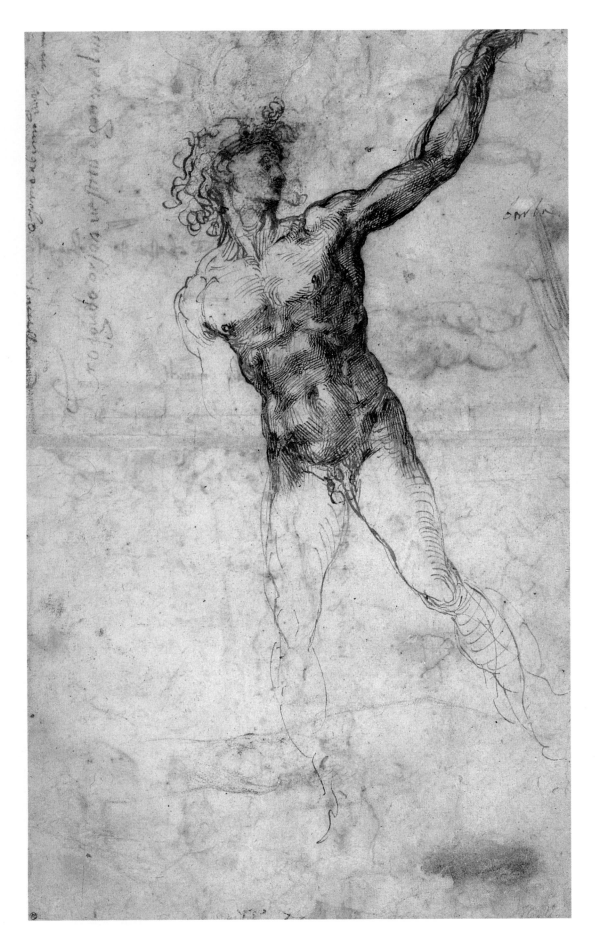

One final work generally attributed to Michelangelo which probably dates from this period is the *Entombment*, now in the National Gallery, London. It is unfinished, and seems to have been painted in two stages: it was started in the traditional egg tempera technique on wood panel, but the upper layers of paint are oil, a medium introduced from northern Europe and already used by Leonardo, but becoming more widely disseminated among Italian painters in the first decade of the sixteenth century. Stylistic changes between the group on the left, particularly the figure in red, whose bright blocklike color recalls the *Doni Tondo*, and the more loosely painted figure of Christ and the group on the right, also suggest a hiatus. One suggestion is that it was intended for the Julius tomb, the original version of which called for an altarpiece; it certainly offers only hints of the painter's power and skill that Michelangelo was to display within a few years on the Sistine ceiling.

ABOVE: *A Youth Beckoning*, c.1503-04, pen and brown ink, 14½ × 10 inches (37.5 × 23 cm), British Museum, London. A number of preparatory drawings for the *Battle of Cascina* survive, of which this striding and gesticulating figure is probably one. It is an example of Michelangelo's characteristic habit of bringing the torso to a high degree of finish and sketching in the rest of the figure.

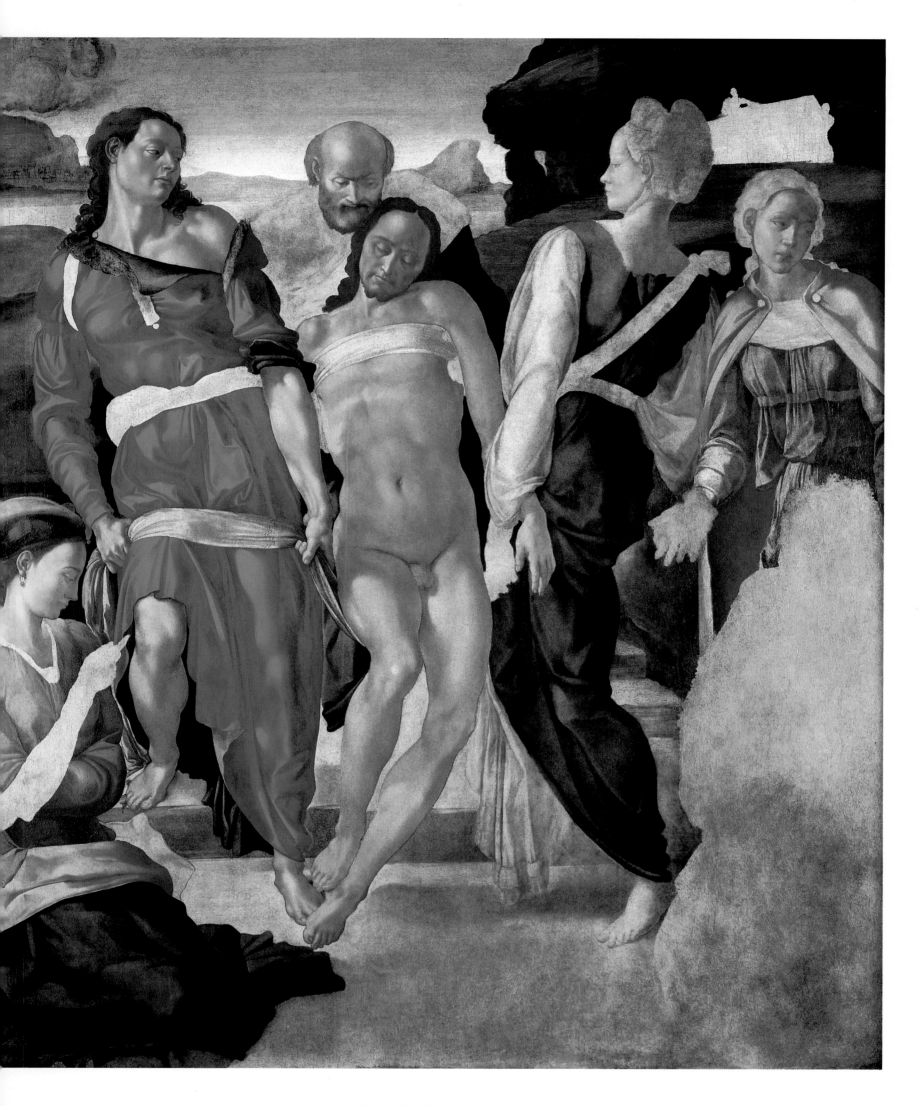

ABOVE: *Entombment, c.*1506, tempera and oil on panel, 63⅔ × 59 inches (161.7 × 149.9 cm), National Gallery, London. This was probably painted in two stages, and still left unfinished. The Christ and the lady in green are more loosely painted than the figure in red on the left; the Christ recalls the *Pietà*, while the bearded man behind him recalls the Joseph of the *Doni* *Tondo.* The later figures show the influence of the antique marble group of *Laocöon*, which was found in a Roman vineyard in 1506 and attracted much attention at the time; it depicted the priest Laocoön and his two sons writhing in the grip of giant snakes, sent by the gods as a punishment.

33

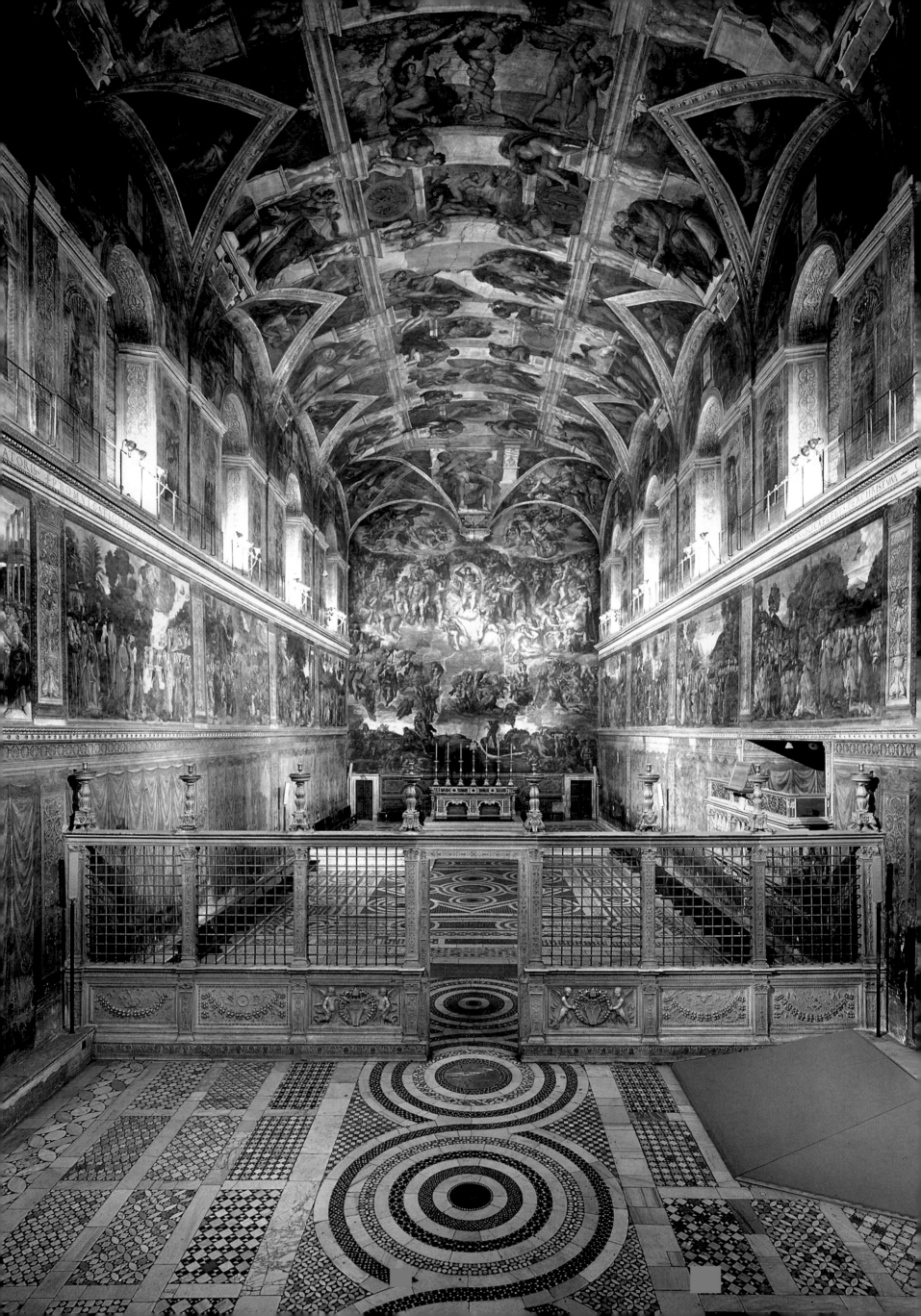

CHAPTER TWO

Painting: Rome,
The Sistine Ceiling, 1505-13

Michelangelo was originally summoned to Rome in 1505, when Pope Julius II (elected pope in 1503) prevailed upon the Florentines to release him from his work on the *Battle of Cascina* cartoon in order to work on the papal commission for a grandiose tomb (see pages 67-72). The fact that this move, in which Michelangelo seems to have acquiesced only reluctantly, was negotiated by the political powers in each case is evidence of the artist's already substantial reputation and standing.

The progress of the tomb commission was far from smooth; patron and artist were both demanding and irascible men, and in April 1506 Michelangelo returned to Florence in a fury, taking up work again on his lapsed contract for a series of apostles for the cathedral. Again the Pope pressurized the Florentine Signoria into handing over their prized artist. Piero Soderini, the Florentine Gonfalonier, or elected head of state, is reported to have told Michelangelo bluntly that:

'He had had a passage of arms that even the King of France would not have dared to try, and since the Florentine state had no desire to go to war over him, he should no longer put them at risk but prepare to depart'.

Julius II had already proved his military mettle since his election, in his efforts to recover the Papal States lost to Venice when the Borgias fell from power, and to re-establish papal control over the fiefs of Perugia and Bologna. Lacking any troops, he created the Swiss Guard from a group of 200 loyal men and led a triumphant campaign in person; by September 1506 he had recovered Perugia, and in November he entered Bologna in triumph. Michelangelo was forced to sue there for papal pardon. It seems that Julius had already by then decided that he wanted Michelangelo to take on the ceiling of the Sistine Chapel, hence his insistence on the artist's return, but it was only in May 1508 that his military commitments slackened sufficiently for him to summon Michelangelo to Rome specifically for the purpose.

Given this background of political uncertainty and upheaval, Julius's lack of funds, and the urgent need to defend papal authority and restore the papal estates, it is staggering that he managed to achieve so much as a patron in the ten years of his pontificate. As well as Michelangelo's work on the papal tomb and the Sistine ceiling, Julius commissioned Raphael (1483-1520) to work on

the Stanze, the suite of rooms in the Vatican he planned to use as offices, and began the reconstruction of St Peter's under the leading High Renaissance architect, Donato Bramante (1444-1514), which was to occupy the final years of Michelangelo's extraordinarily long life (pages 107-109).

The Sistine Chapel had been built by and named after Julius II's uncle, Sixtus IV (1471-84), as part of his campaign to restore papal control in Rome after the long exile in Avignon during the Papal Schism (1309-77). The great size of the chapel reflects its dual function. It served as a bastion of the Vatican; its walls are nine feet thick and the only natural light comes from windows set high in the walls, a reminder that the papal palace in Avignon had been besieged more than once. But it was also the principal focus of papal ceremony, above all the meeting of the Conclave for papal elections, and as such needed to be both large – about 132 foot long and 45 wide – and gloriously decorated. The walls are divided into three horizontal tiers, the lowest of which consists simply of painted curtains, intended to be covered by tapestries on ceremonial occasions. Above this Sixtus commissioned two fresco cycles of

LEFT: Interior view of the Sistine Chapel from the east, showing the three horizontal tiers into which the walls are divided, the spandrels and lunettes which link the walls with the ceiling and which form part of Michelangelo's decorative scheme, the ceiling itself, and Michelangelo's much later *Last Judgment* on the end wall.

OVERLEAF: This overall view of the ceiling demonstrates how Michelangelo set both his major and minor subjects within a painted architectural framework, which gives a coherence and unity to a scheme which might otherwise seem too overwhelmingly complex.

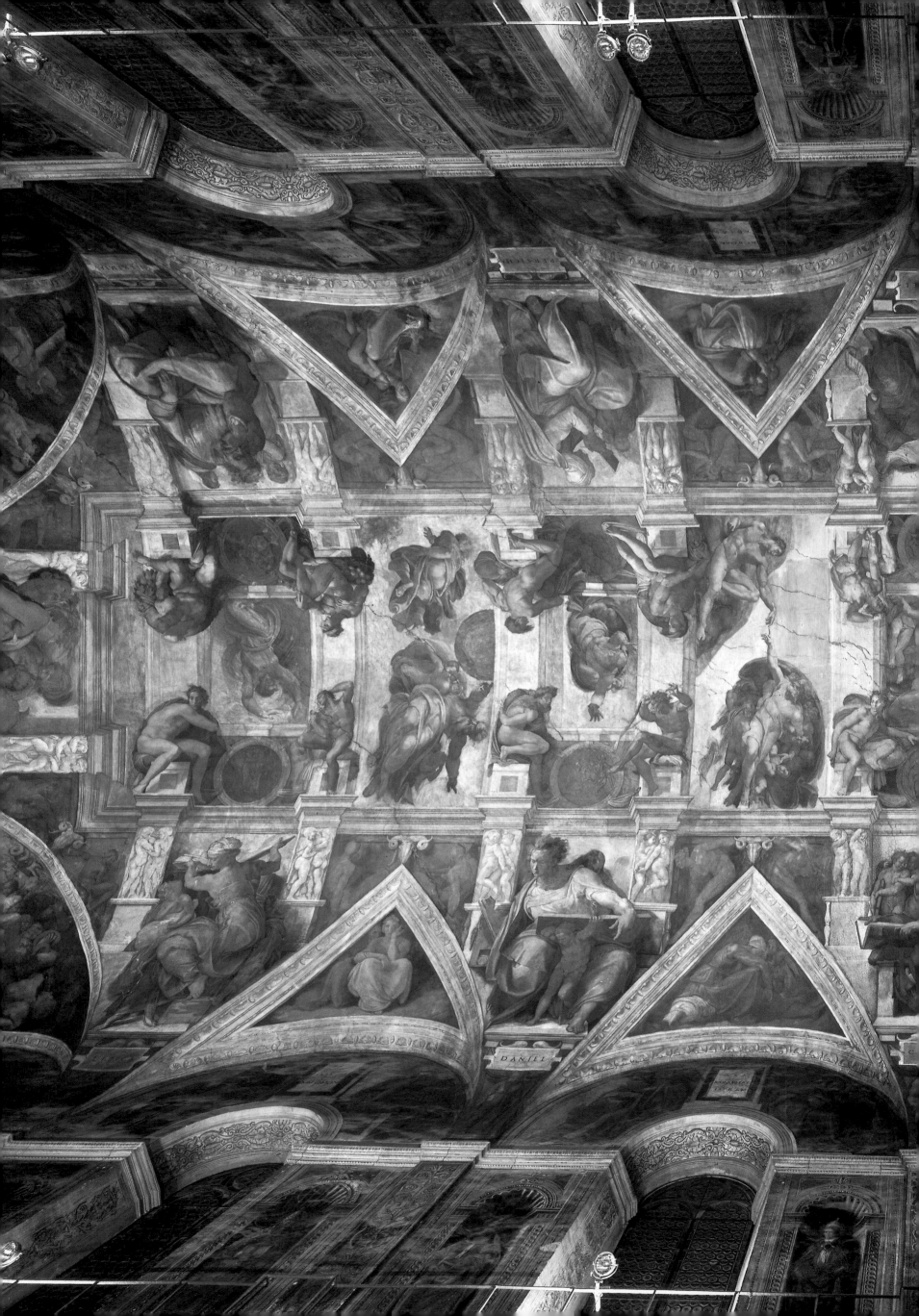

DANIEL

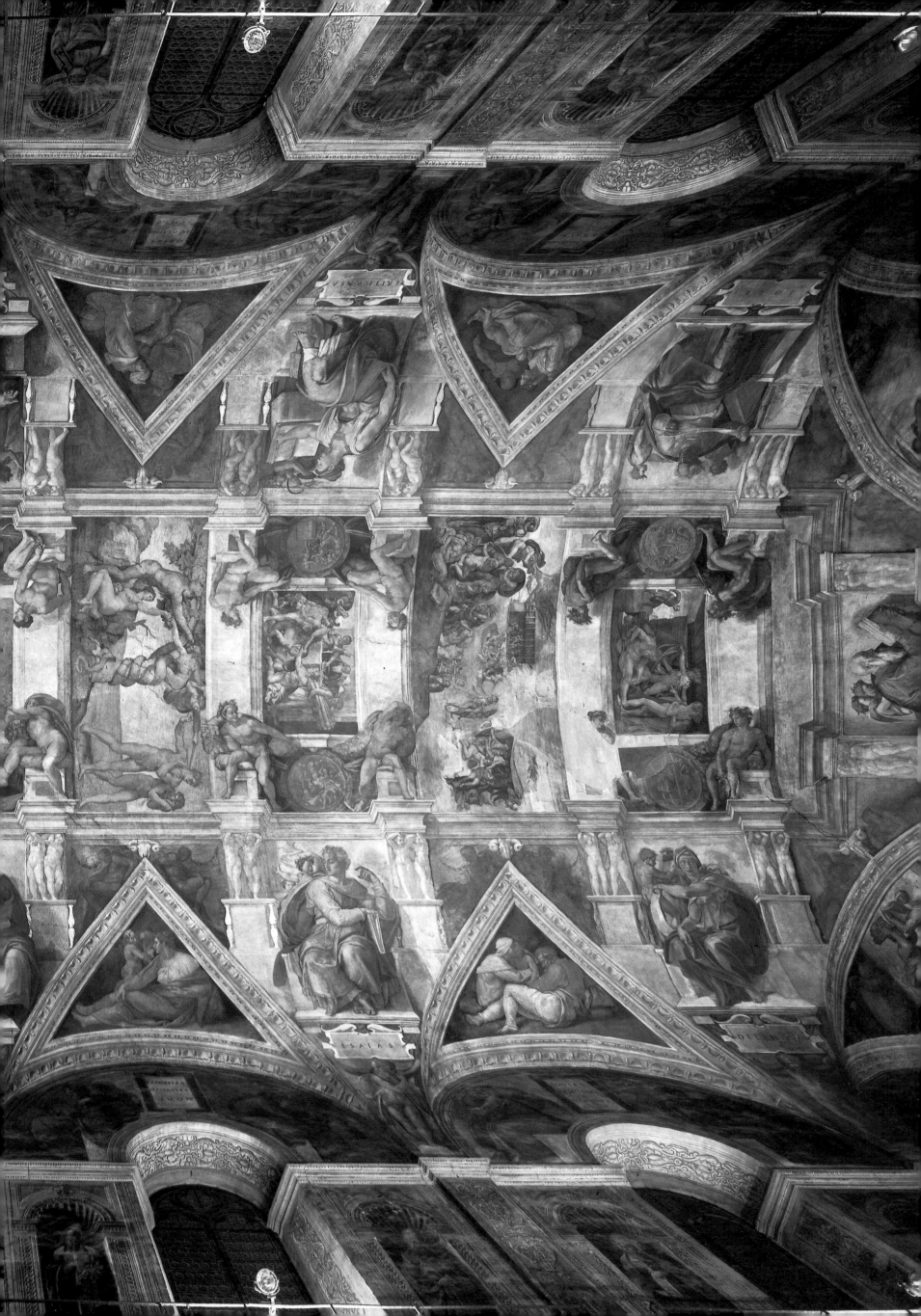

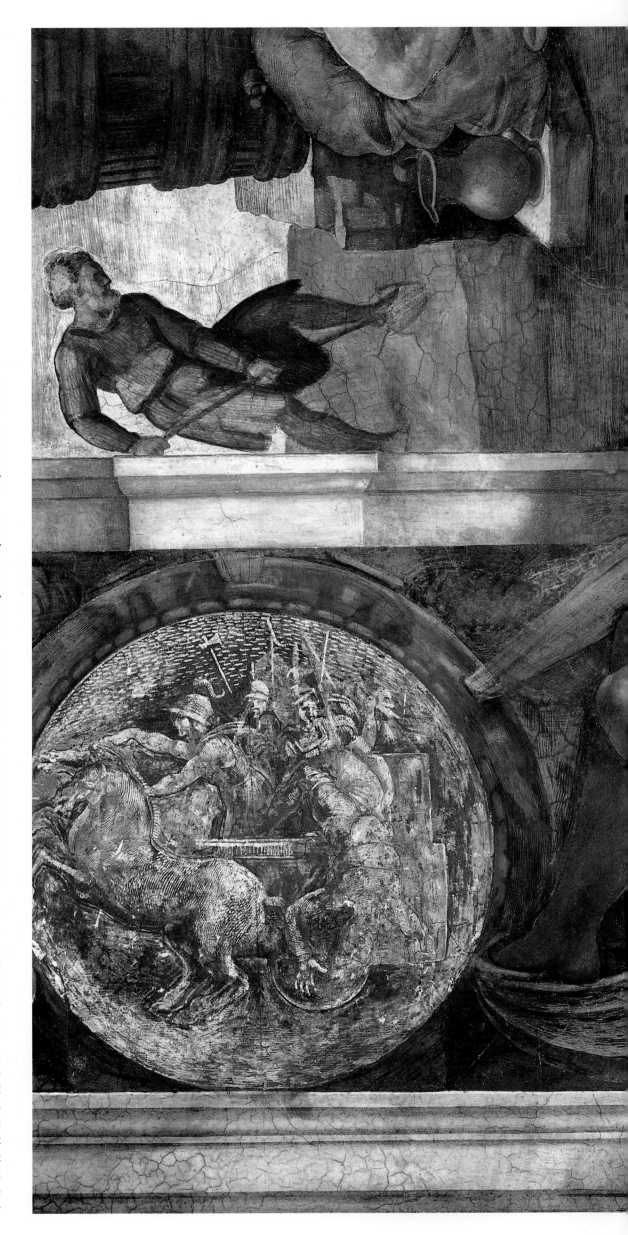

the *Life of Christ* and the *Life of Moses*, both intended to reinforce the idea of the papacy as a direct descendant of the Apostle Peter. These were painted by such leading Tuscan artists of the time as Perugino, Botticelli, and Michelangelo's early teacher Ghirlandaio. The upper tier between the windows contains images of early popes, painted by the same artists.

The ceiling is a shallow barrel vault, with the window arches that break up the upper decorative tier along the sides of the chapel rising into and interrupting the curve of the vault. This creates a series of spandrels, triangular sections of vaulting which link the window arches with the ceiling, while in the window arches themselves are a series of lunettes, semicircular areas of wall which are treated, for decorative purposes, as part of the ceiling. The third architectural feature for which Michelangelo had to find a unifying theme was the four corner spandrels, the deeper areas of vaulting which form the junction between the side and end walls and the ceiling. The original ceiling decoration was a blue sky speckled with gold stars, a common Early Christian motif, and Julius proposed a complete reworking of this to give the ceiling more emphasis and to reflect contemporary taste.

Michelangelo was initially deeply reluctant to undertake the Sistine commission, preferring to finish the tomb commission in which he had become deeply involved, and complaining that he was a sculptor not a painter. Certainly he had not had much experience as a frescoist, apart from the abortive battle scene project for the Palazzo della Signoria in Florence (page 30), or as a colorist, and he undoubtedly foresaw that planning and painting such a vast and awkward space would be extremely taxing. It is doubly ironic that the commission that he accepted so grudgingly should not only be recognized by his contemporaries as a triumph, subsequently hailed as the greatest pictorial ensemble in the history

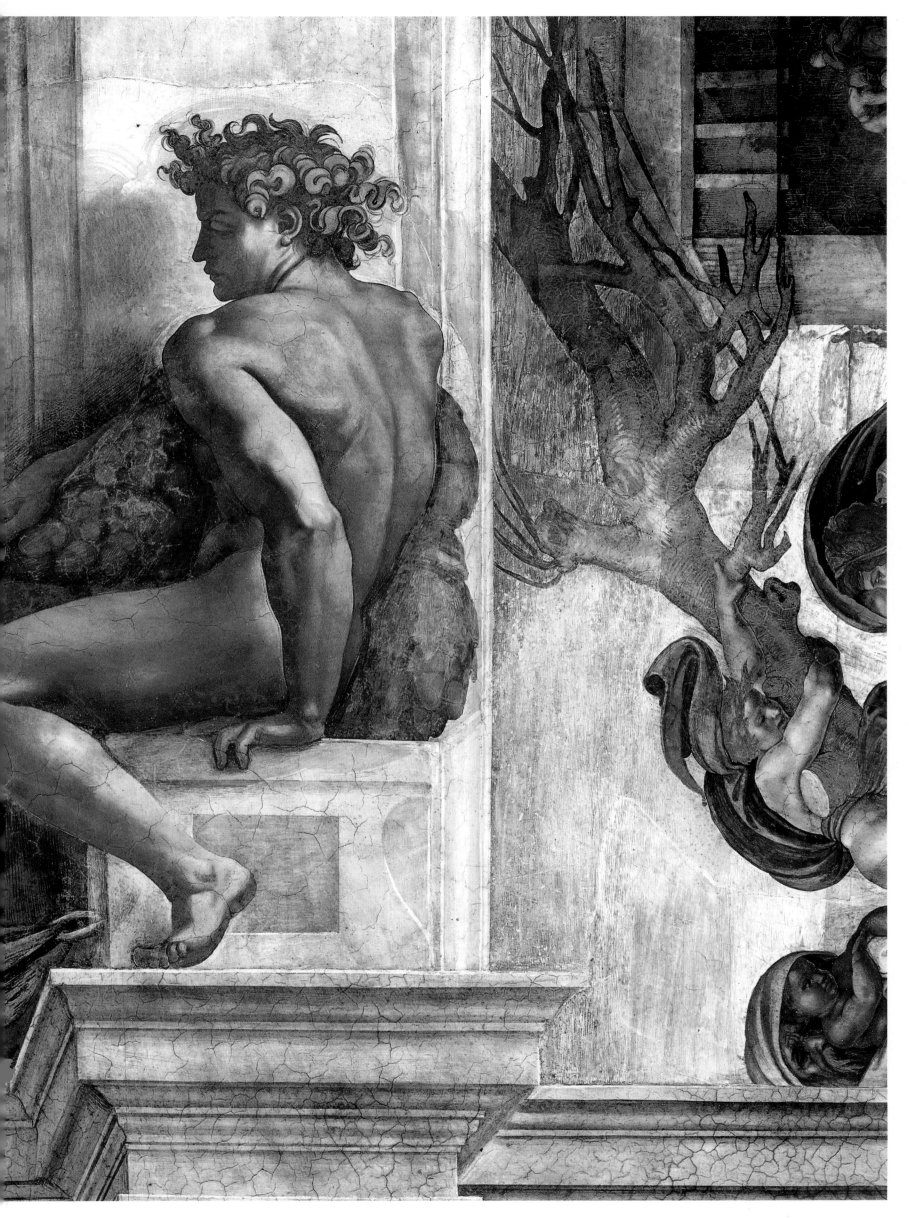

RIGHT: *Joel*, one of the prophets painted in the first phase of the ceiling project. Like his flanking *ignudi* (previous page), Joel is portrayed in a fairly sedate pose, enclosed within the niche of the throne on which he sits. The niche is in turn an integral part of the architectural framework, and thus the prophets and their companions, the sibyls, are represented as being of a different order of reality from the central narrative panels.

of Western art, and the work by which he is best known today, but should also be one of the few major commissions which he completed – in a mere, astoundingly fertile, four years.

The first proposal was for a series of 12 Apostles enthroned, but Michelangelo soon found fault with that as being only a 'poor thing', and persuaded Julius to a change of design. According to his own account, as reported by his faithful biographers, the Pope then gave him a free hand with the content and design of the ceiling, but this is now agreed to be highly improbable. The Church would not have allowed the iconographical scheme for somewhere as important as the Vatican chapel and the seat of the Conclave to be left to an artist, however famous and well-educated. The program is a subtle and complex one, and must have been worked out with the help of a theologian.

Michelangelo gave the ceiling an architectural framework, which seems to have survived from the previous Apostle scheme, of which two small drawings exist. His long involvement with Julius's tomb, also composed of single figures in an architectural setting, is reflected in this spatial approach, which emerges again in his later, more specifically architectural work on the facade of San Lorenzo and the Medici Chapel in Florence (pages 71-74 and 75-81). Here the framework consists of a painted cornice which separates the central section of the ceiling from the more curving portion into which the spandrels encroach. The cornice is dissected by five pairs of painted ribs, which in turn seem to spring from the spandrels straddling the window arches. Thus the painted framework serves a dual purpose. It links the barrel-vaulted ceiling proper with the real architectural elements, the spandrels and pendentives, that connect the ceiling with the walls, but it also divides the ceiling proper into a series of linked but separate panels, allowing a narrative approach to the whole.

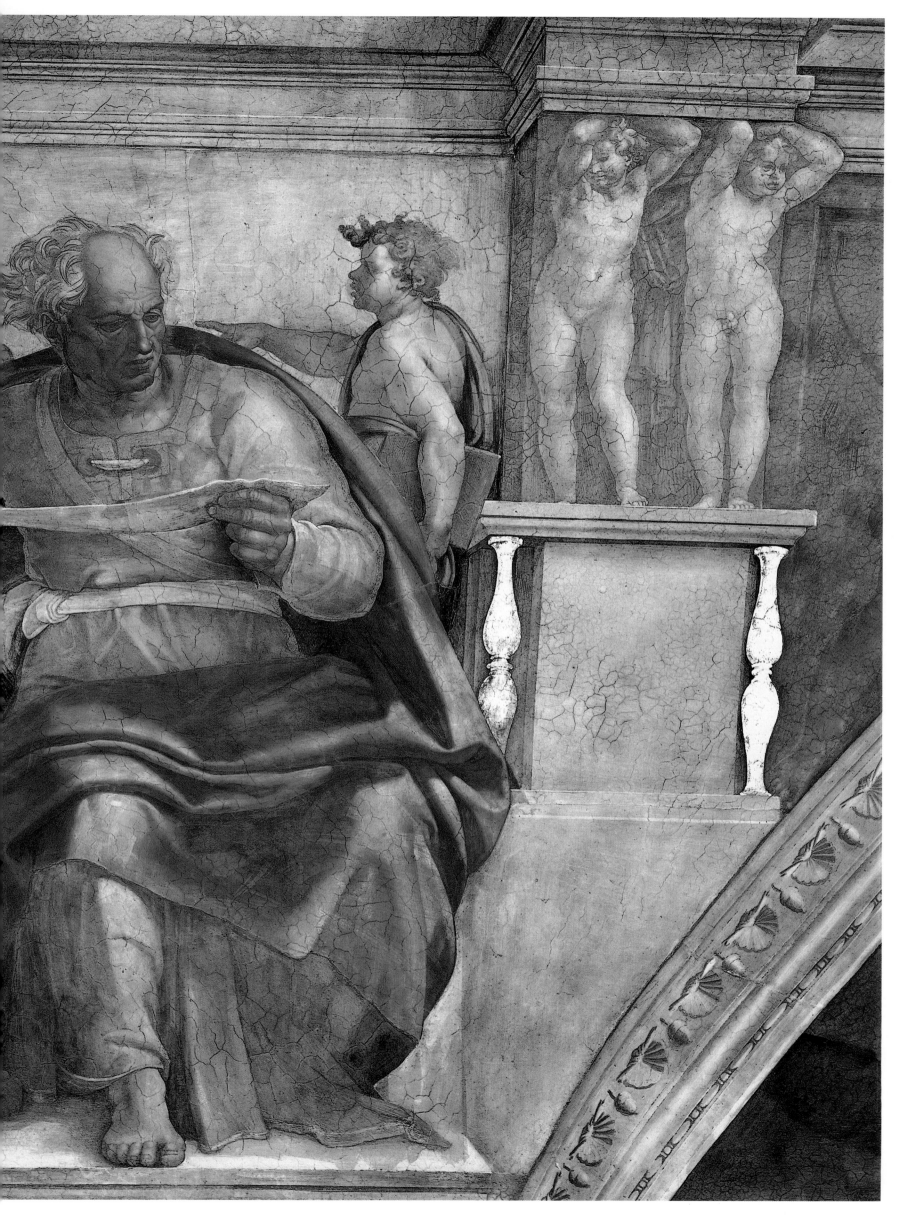

RIGHT: The Sistine Chapel ceiling, entrance end. Michelangelo began painting from this end, although the scenes he painted first in fact fall later in the chronology of the narrative. Thus one of the first scenes painted, the *Drunkenness of Noah*, is the last scene chronologically, representing the degeneracy of mankind before the birth of the Savior. The prophet Zachariah, a magisterial figure above the entrance used by the laity, was both a prophet of gloom, condemning the backsliding of the Jews, and of hope, for he foretold the building of a new Jerusalem, the restoration of peace and prosperity, and the coming of a Messiah 'lowly and riding upon an ass.' He thus forms a link between the ceiling scheme and the two wall fresco cycles devoted to the life of Moses and the life of Christ. Flanking Zachariah, in the two corner pendentives, are two scenes from the history of the Jews in which a mighty adversary is overcome by the ingenuity and courage of an apparently weaker opponent, Holofernes by Judith and Goliath by David. In this earlier section of the ceiling, the narrative panels are densely populated and hard to decipher, and the prophets and sibyls are relatively static and contained within their architectural framework.

The choice of subject relates to the two earlier fresco cycles along the walls of the Chapel; the life of Moses, representing the history of Man under the old law of the Old Testament, and the life of Christ, illustrating the new dispensation of grace and redemption revealed in the New Testament. The ceiling, logically enough, depicts scenes from the earliest history of the world, before God's pledge of a Promised Land to Moses and his granting of the law in the form of the Ten Commandments. The painted ribs have the effect of dividing the central section of the ceiling into four large and five smaller rectangles, which Michelangelo filled with scenes from *Genesis*. The sequence therefore begins at the altar end with the Creation itself, first the primal act of creation, the *Separation of Light from Darkness*, then the *Creation of the Sun and Moon*, finally the *Separation of Land from Water*. All these nine central scenes are painted so as to be viewed from the altar, and therefore seem upside down to the visitor entering from the west door.

Before looking in detail at the individual scenes, it is important to understand how Michelangelo treated the rest of the pictorial space he had so ingeniously created with his architectural framework. He effectively created three distinct zones, echoing the three tiers of the walls. The nine scenes of the vault proper are all treated as independent conceptions, each with its own perspective. But contradicting the individual perspective of these *Genesis* scenes are the 20 male nude figures or *ignudi* (one of them almost wholly lost) which perch on pedestals above the cornice and in front of the pilaster ribs which form the grid of the vault. These rows of *ignudi* give the central section of the ceiling both a unified and an alarmingly vertiginous quality. The second zone consists of prophets and sibyls, seated on thrones below the cornice and larger in scale than any of the central figures, but painted with a degree of foreshortening that gives

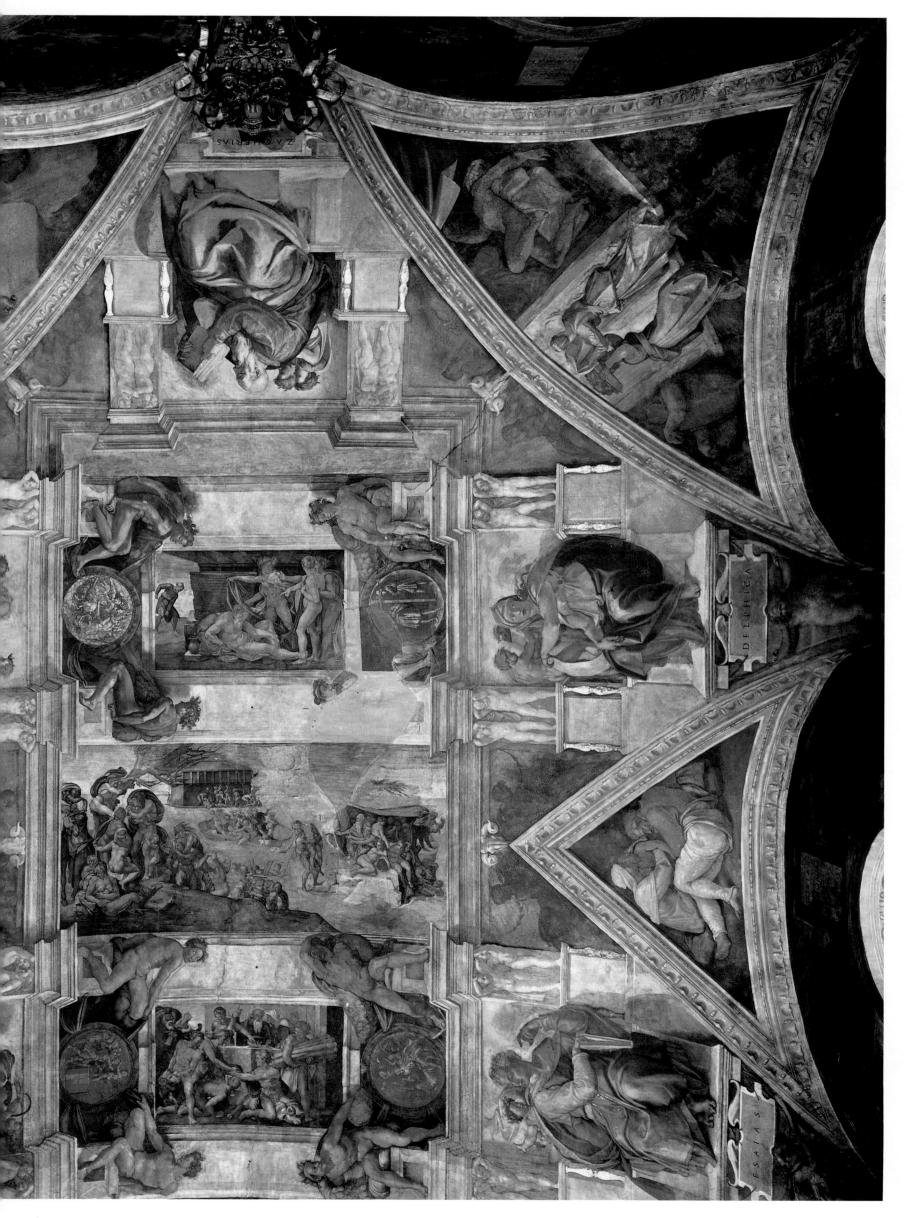

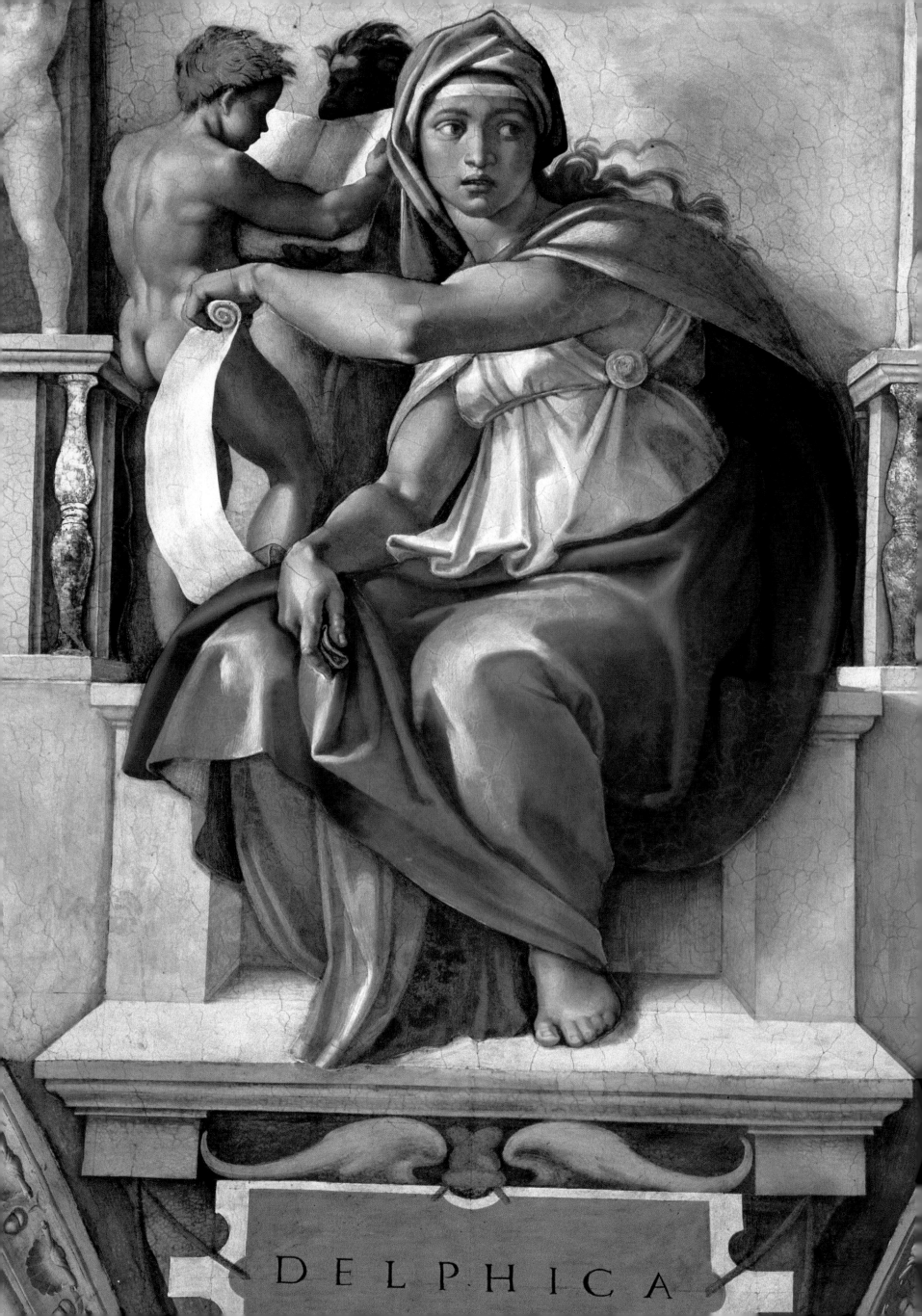

DELPHICA

LEFT: *Delphic Sibyl*, photo © Nippon Television Network Corporation. The cleaning of the ceiling in the 1980s revealed the brilliantly contrasting colors used by Michelangelo, which had become overlaid with the grime of centuries. The sibyls were prophetesses revered in classical antiquity, who were believed to have foretold Christ's coming; the Delphic sibyl predicted that a prophet should be born of a Virgin who knew no human corruption.

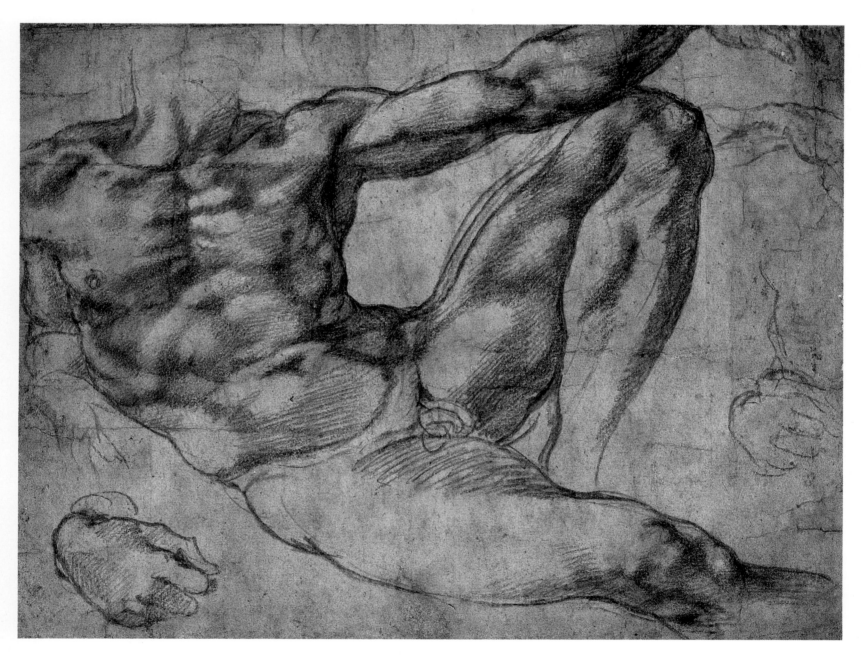

ABOVE: *Drawing for Adam*, c.1511, red chalk, 7½ × 10 inches (19.3 × 25.9 cm), British Museum, London. This working drawing is characteristic of Michelangelo's tendency to concentrate on the torso and leave the extremities unfinished.

added depth to the vault above and relates them to the viewer on the floor. The spandrels between them and the lunettes below, depicting the Ancestors of Christ, represent a third level of reality, closer both in perspective and in subject matter to the world of the viewer.

Although the chronological order of the central nine scenes begins at the altar end with the Creation, Michelangelo actually began work at the other end, with the final scenes from the life of Noah. The scaffolding which he used ex-

tended from the west door to halfway down the length of the Chapel, and it seems that he painted this portion in little more than 18 months between the end of 1508 and summer 1510. The first scene, over the entrance used by the laity, is the *Drunkenness of Noah*, placed slightly out of biblical sequence in order to allow a progressive ascent from the degradation of man when left to his own devices, to the splendor of God the Father and Creator, soaring magisterially over the altar.

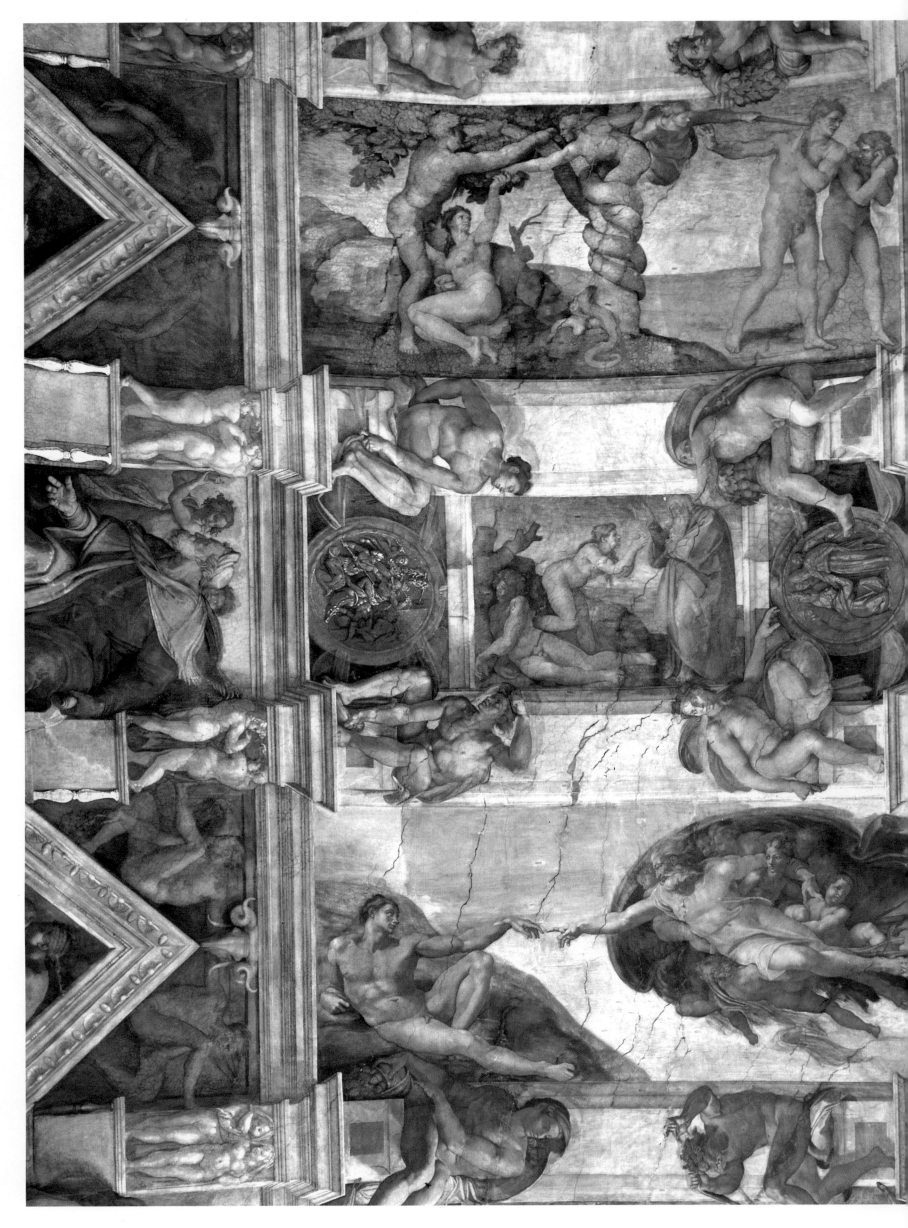

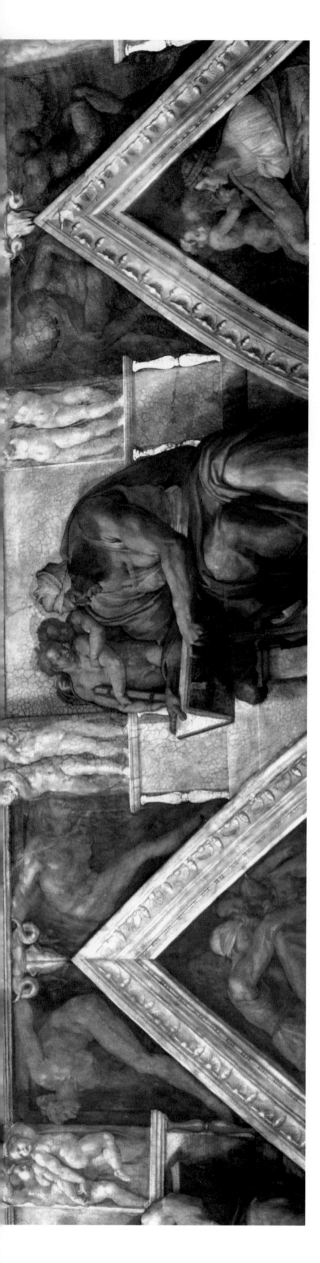

LEFT: The central section of the Sistine ceiling shows the *Fall of Man and the Expulsion from Paradise*, treated as a single sequence; the *Creation of Eve*; and, painted after a break in the work through lack of funds, the famous *Creation of Adam*. The first two are reminiscent of the work of Masaccio which Michelangelo had copied as a youth. The *Expulsion* provokes comparison with Masaccio's painfully poignant Adam and Eve in the Brancacci Chapel, Florence, while the massive draped figure of God in the *Creation of Eve* recalls Michelangelo's drawings from *The Tribute Money* (page 12). By the time he came to paint the *Creation of Adam*, Michelangelo had been able for the first time to view the ceiling he had so far painted from the floor, as the scaffolding had been taken down and moved. This scene is anyway one of the four larger narrative panels, but compared with the two larger ones already painted, the *Deluge* and the *Fall*, it is both more clearly and simply conceived and infinitely more dramatic and immediate. There is a movement and tension in the swirling act of creation which is wholly missing from the calmer, more static *Creation of Eve*, and this animation spills over into the prophets and sibyls which accompany the later narrative scenes.

The restorers who recently finished their still-controversial work on the Sistine ceiling concluded on technical and stylistic grounds that the larger scene of the *Deluge* was painted before the *Drunkenness of Noah*. The deduction is based on the sequence of *giornate*, the measures of plaster applied each day. Throughout the project Michelangelo seems to have followed the same procedure of painting a central panel, then the adjacent prophets and sibyls, and then the spandrels and lunettes. The *Deluge* is reminiscent of the Cascina cartoon, with its multitude of nude figures, both male and female, fleeing the flood, and its minimal landscape detail.

The next two *Genesis* scenes painted, the *Drunkenness of Noah* and *Noah's Sacrifice*, are conceived on a larger scale with fewer figures, suggesting that Michelangelo realized that the complexity and detail of the *Deluge* scene was hard to read from the floor. As he worked on the ceiling, he continued progressively to eliminate extraneous detail and to paint more freely and energetically. In the *Drunkenness of Noah*, Noah's son Ham summons his brothers to cover the sleeping body of their father, who has been overcome by the effects of wine from the vineyard he planted. Ham, however, has seen his father's nakedness, which is forbidden, and his family is therefore cursed. Despite the point of the story, Michelangelo paints all the characters nude, an indication of contemporary ecclesiastical worldliness which was to change soon and radically with the Counter-Reformation.

The final scenes, painted before work was interrupted in 1510 by lack of money, were the *Fall of Man and the Expulsion from Paradise*, treated in an old-fashioned manner as a single narrative sequence through lack of space, and the *Creation of Eve*. In the first, Eve's curiously contorted pose recalls the Madonna of the *Doni Tondo* (page 27), and the serpent is also, and unusually, a female figure. The

47

RIGHT: The final section of the Sistine Chapel ceiling has a greater dynamism than the earlier parts, visible both in the increased forcefulness and clarity of the narrative scenes and in the exaggerated poses of the attendant prophets, sibyls and *ignudi*. Over the altar the prophet Jonah, a prefiguration of the Crucifixion and Resurrection on account of the three days he spent inside the whale, leans back in exaggerated terror to observe the first act of creation, the *Separation of Light from Darkness*, above him. The last three narrative scenes painted – the first three chronologically – all show stages in the Creation. The largest of the three, the *Creation of the Sun and Moon*, echoes the composition of the *Creation of Adam*, with two opposing diagonal masses linked by the outstretched arm of God, but it is painted more loosely and with less detail. The two smaller panels, the *Separation of Earth from Water* and the *Separation of Light from Darkness*, are still further simplified. In both, the figure of the Creator is shown filling almost the entire picture space in a dramatically difficult foreshortened pose. In the first of these he is accompanied by two angelic companions; in the second he is shown alone, dividing the light from the dark by main force and viewed from below, arms extended and head tilted back from the chin. This type of bravura pose was borrowed and further exaggerated by the next generation of artists, and as a result Michelangelo has been sometimes held responsible for the excesses of Mannerism.

second shows God for the first time, a vast and magisterial figure, reminiscent of Michelangelo's early drawings from Masaccio (page 12), who would burst out of the frame were he not leaning forward to call Eve into being; in both these scenes the background, even in Eden, is little more than a few rocks and a tree.

Julius was fighting a bitter campaign against Ferrara and Mirandola in 1510, and unable to provide funds for the re-building of the scaffolding to enable Michelangelo to begin the second half of the ceiling. The hiatus seems to have lasted until early in 1511, when some money was provided and work began again, although the Pope himself did not return to Rome until June. The removal of the scaffolding enabled Michelangelo for the first time to view the overall scheme from a distance, and when he re-commenced, he further increased the energy and clarity of the images. The re-maining four narrative panels are all con-cerned with acts of creation, the first one painted, the *Creation of Adam*, perhaps the most famous single image of all, and an extraordinary contrast to the much more static and emotionless *Creation of Eve*. Instead of the traditional image of a standing God extending a hand to raise Adam to his feet, Michelangelo shows the Creator surging across space in a swirl of drapery with supporting angels, to im-part life with a touch of his finger to the just-awakening Adam, who in turn is shown as an idealized male nude imbued with a wholly classical spirit.

The three remaining scenes are all con-cerned with God's work of creation. In the first, the *Separation of Land from Water*, the figure of the deity, in an ex-tremely foreshortened pose, almost fills the panel, still surrounded by his cloak but with only two angel companions, and barely a hint of the divided elements. The *Creation of the Sun and Moon*, one of the larger panels, is again a continuous repre-sentation in which God appears twice, surging forward on the right to touch the

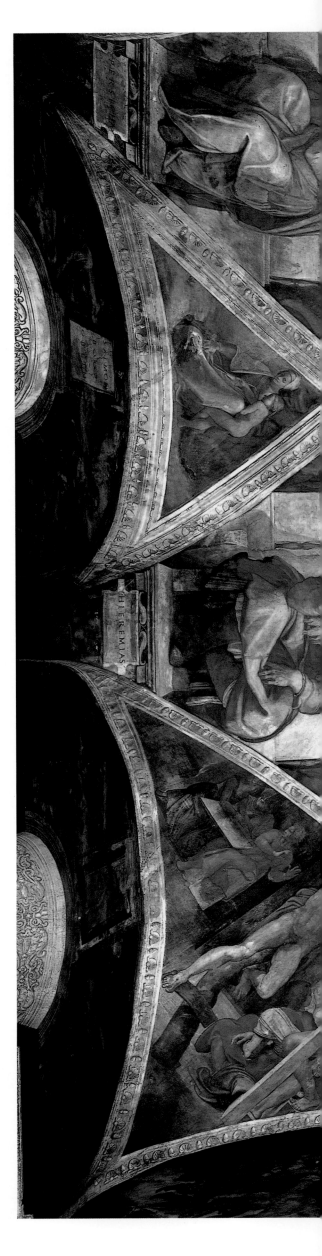

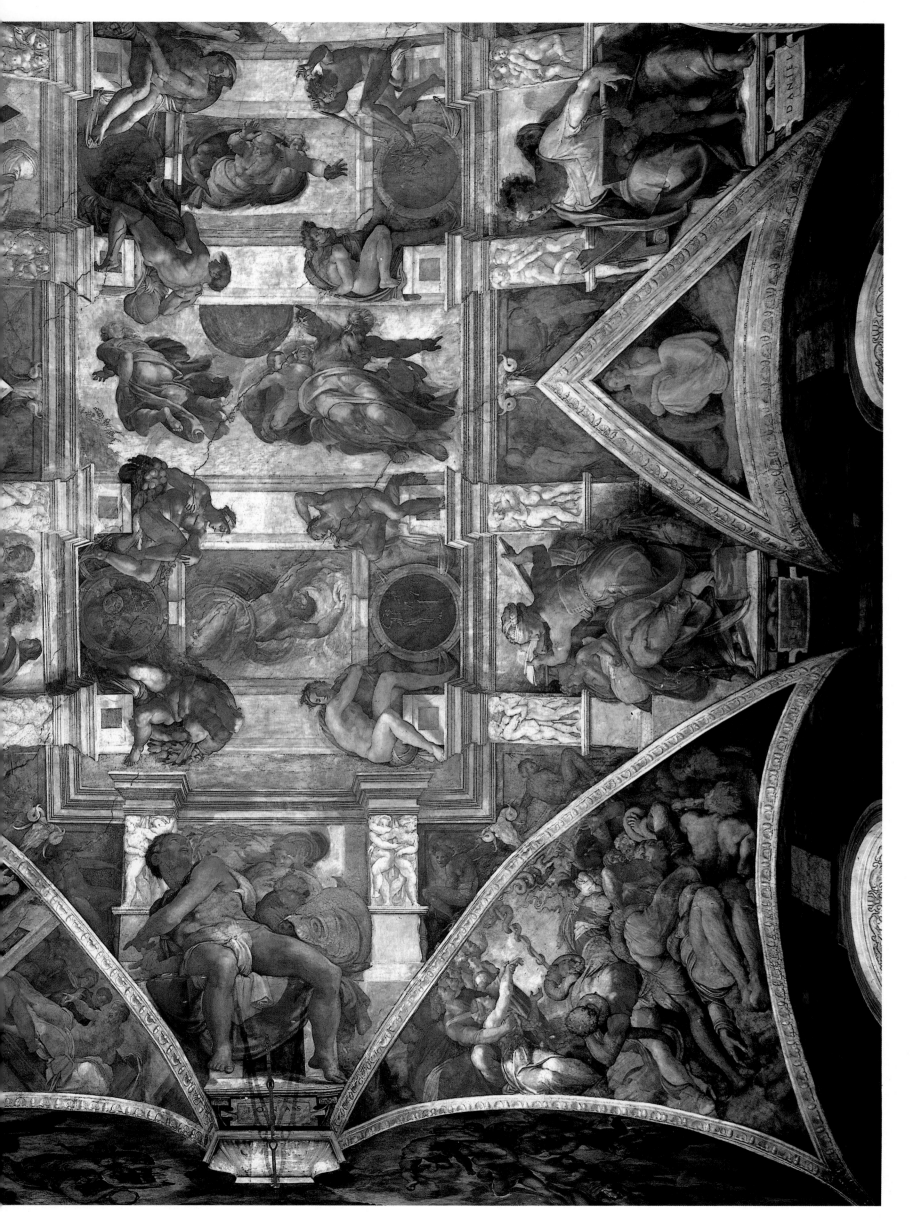

RIGHT: *Ezekiel* is one of the two central prophet/sibyl figures, flanking the small narrative panel showing the *Creation of Eve*. The prophet of the Babylonian exile, his pronouncements consisted principally of denunciation and exhortation; the anger of his tone is reflected by Michelangelo in his emphatically gesticulating and windswept appearance.

sun and moon, swinging away on the left in an oddly ungainly rear view to gesture toward the newly verdant earth. The last scene of all has attracted perhaps the most comment. It shows a single figure, much less than full length, filling the panel, and again in a deliberately difficult pose viewed directly from below, which symbolizes the *Separation of Light from Darkness*, or of form from chaos. No fifteenth-century artist – in fact no one before Michelangelo – had the temerity to reflect in pictorial terms on the very beginning of things. It is a mark of how far art had come from the days of the Early Renaissance, but above all an indication of the divine self-confidence of the artist that he was able to create such an image.

The *Genesis* scenes, though the focus of the iconographic program, are only a part of it, and are closely linked into the overall design. The huge seated figures of prophets and sibyls who alternate between the spandrels are the largest elements of the ceiling, are clearly also central to its meaning, and have inspired much learned debate as to their exact role. Of the seven prophets four – Isaiah, Jeremiah, Daniel and Ezekiel – are major while Zacharaiah, Joel and Jonah are of secondary importance. It has been suggested that they were chosen because their particular prophecies related to the central scenes, or anticipated the coming of the Messiah. Certainly the figure of Jonah, shown over the altar in an extra-ordinarily complex and difficult pose looking up in terror at the first moment of creation, is the accepted prefiguration of the Crucifixion, Etombment and Resurrection, in that he was willingly thrown overboard to save his companions and the ship, spent three days inside the whale, and was then cast up unharmed. Another persuasive line of argument, which takes into account the mood of the individual figures, relates them to the Seven Gifts of the Holy Spirit defined by Isaiah: Wisdom, Understanding, Counsel, Fortitude, Knowledge, Compassion

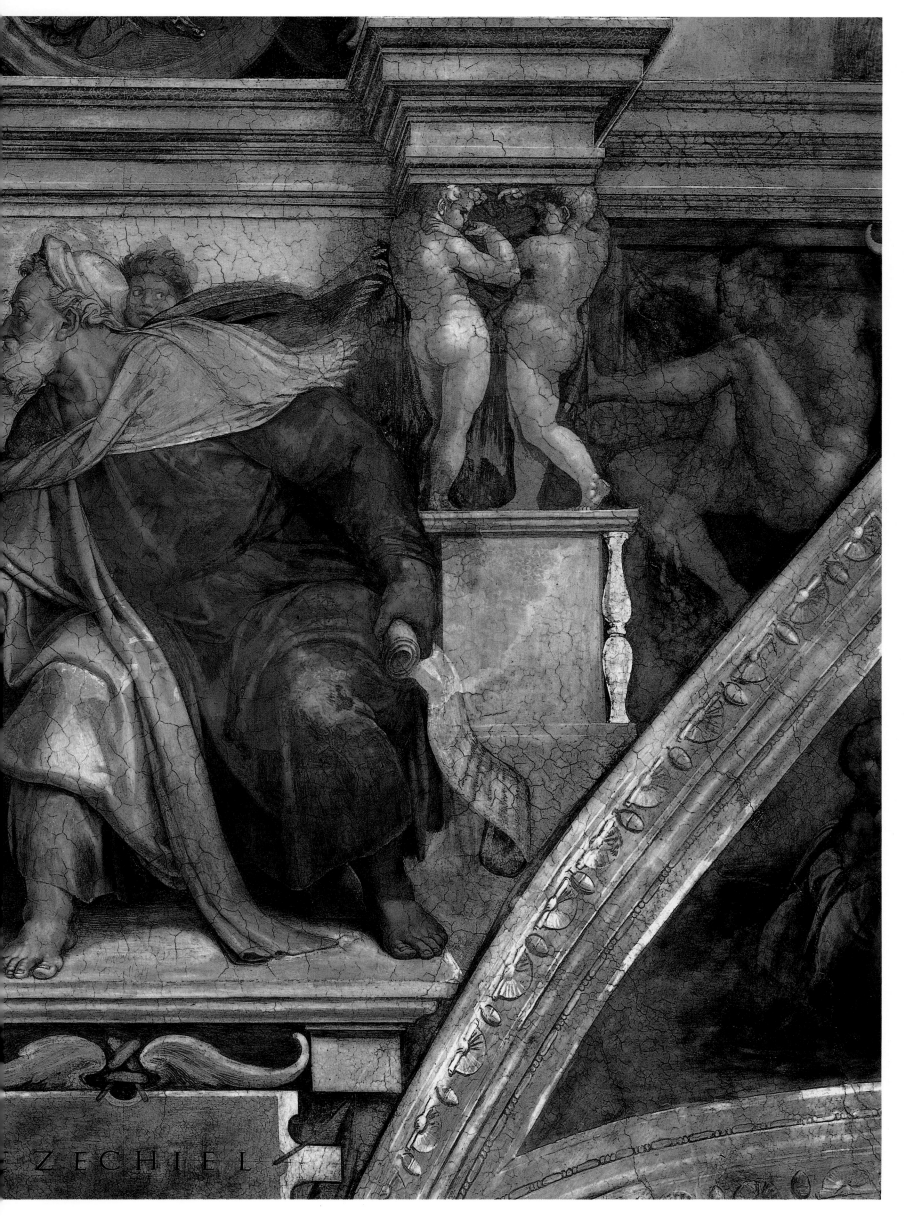

ZECHIEL

BELOW: Spandrel of *Asa*. The eight triangular areas over the windows represent the genealogy of Christ, linking the ceiling with the subject matter of the earlier wall fresco cycles and underlining Christ's legitimate claim to the leadership of Israel.

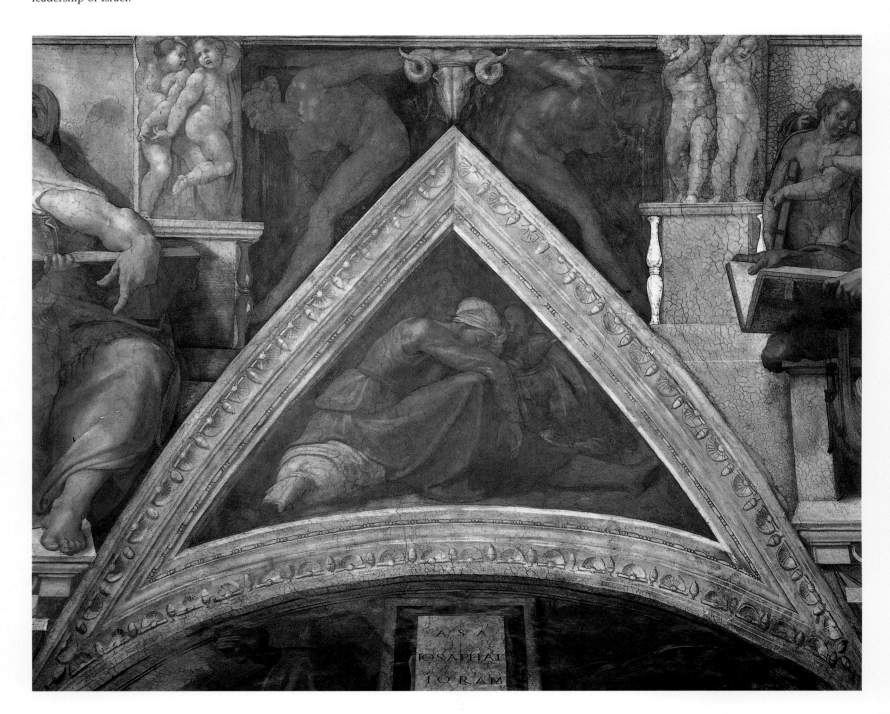

and the Fear of the Lord – this last again being represented by Jonah.

The sibyls are the pagan classical equivalents of the Jewish prophets, all-seeing priestesses of Ancient Greece, whose enigmatic foretellings were interpreted by theologians as linking pagan and Christian beliefs. The five chosen are probably intended to represent the ancient civilizations: Delphica for Greece, Persica for the Persian Empire, Erythraea for Ionia, now Turkey, Libyca for the African continent, and Cumaea for Rome. All the prophets and sibyls are shown accompanied by two small figures or genii (except Daniel, who has only one), which echo and support the main figure. It has been suggested that these derive from the Neoplatonist Pico della Mirandola's thesis that each human is

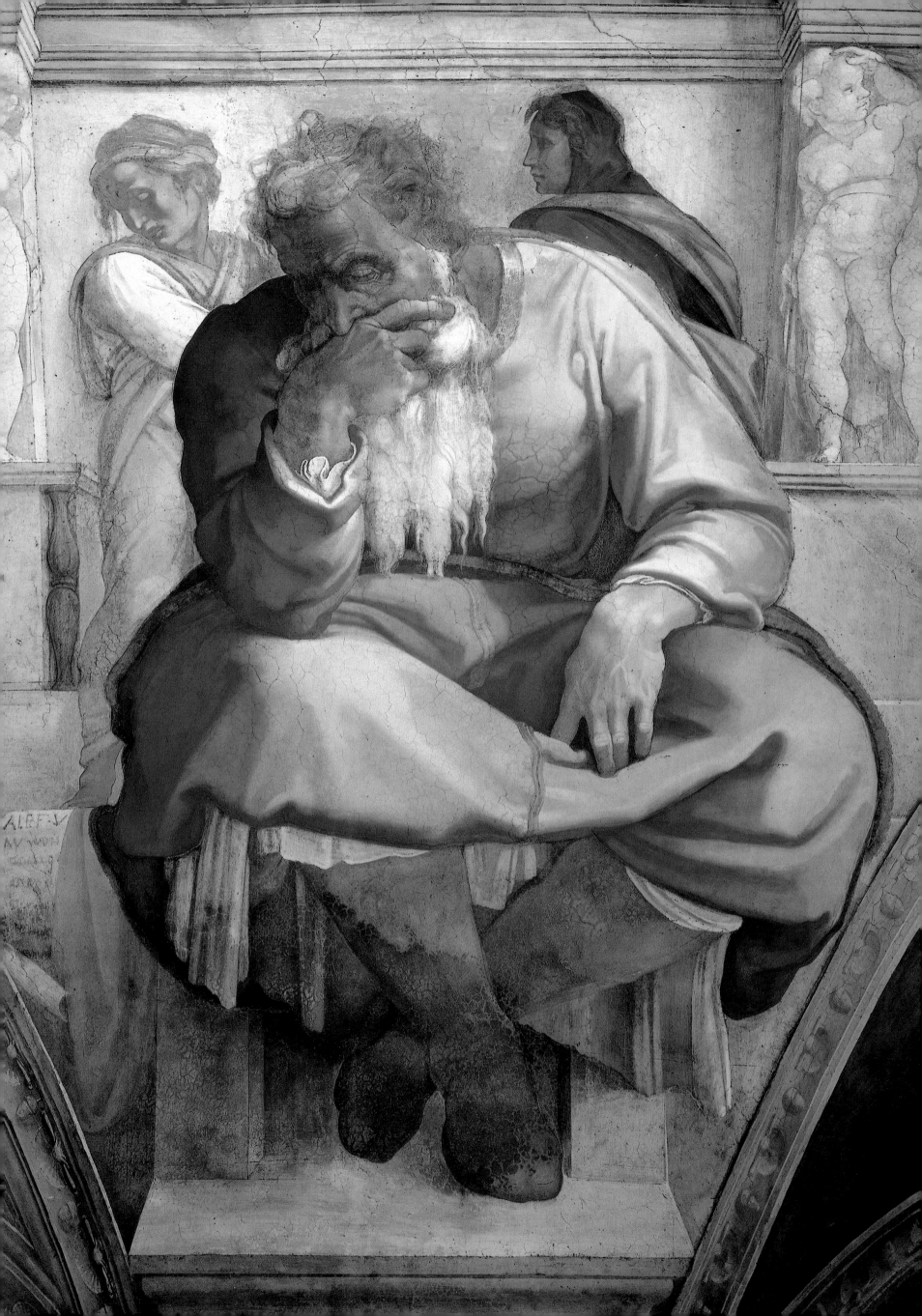

RIGHT: The *Libyan Sibyl* is the counterpart of Jeremiah and another late figure. In contrast to his withdrawn, reflective mood, she is animated and youthful, reflecting her prediction of the day when the Queen would hold the King in her lap. Stylistically she is one of the most developed of the ceiling figures, and her spiralling, almost contorted, pose and foreshortened arms were influential in the development of Mannerism.

BELOW: Drawing for the *Libyan Sibyl*, *c*.1511, red chalk, Metropolitan Museum, New York. Michelangelo used male models even for his female figure studies; this life study for the serpentine pose of the Libyan sibyl is one of the few preparatory drawings for the Sistine ceiling that survive.

accompanied throughout his/her life by two such spirits, representing respectively his spiritual and corporeal nature.

The prophets and sibyls, with their strongly modeled, sculptural quality, are among Michelangelo's most powerful painted images and prefigure his own great sculpted figures, the *Moses* (page 66) and the Medici *Capitani* (pages 78-80). They also reflect the same changes of style as the central vault scenes, with those painted earlier in the sequence

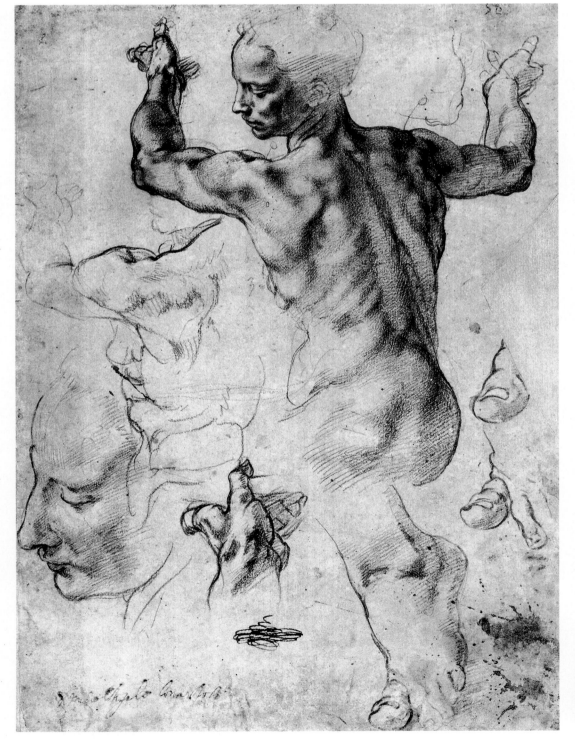

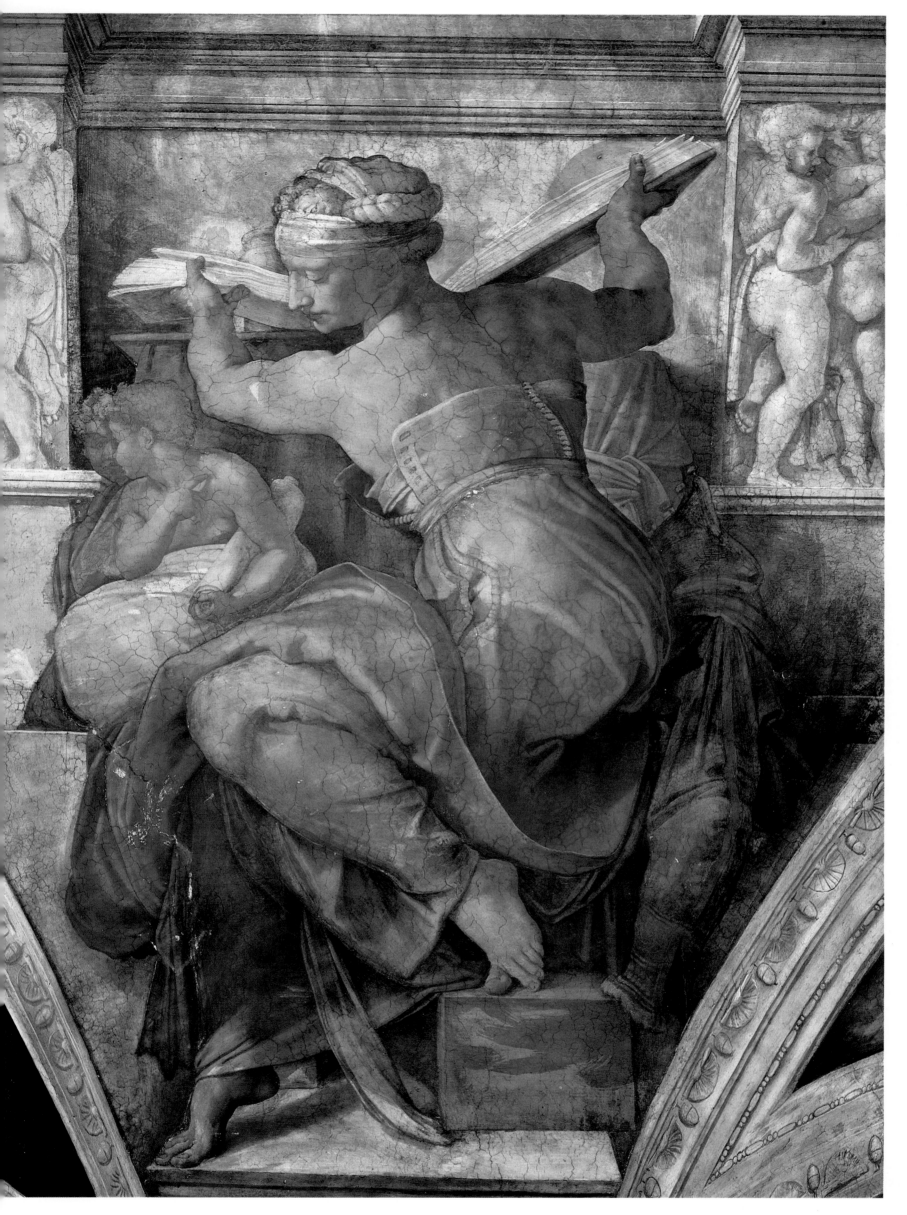

smaller and more self-contained than the more freely rendered and expansive later figures. Thus *Delphica* and her attendant genii form a closely-knit compact and static group, while *Ezekiel*, in the center of the ceiling, is caught in action, rising from his throne with an emphatic gesture which seems to burst out of his picture space. At the east end the figures become larger and even more dominant. *Jeremiah* extends well beyond the confines of his throne, and is painted in somber mood, reflecting his foretelling of the destruction of Jerusalem by Nebuchadnezzar — he himself died in the siege. In contrast, *Libyca*, with whom he is paired, is a vital, youthful figure, whose artificial twisted pose represents the latest stage of Michelangelo's stylistic development on the ceiling, prefiguring the excesses of Mannerism.

The celebrated *ignudi* are also a fundamental feature of the central composition, four of them seated at the angles of each of the five smaller narrative panels, and supporting the medallions that fill up the remaining space. The inspiration for these is clearly Michelangelo's study of antique sculptural types, but their purpose in this context is hard to determine. One suggestion is that they represent ideal versions of the human race in its earliest days, a reflection of the Neoplatonist idea of the ideal man, which would certainly fit in with the Neoplatonist resonances elsewhere in the ceiling. The possibilities they offered clearly fascinated the artist; they are not controlled by the same perspective which governs the architectural framework that they inhabit, but instead act as a linking element, both between the illusionism of the architectural frame and the frontality of the narrative panels, and between the different scales of these panels and the much larger prophets and sibyls.

The subsidiary areas of the ceiling, the spandrels and lunettes, are treated separately from the vault, but retain a logical place within the overall composition.

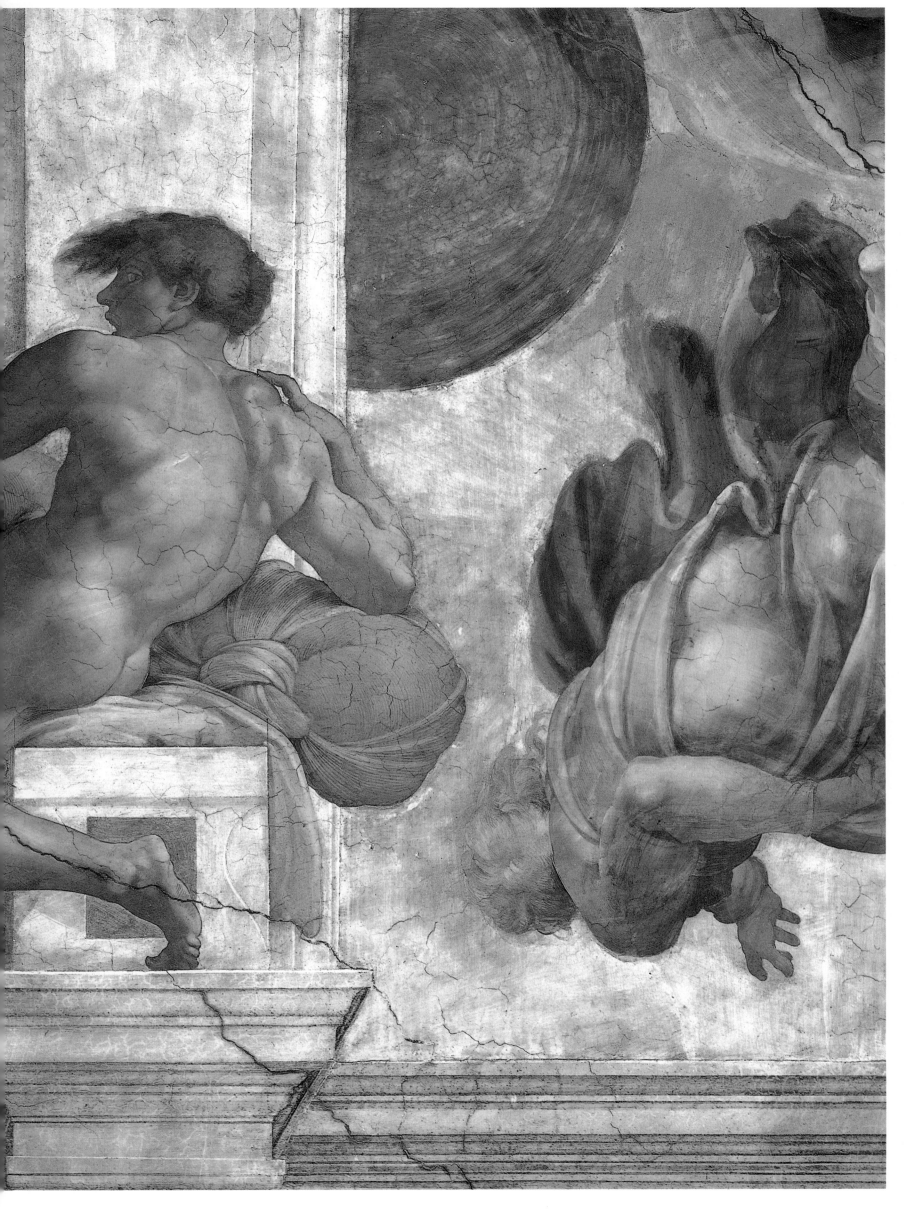

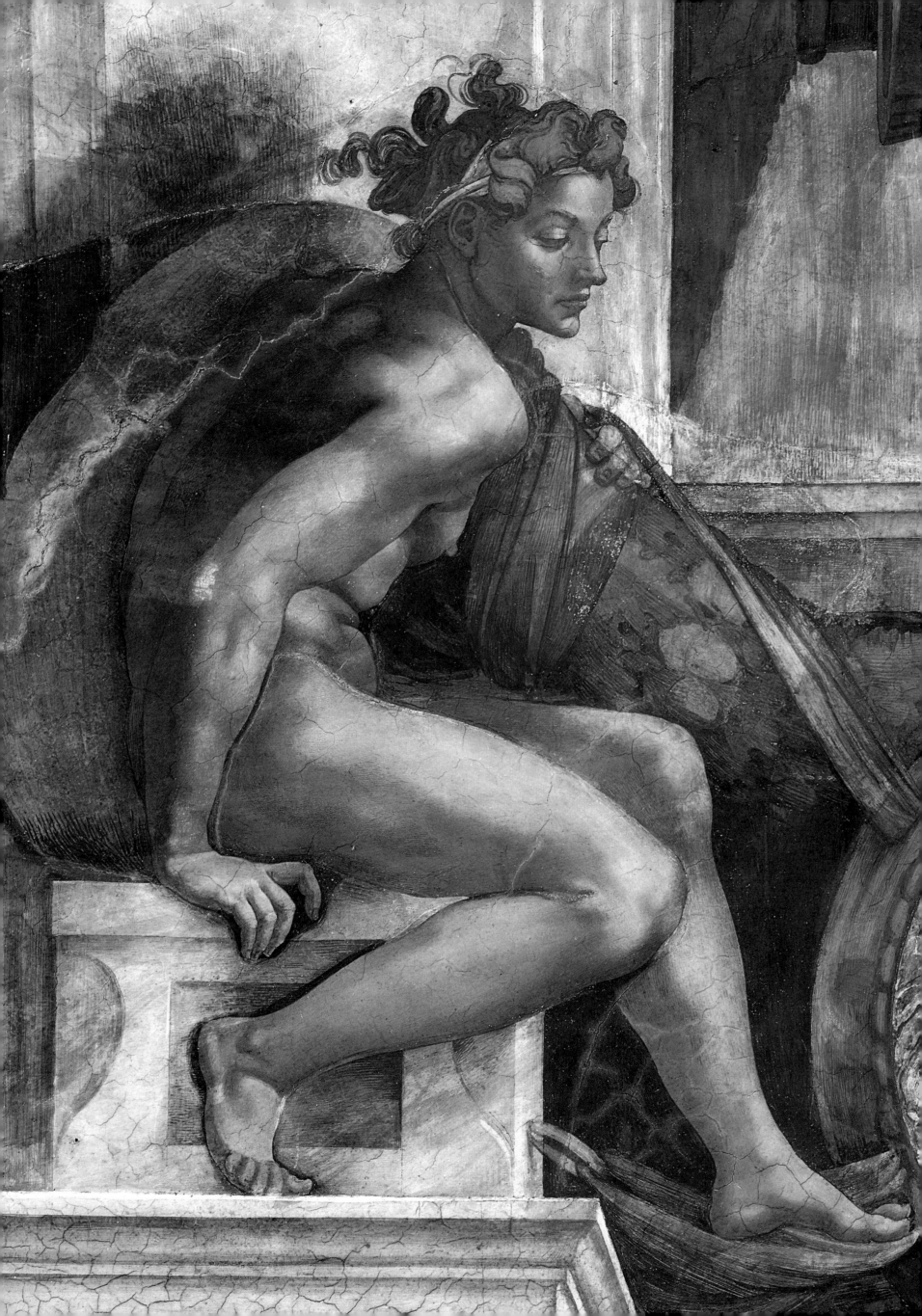

LEFT: *Ignudo* to the left above Joel, one of the earlier *ignudi*, and painted with a calm, sculptural voluptuousness which is in striking contrast to that on pages 56-57. The figure is almost a mirror image of his pair; both are shown with downcast eyes, intent on their task, and are painted in some detail, with carefully delineated hair and musculature.

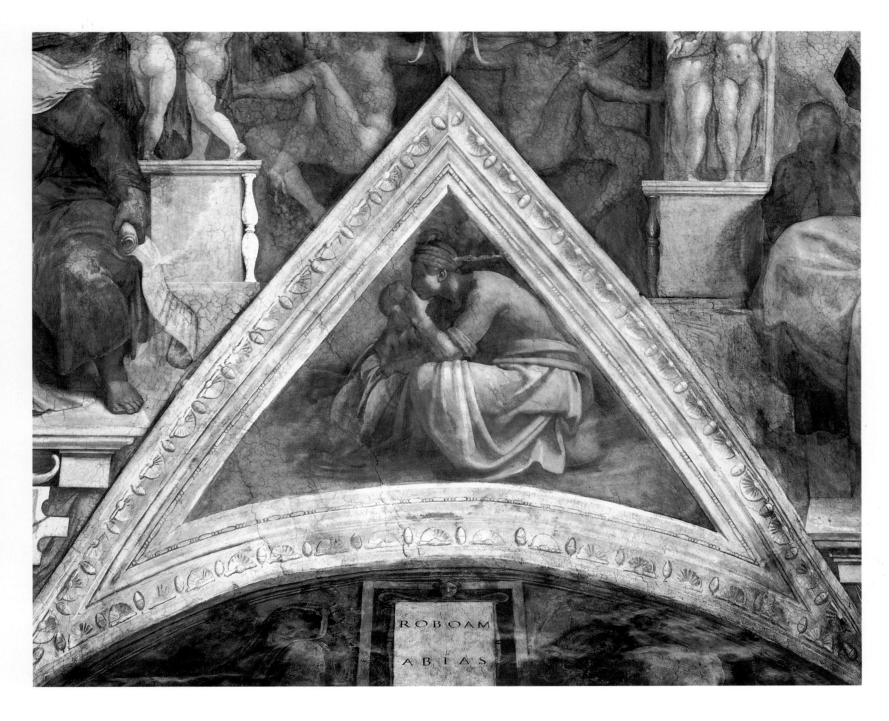

ABOVE: Spandrel of *Roboam*, one of the triangular areas above the windows devoted to the families of Christ's ancestors.

The four corner spandrels represent the theme of the salvation of the Jews, and show the same stylistic development as the central area. Over the entrance are the stories of Judith, who saved the children of Israel from destruction by the Assyrians by killing their leader Holofernes, and David, who slew the Philistine giant Goliath. These are both relatively simple; Judith looks back at the

body of Holofernes as she and her maid bear away his severed head, while David is shown in the act of conquest. The eastern spandrels depict the story of Esther, who saved the Israelities from destruction by Haman, chief minister of the Persian king Ahasuerus, and that of the brazen serpent, which saved the Jews from the plague of fiery serpents sent as a punishment for their disobedience to

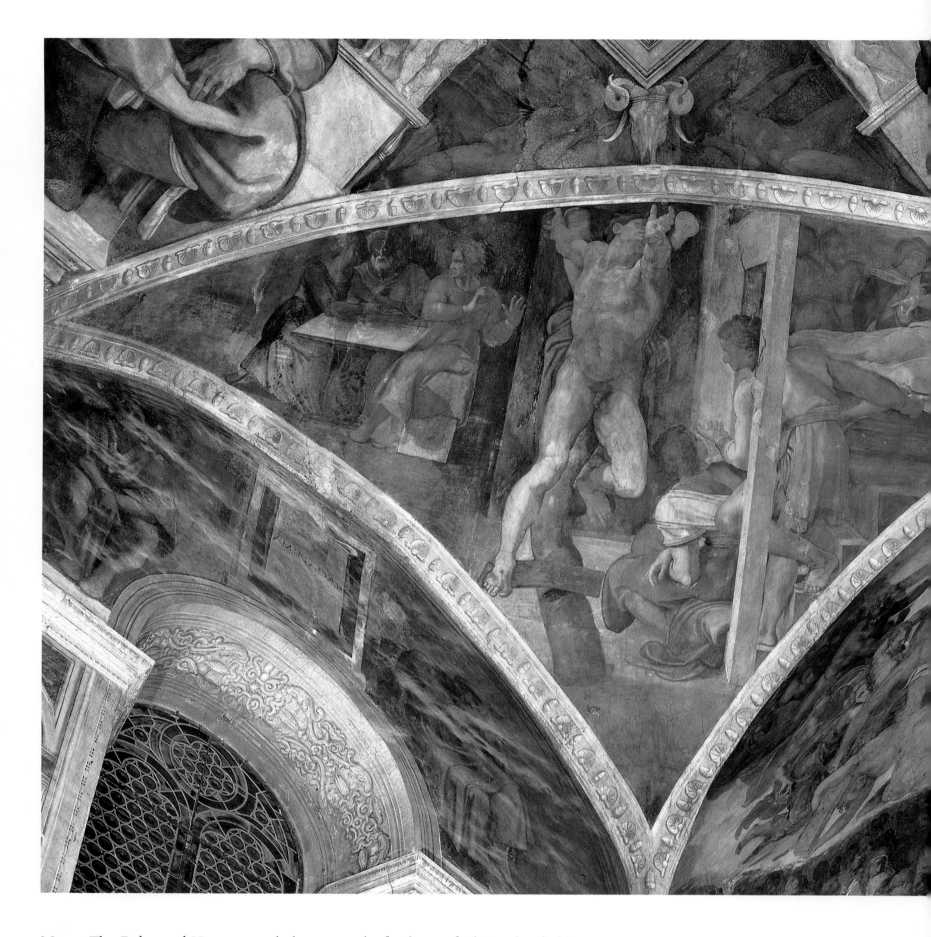

Moses. The *Esther and Haman* spandrel again adopts the device of continuous representation, with the central figure of a writhing Haman on the cross he had prepared for another, a striking instance of Michelangelo's interest in the contorted male nude. The *Brazen Serpent* spandrel, with its tangled mass of figures and division between those who gaze on the serpent and are saved, and those who turn their backs and perish, prefigures the *Last Judgment* that Michelangelo was to create on the altar wall of the Sistine Chapel many years later (page 90).

The smaller triangular spandrels and the curved lunettes over the windows are subsidiary to the main subject and repre-sent the forebears of Christ, thus linking the narrative of the vault to the two fresco cycles of Moses and Christ below. These, though shown in a considerable variety of poses, are far less dramatic and energetic than the ceiling figures, and were long overlooked because they had grown so dark with time. They are depicted as a series of crushed, oppressed figures, waiting in darkness for the coming of the hoped-for new dawn.

Of all the grand architectural and sculptural ensembles that Michelangelo planned, only the Sistine Chapel ceiling was completed, and that in a miraculous four years. Despite the changes of style, the loosening and energizing of the

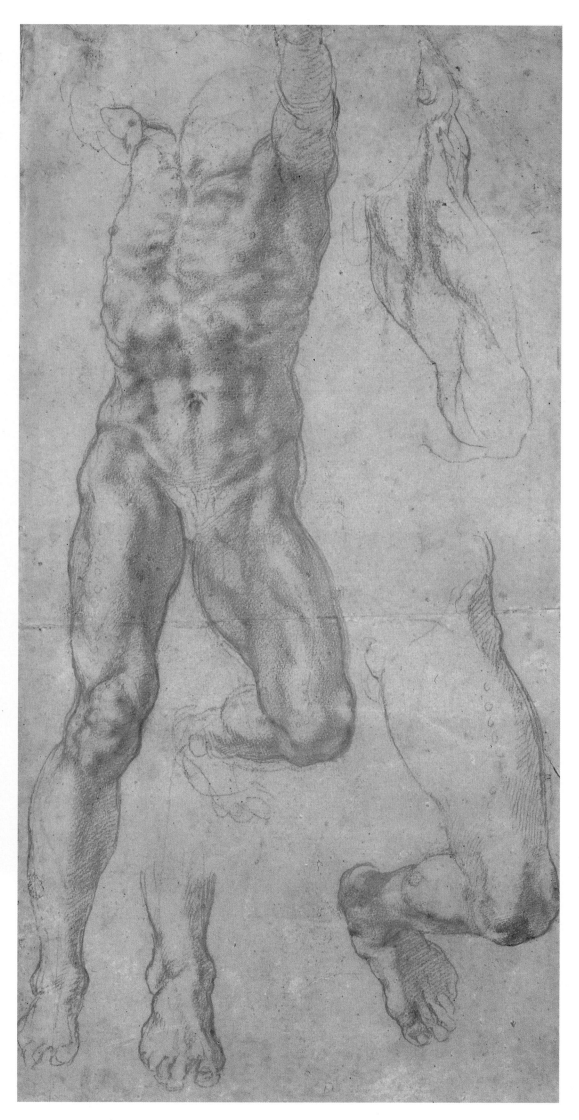

ABOVE: Corner spandrel of *Esther and Haman,* at the altar end of the chapel. Esther was the Jewish wife of the Persian king Ahasuerus, but she kept her religion secret until the king's chief minister Haman plotted to kill all the Jews. As a result of her intervention, Haman was hanged on the gallows he had intended for Esther's uncle Mordecai, although Michelangelo has shown him being crucified.

RIGHT: *Four Studies of a Crucified Man,* red chalk, 15¾ × 8 inches (40.6 × 20.7 cm), British Museum, London. This drawing for the figure of Haman shows the dramatic foreshortening which is typical of many of the later ceiling figures.

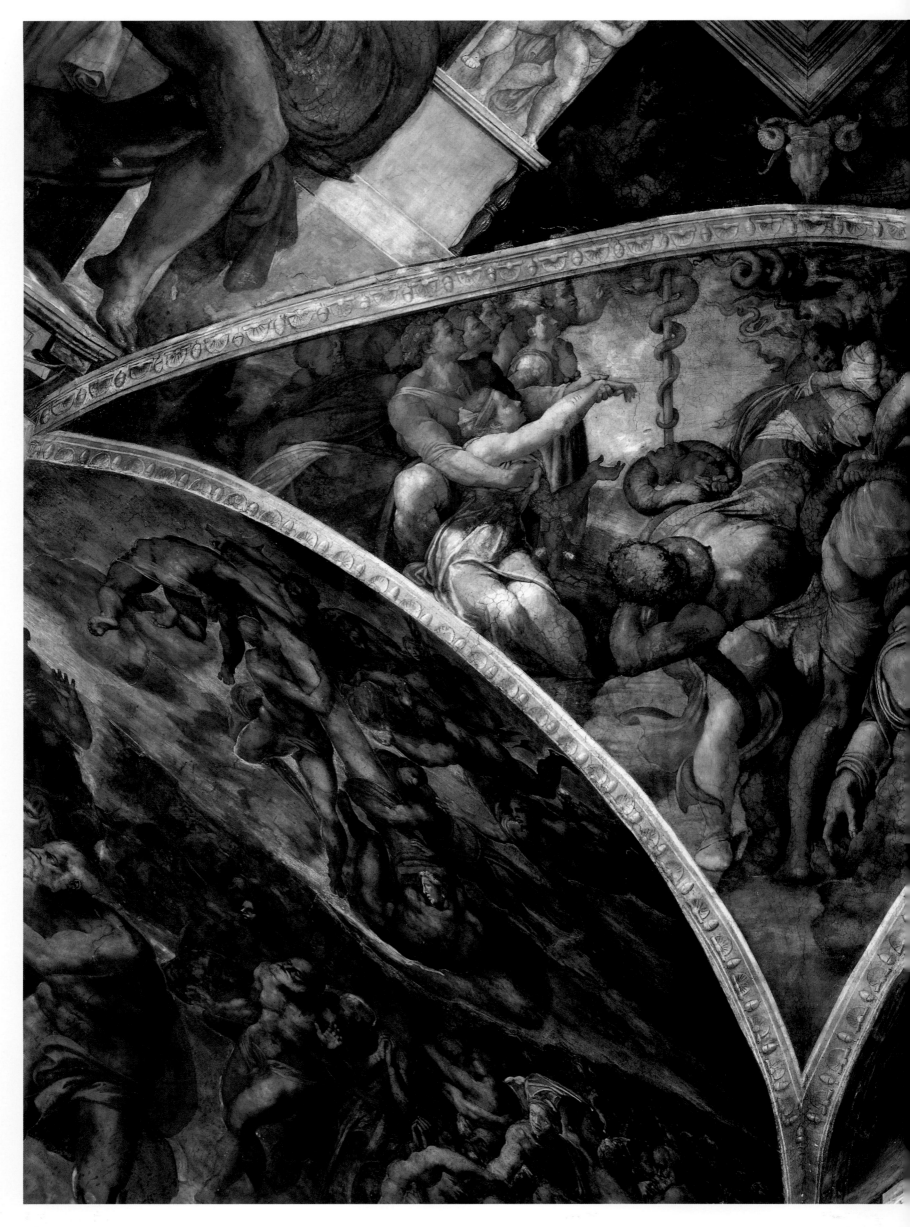

figures, the overall impression it gives is of a single epic conception, the creation of a single triumphant genius. From the altar end the cycle of Creation unfolds, from the very dawn of matter and time, through the forming of man in God's own image, the loss of innocence and the Fall, to the Deluge and the final degeneration of mankind as reflected in the *Drunkeness of Noah* and the mockery of his sons. Set against this tragedy, the seers presage mankind's salvation through the long-foretold Messiah, and the Ancestors of Christ await it; the promise of redemption is made explicit.

LEFT: Corner spandrel, the *Brazen Serpent*. To punish their backsliding, God sent a plague of serpents to devour the children of Israel. The writhing poses of Michelangelo's figures as they struggle against the snakes recall the influence of the antique *Laocöon*, which is also traceable in Michelangelo's *Entombment* panel painting (page 33), and echo his long-held fascination with the contorted male nude. The theme of the four corner spandrels is the preservation of the Jews through divine intervention; here the virtuous are saved by the brass serpent made by Moses.

BELOW: Lunette of *Eleazar and Nathan*. The arched areas over the windows show the ancestors of Christ, many of whose names were known only from a biblical list and who had never before been painted. The lunettes are relatively minor in the overall decorative scheme and are far less energetically painted than the central figures.

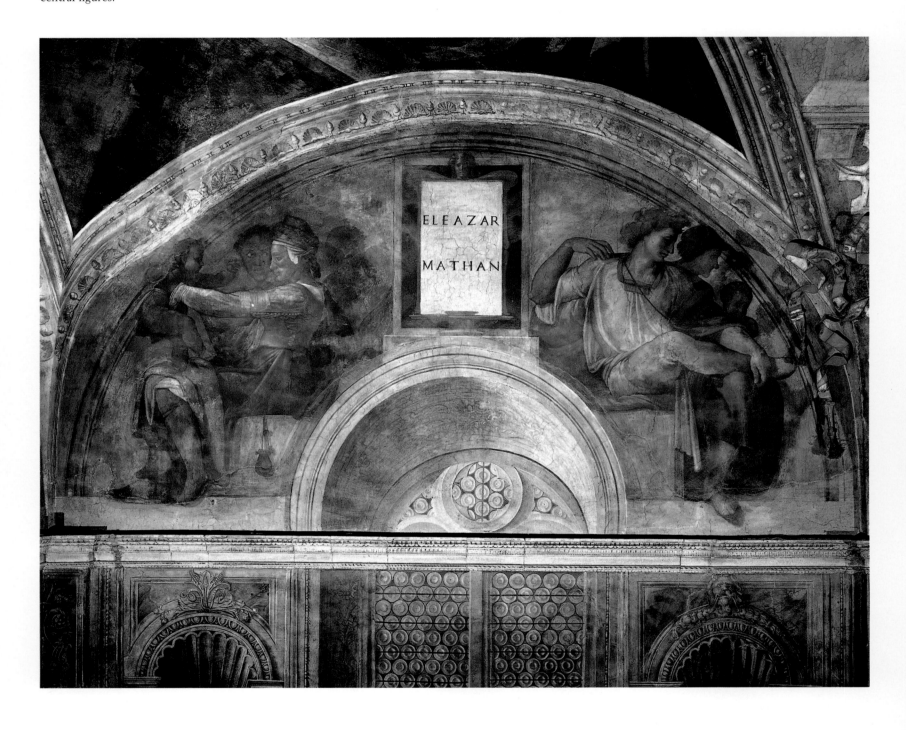

BELOW: Lunette of *Jacob and Joseph*. Many of the ancestors are shown as slumped, despairing figures, which may reflect the twilight in which mankind struggled before the coming of grace – or may suggest Michelangelo's own sense of inadequacy in the face of his daunting task. Recent cleaning has revealed that the lunette figures were painted in bold combinations of brilliant colors, recalling Michelangelo's training under Ghirlandaio, and possibly chosen to relate to the earlier wall frescoes.

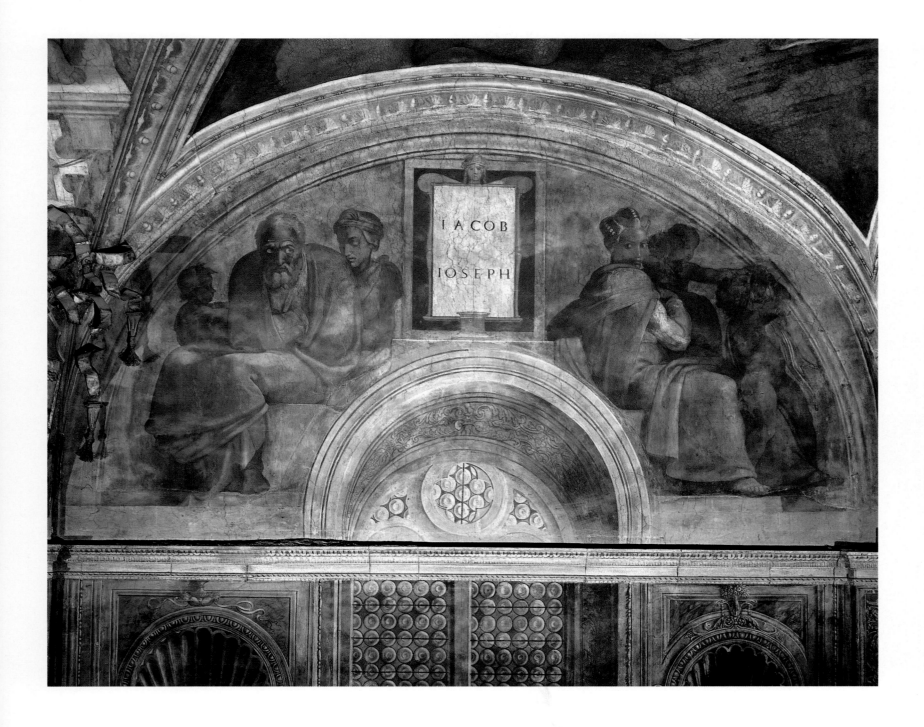

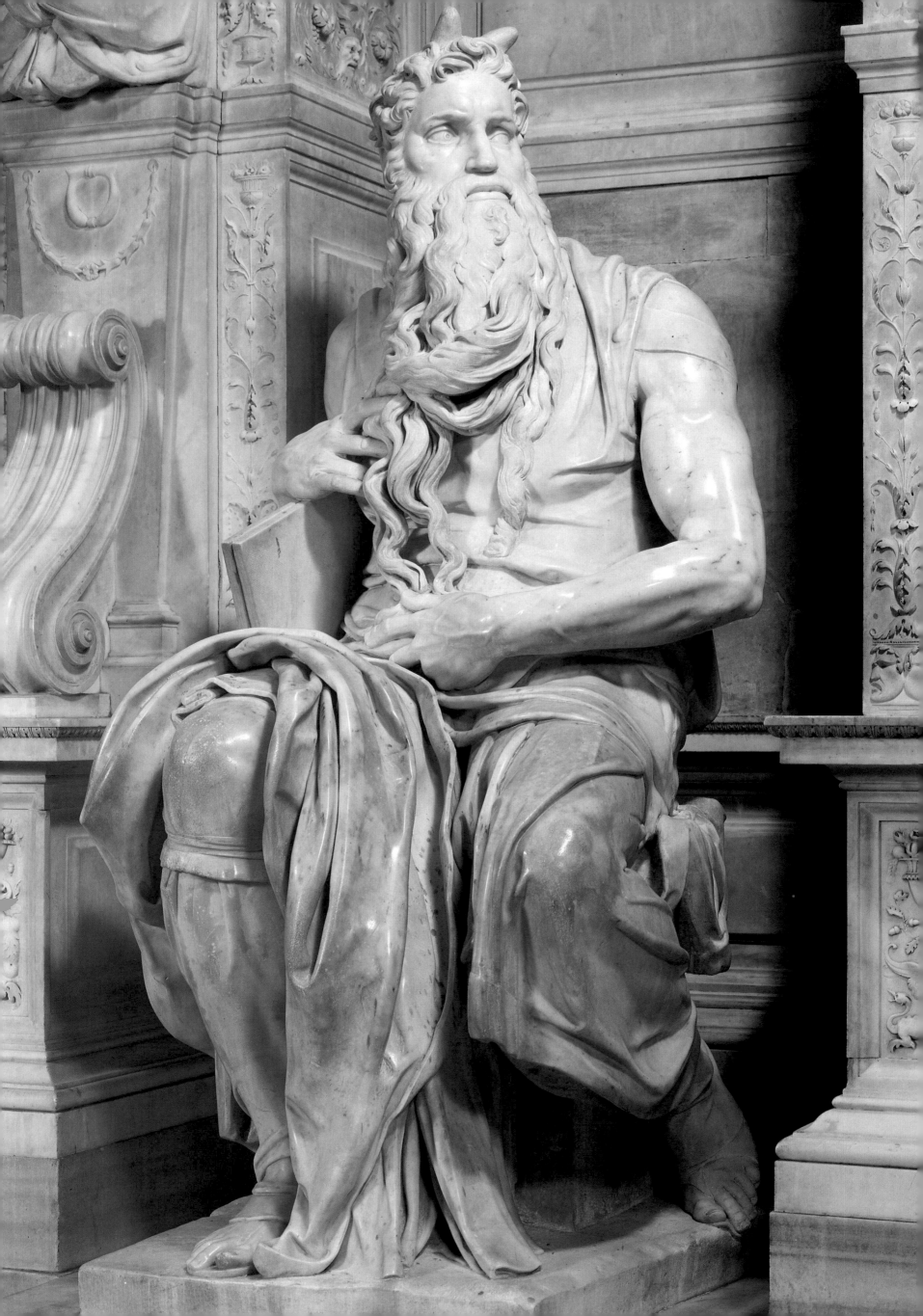

CHAPTER THREE

Sculpture and Architecture: Rome and Florence, 1505–34

Pope Julius II's original motive in summoning Michelangelo to Rome in 1505 was for the construction of a grandiose tomb to commemorate his papacy. As an old man, Michelangelo remembered the experience with bitterness, writing that he 'lost the whole of my youth chained to this tomb'. It was certainly the largest sculptural commission of his career, and the most significant one to the artist himself; he worked on it intermittently for nearly 40 years, and his ideas and aims changed so radically in the course of this time that the final result as we see it today lacks any coherence of scale or theme.

The original plan as conceived by Michelangelo and Julius in 1505 does not survive, except in a later account by Michelangelo to Condivi. Apparently it was to have been a huge, free-standing structure of two or three storys or zones, about 50 feet high and with an internal chamber designed to hold the Pope's sarcophagus. As decoration it was intended to bear about 40 life-sized or larger statues, together with relief and decorative sculpture and scenes from the life of the Pope, all in a complex architectural setting. It is unclear where this edifice was designed to stand, as it would not have fitted easily into Old St Peter's; possibly a separate building was planned. By

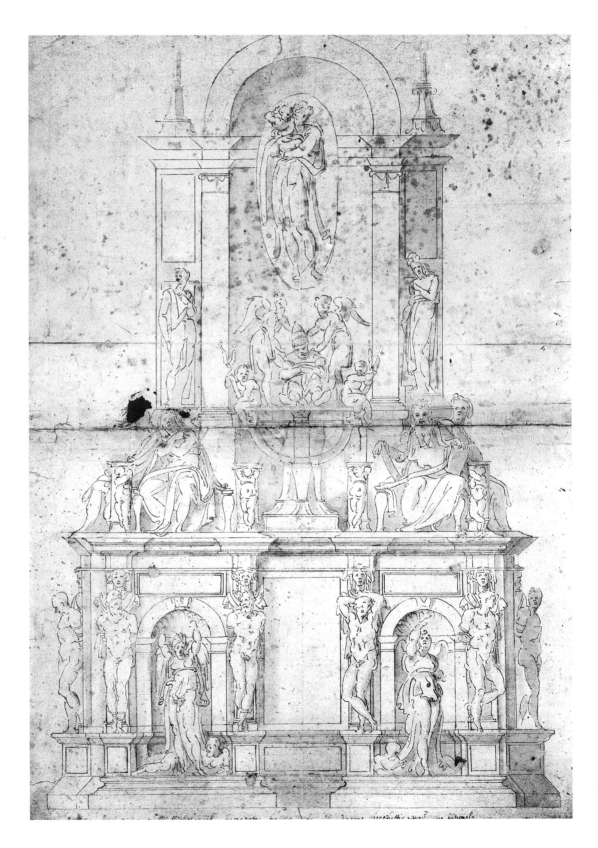

LEFT: *Moses*, 1513-16, marble, h. 91¾ inches (235 cm), S Pietro in Vincoli, Rome. This great seated figure, which forms the centerpiece of the Julius Tomb as we know it today, is, with the *Slaves*, the only survivor of the 1513 project. The horns were a medieval convention, based on a misreading of the Hebrew word for rays of light, and one which Michelangelo retained deliberately.

RIGHT: Giacomo Rocchetti, after Michelangelo, *Drawing of 1513 project for the tomb of Julius II*, pen and ink, 20½ × 15¼ inches (52.5 × 39 cm). This shows the original plan for a free-standing tomb already reduced to a large wall tomb, with the great *Moses* on the right of the platform paired probably with St Paul on the left.

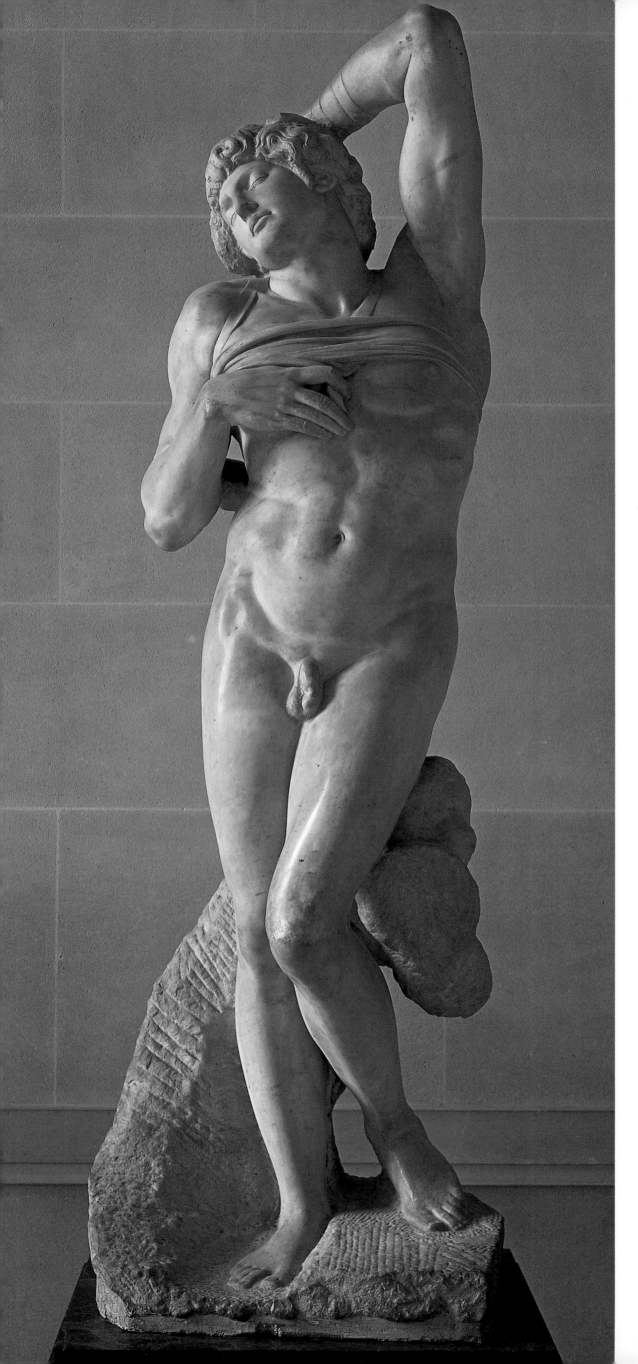

LEFT: *Dying Slave*, 1513-16, marble, h. 89½ inches (229 cm), Musée du Louvre, Paris. Another figure carved for the 1513 tomb project, this is one of Michelangelo's most highly finished, tender and erotic representations of the male nude, combining the sensuality of the *Bacchus* with the poignant elegance of the Christ of the *Pietà*.

April 1506, after Michelangelo had spent eight months at Carrara choosing the marble and doing preparatory work, the Pope laid the foundation stone of the new, centrally planned St Peter's as designed by Donato Bramante and it was clear that his interests and resources had been diverted to this even more ambitious undertaking – and one to which Michelangelo himself was to devote his last years (see pages 106-108). Furious at the perceived slight and lack of payment, Michelangelo swept back to Florence and had to sue ignominiously for papal pardon in November 1506.

The Sistine Chapel project, then, occupied Michelangelo's entire attention for the duration of Julius's papacy, and it was only on his death in February 1513 that the tomb project was revived, although in a different form. Julius had left funds to ensure its completion, and the election of Leo X as his successor left Michelangelo free to pursue work on it. Leo, although born Giovanni de' Medici, younger son of Lorenzo the Magnificent, and therefore familiar with Michelangelo since youth, showed no inclination to employ him as painter, preferring Raphael. A new contract for the tomb, drawn up in 1513, abandoned the free-standing design in favor of a more traditional wall-tomb, although still on a vast scale and with almost as much sculpture.

Of the 40 or so figures planned for the sculptural program, only three were carved: the two *Slaves* now in the Louvre; and the majestic figure of *Moses* which remains the focus of the tomb as it survives and is the only indication of the grandeur of the original 1513 plan. All three figures are related to ideas Michelangelo had developed in the Sistine ceiling; the *Slaves* to the *ignudi*, and *Moses* to the later prophet figures *Jeremiah* and *Joel*. The two *Slaves* were planned as part of a series of 12 figures intended to represent the Liberal Arts crushed and fettered by the death of their patron. One, known as the *Dying Slave*, is the perfect expres-

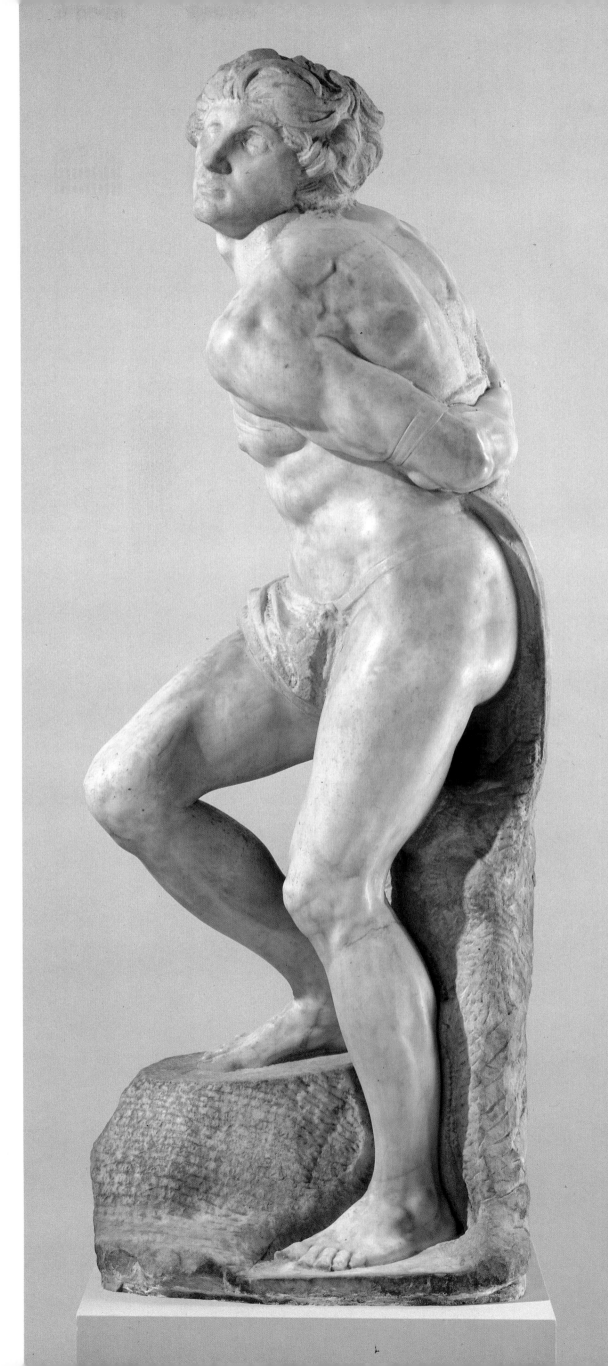

RIGHT: *Rebellious Slave*, 1513-16, marble, h. 84 inches (215 cm), Musée du Louvre, Paris. In contrast to the *Dying Slave*, this figure is sturdy and well muscled, and appears to rebel against the fate to which the former succumbs. Pairs of contrasted figures, in this case the active and the passive, are common in Michelangelo's work, recalling the Neoplatonist philosophies to which he was exposed at the Medici court. Here the pose is contorted and exaggerated, and the jagged angles of its profile suggest that the *Rebellious Slave* was intended for a corner site, while the *Dying Slave* is meant to be seen frontally.

sion of Michelangelo's lifelong obsession with the idealized male nude. The smooth, almost languid, line, tender expressiveness and unusual perfection of finish give this figure a haunting and poetic quality. The *Rebellious Slave*, its companion, is by contrast more animated, more thickset and less highly finished – Michelangelo may well have abandoned it because of the crack running across face and shoulders. While the *Dying Slave* succumbs to his notional bonds, and by implication yields to death, the *Rebellious Slave* struggles against the restraining ropes in an exaggerated pose that emphasizes the musculature of his arms and back.

The third statue carved for the tomb at this time was the huge, majestic figure of *Moses*. This was an element both of the first plan for the tomb and of all subsequent plans, although its rôle changed. Originally intended for the upper level as one of six statues, all of them twice lifesize, the *Moses* was finally placed centrally on the lower level, where the facial expression, intended to be seen from below and at a greater distance, seems unnecessarily exaggerated. The fixed and glaring gaze has led to suggestions that Moses is raging at the Jews' worship of the Golden Calf, that he is intended as a spiritual portrait of the tormented man of genius, or that he represents active as against contemplative life, a Neoplatonic theme to which Michelangelo returned in his work for the Medici Chapel (page 79).

In 1515 Leo X diverted Michelangelo to the façade project for the Medici family church of S Lorenzo in Florence, and the tomb contract was again renegotiated, providing for a much reduced and simplified wall-tomb, with only 20 instead of the original 40 statues, and with the sculptural program much more closely integrated into the architectural setting. Of the statues, only the two-figure group known as the *Victory* was carved, one of four such groups planned.

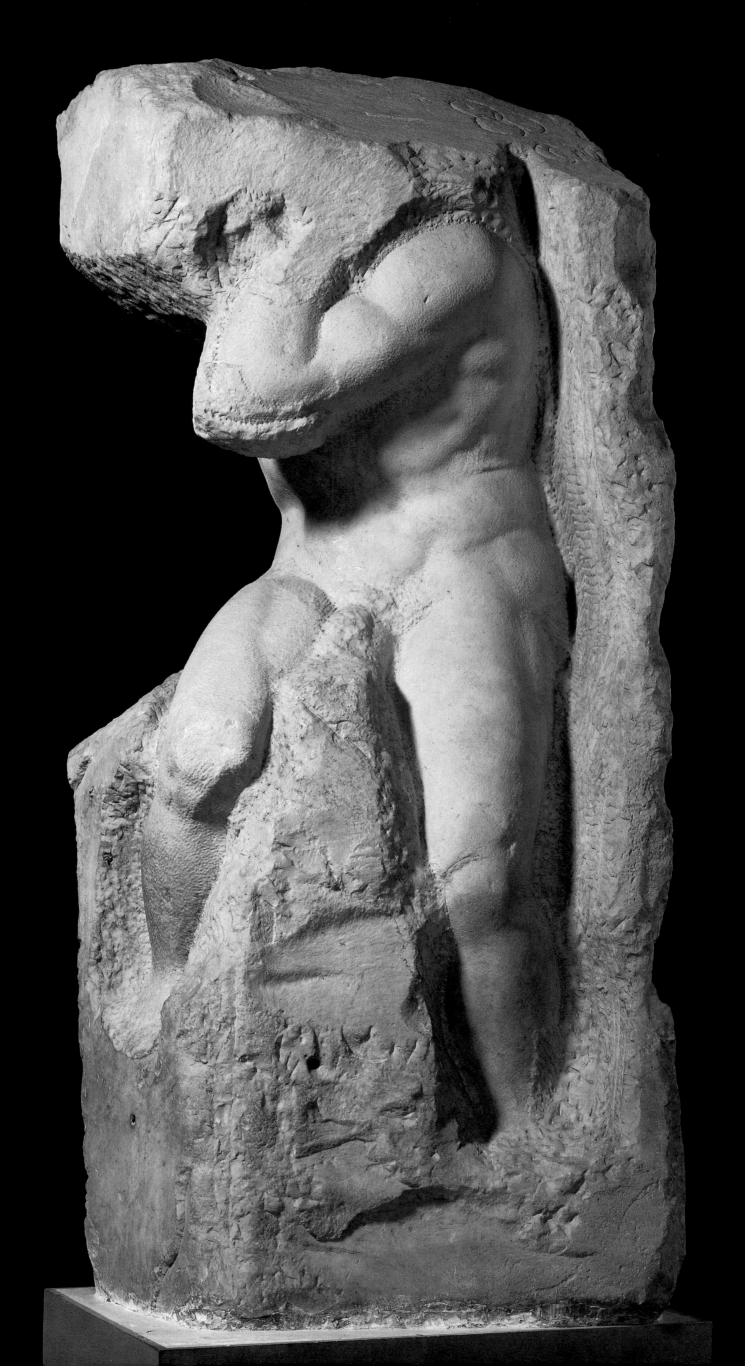

LEFT: *Atlas*, 1520-23, marble, h. 97½ inches (250 cm), Galleria dell' Accademia, Florence. This is one of five figures of slaves or, more probably, *Prisoners* that Michelangelo began to carve for the revised 1516 version of the tomb project, four of which are in the Accademia. They are considerably larger than the *Slaves* and may well have been intended to have a more structural function than that simply of sculptural decoration; this figure certainly looks as if it was intended to carry a load, hence its name.

RIGHT: *Victory*, c.1530-33, marble, h. 102 inches (261 cm), Palazzo Vecchio, Florence. Also carved for the 1516 version, this two-figure group is the same size as the *Prisoners*, its spiraling pose and self-conscious elegance recalling the later *ignudi* on the Sistine Chapel ceiling. The bearded victim on whom the victor rests his knee has been suggested as an ironic self-portrait of the artist.

Vasari records that this was part of the original tomb plan, but the exaggerated spiraling pose, taken up and developed by Mannerist artists, suggests a date in the 1520s. Again, many interpretations have been offered. The figure's raised arm is derived from the pose of *David*, while its smooth elegance of form recalls the *Dying Slave* or the Sistine *ignudi*, leading to suggestions that youth is conquering age or, more metaphysically, virtue overwhelming vice. Four barely-carved blocks now in the Accademia, Florence, are also believed to belong to this stage of the tomb project.

From the early 1520s, Michelangelo came under growing pressure to delegate work to other artists in order to finish the tomb. In 1532 he finally agreed to a yet more reduced contract, consisting of only six sculptures by himself and five by other artists. The tomb, as it survives today in S Pietro in Vincoli, is an unsatisfactory mixture of elements from all these various contracts. The lower level is basically the 1513 plan, with the *Moses* at its center flanked by two statues of *Rachel* and *Leah*, representing the active and contemplative life, carved by Michelangelo under protest as late as 1542. The much less ornate upper level belongs to the 1516 revision and all the additional sculpture was carved by Michelangelo's assistant Raffaello da Montelupo.

It was Leo X's commission of a design for the S Lorenzo façade that introduced Michelangelo to architecture. In 1512 the Medici had regained power in Florence, and Leo's intention was to underline this by completing the Medici parish church built by the early Renaissance architect Filippo Brunelleschi (1377-1446). Designs were also produced by already established architects, including Raphael, Jacopo Sansovino and Antonio da Sangallo the Younger and, since the Pope planned an elaborate sculptural program, it is possible that he originally envisaged it as a collaborative effort between sculptor and architect. Clearly,

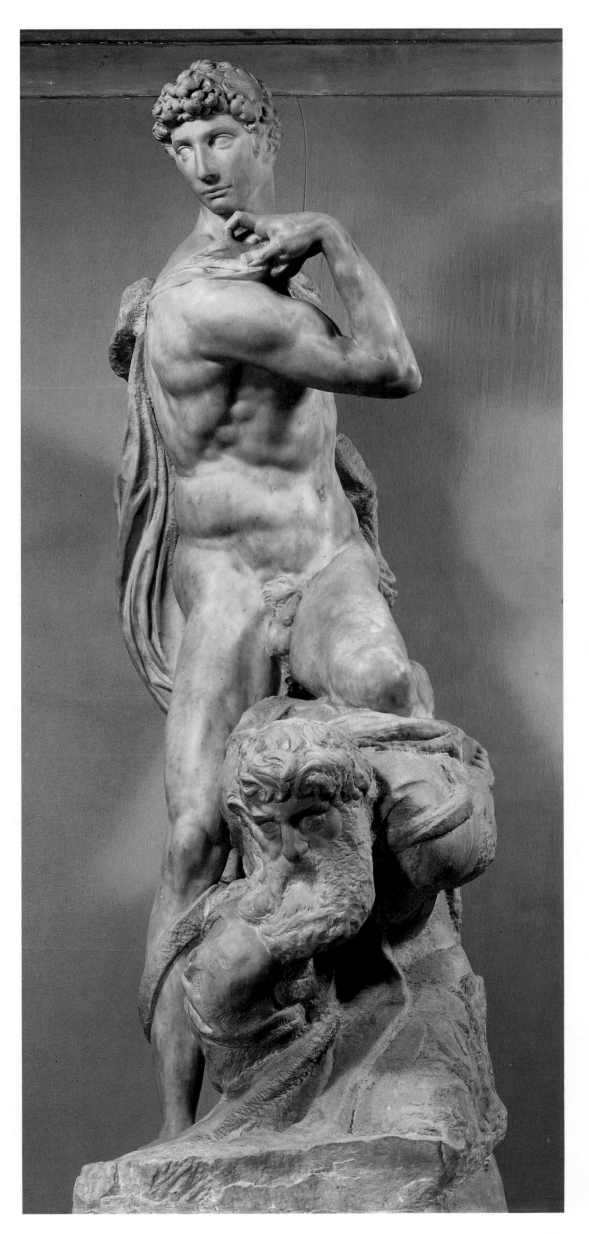

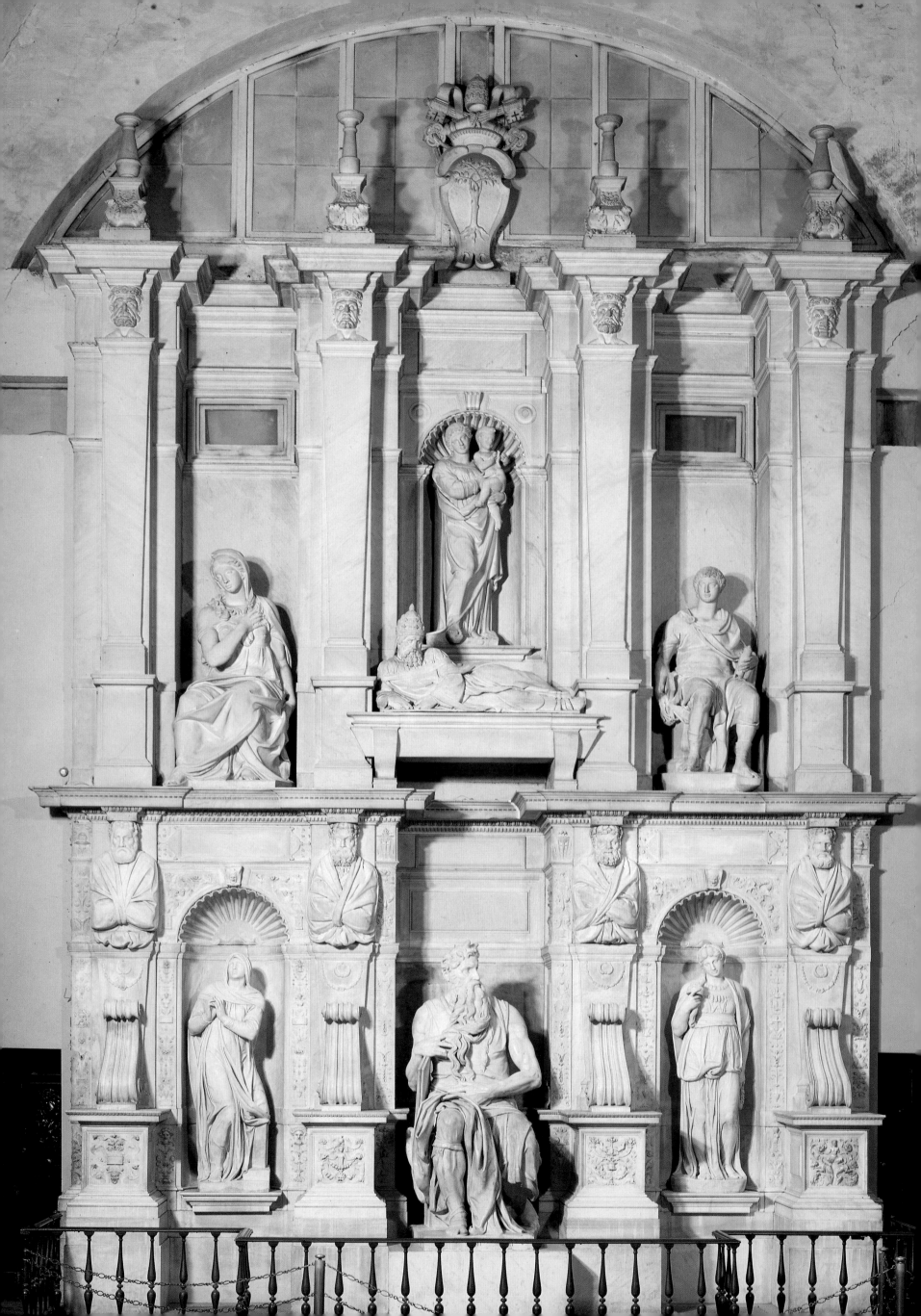

LEFT: *Tomb of Julius II*, marble, Rome, S Pietro in Vincoli. The tomb was finally finished more than 40 years after its inception, incorporating elements in different styles and to different scales from various stages of the tortuous design process. The result is a static and unsatisfactory mixture.

BELOW: The Temple Maletestiano, also known as S Francesco, Rimini, with its unfinished façade by the early Renaissance architect Leon Battista Alberti (1404-72), demonstrates the difficulties that were encountered when trying to add a classical façade, with its combination of columns, architrave and triangular pediment, to a church building.

however, Michelangelo was in sole charge by 1517, when he made his first clay model. A church façade, with its high central element and lower wings, representing the nave and aisles respectively, caused problems for Renaissance architects, whose architectural repertoire was drawn from Greek and Roman building, with its emphasis on columns carrying a horizontal lintel. The surviving designs by Sangallo adopted the already established solution of a triumphal arch system for the lower story, with a temple front above covering the higher nave gable. Michelangelo's first designs also followed this approach, but in summer 1517 he produced a radical new design, of which a wooden model survives. Instead of designing the façade to cover the existing wall like a skin, he proposed to add an additional bay, in the form of a narthex or porch, to the church which would run across the whole front to the height of the nave. This would have disguised the different heights and created a bold and coherent scheme, designed to carry a large sculptural program, and reminiscent of the Julius tomb project in its combination of architectural setting and sculptural decoration.

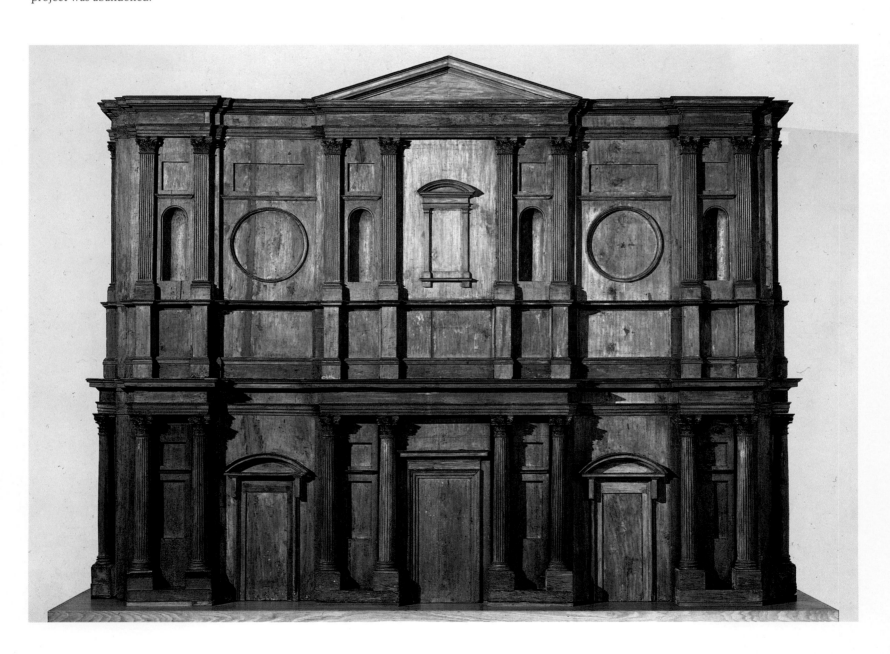

The death in 1519 of the Pope's nephew, Lorenzo, Duke of Urbino, caused Leo X to lose interest in the façade project, however, and Medici money was instead diverted to the building of a family memorial chapel, the New Sacristy, in S Lorenzo. The guiding force behind this was Cardinal Giulio Medici, later Clement VII, who planned it to open off the north transept as a counterpart to the Old Sacristy, built in 1419-28 off the south transept by Brunelleschi. It is unclear when Michelangelo became involved in the project and whether he was

responsible for the exterior; his first definite contribution was a design for the interior sent to Cardinal Giulio in November 1520. The interior was planned to contain the tombs of the Duke of Urbino and his uncle Giuliano, Duke of Nemours, who had died in 1516 (they are jointly referred to as the 'Capitani'), and also those of Leo X's father Lorenzo the Magnificent and Lorenzo's brother Guiliano, together known as the 'Magnifici'. The first proposal was for a free-standing edifice reminiscent of the ill-fated Julius Tomb in Rome, but this was abandoned

in favor of a series of elaborate wall-tombs to be constructed within an architectural framework to be designed by Michelangelo himself.

In Michelangelo's design for the S Lorenzo façade, the architecture, arguably, plays a secondary role as a setting for a display of sculpture, but by the time he turned his attention to the Medici chapel, his ideas about architectural form had developed significantly. Vasari discusses at length, and not always totally approvingly, the variety and novelty of the architectural forms used in the chapel and

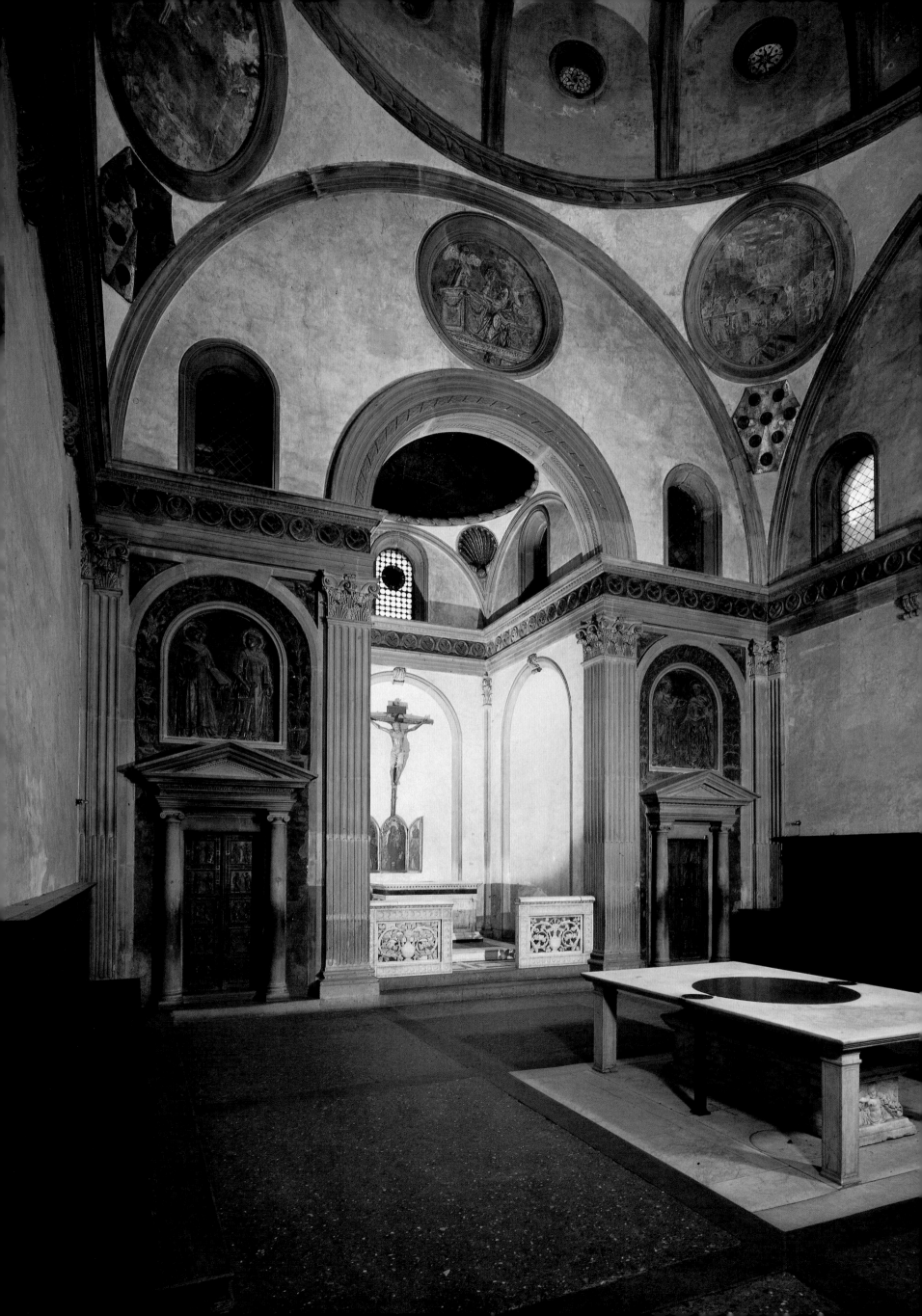

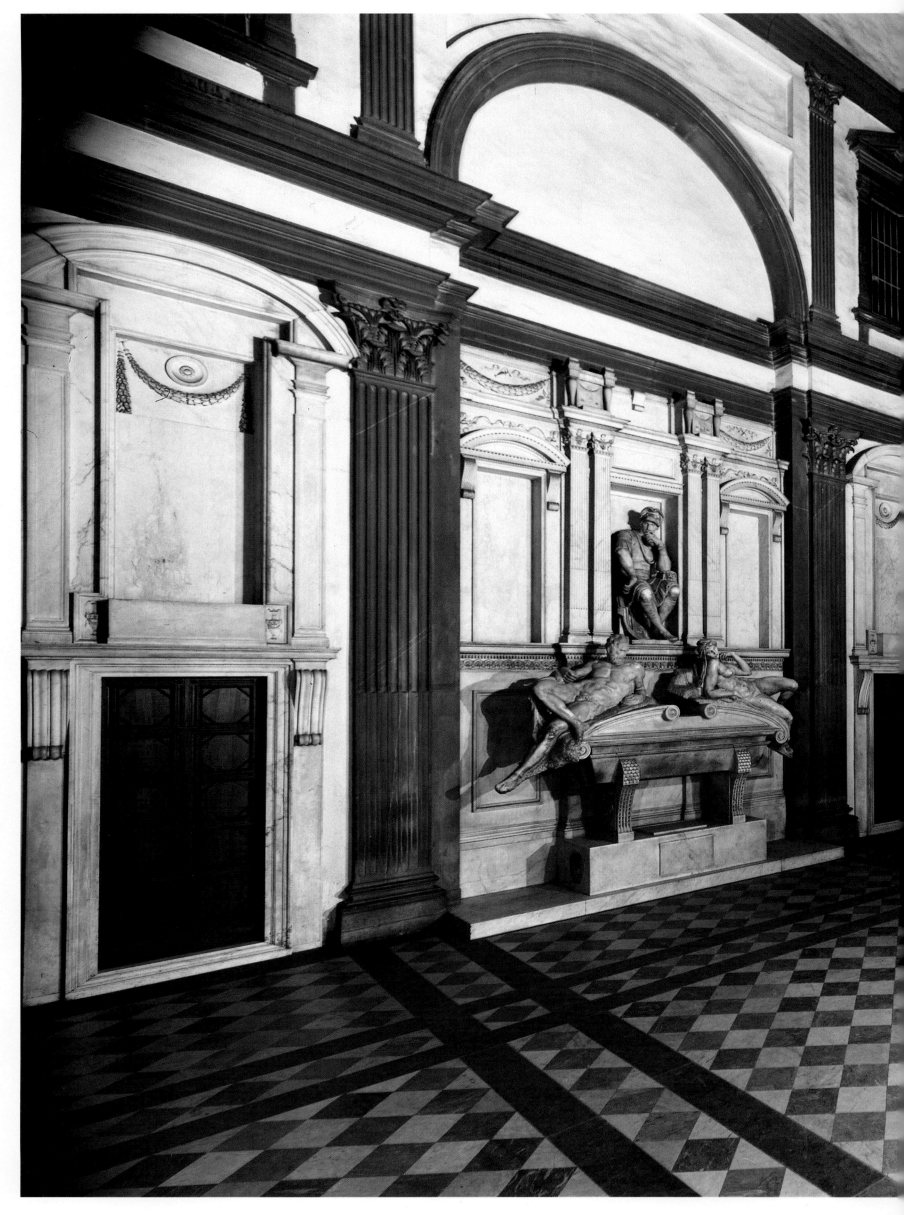

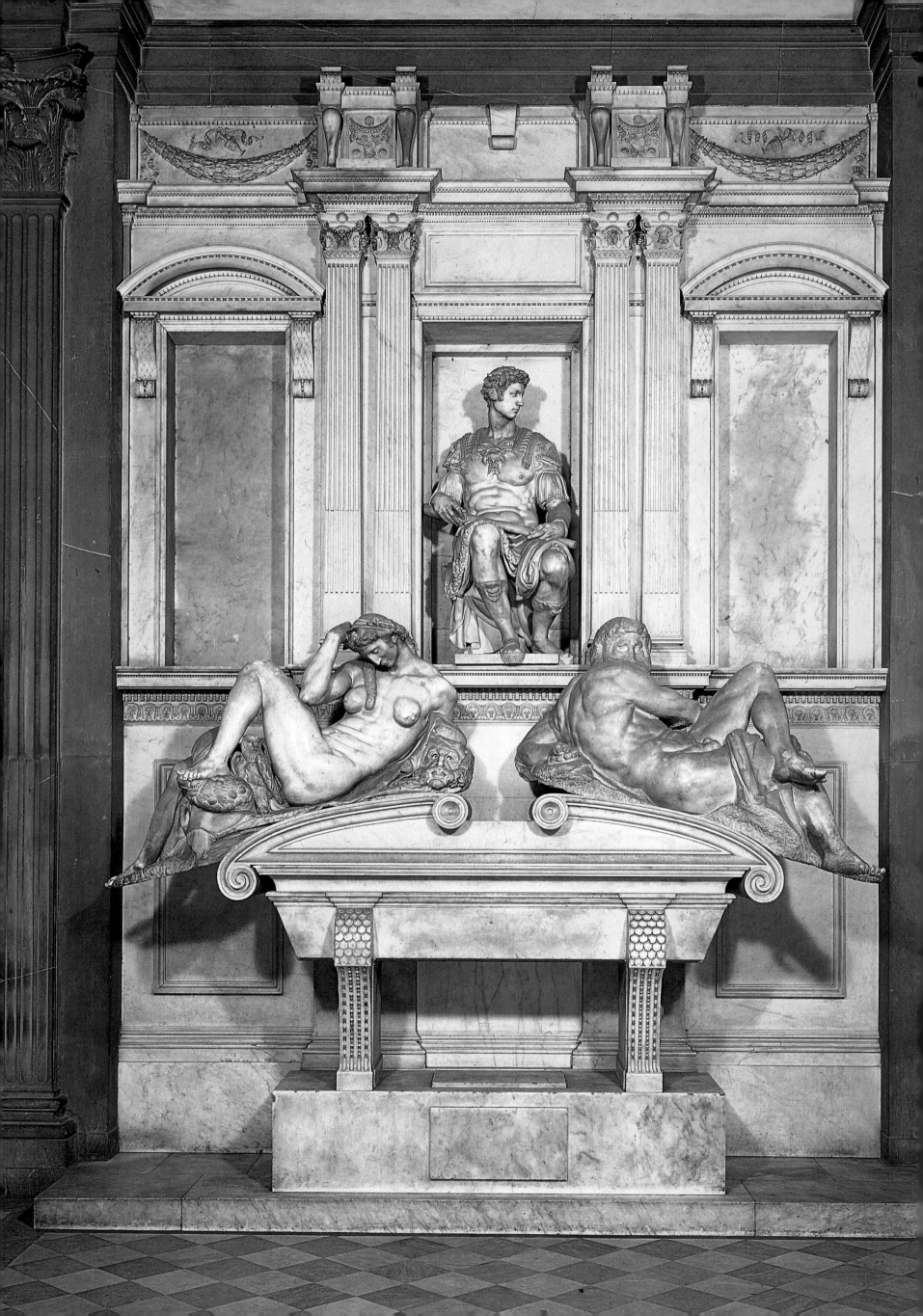

LEFT: *Tomb of Giuliano de' Medici*, 1520-34, Medici Chapel, Florence. Giuliano is represented as an idealized, classicizing figure, his setting replete with classical motifs. This is the most highly finished of the tomb statues and was probably one of the first to be carved. Below him are statues of *Night* and *Day*, the former demonstrating Michelangelo's lack of sympathy for the female figure.

RIGHT: *Lorenzo de' Medici*, 1520-34, Medici Chapel, Florence. In contrast to Giuliano, Lorenzo is shown as a withdrawn and reflective figure; again Michelangelo is adapting the Neoplatonist theme of contrasting pairs.

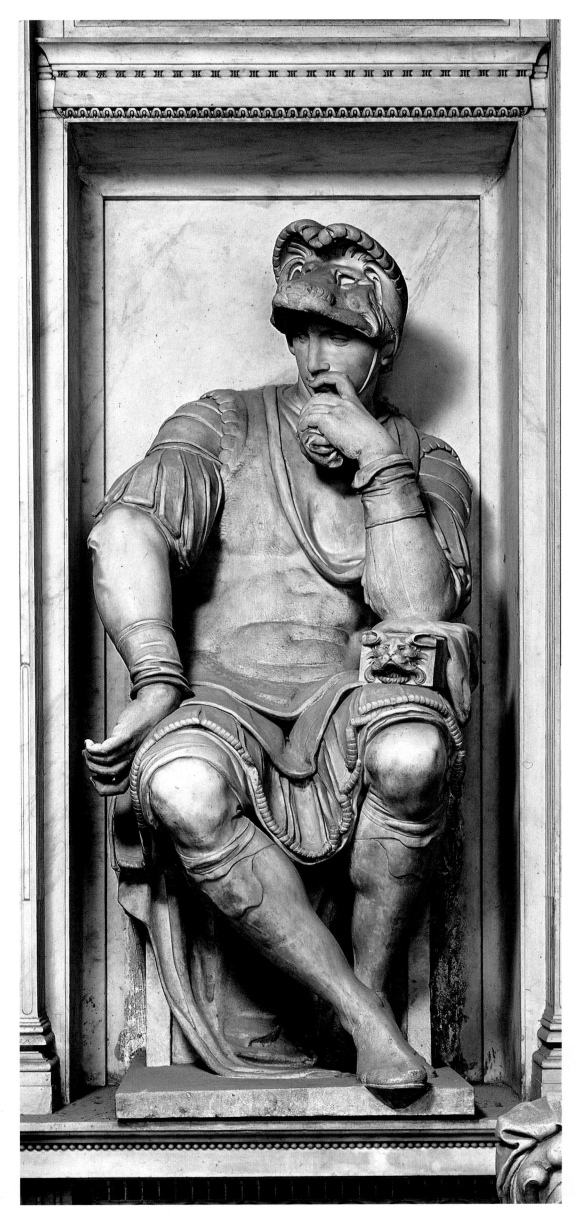

Michelangelo's departure from accepted classical norms. As so often with innovatory systems, the classical language of architecture adopted by Renaissance architects had begun to have a limiting effect on design; it was Michelangelo's achievement as architect to overcome this limitation, to introduce a more flexible and daring use of classical components, a new vocabulary of ornament and an entirely new approach to internal space, which revolutionized building design and was ultimately to contribute to the development of Baroque architecture.

As with so much of Michelangelo's work, the chapel remains unfinished and his full intentions are unclear. The basic structure, however, echoes that of the Old Sacristy. It is centrally planned, with a small domed choir at one end, and is roofed with a hemispherical dome; gray *pietra serena* Corinthian columns carry an unbroken entablature which together provide the architectural framework. Whereas Brunelleschi treated the wall as a flat surface to be decorated, Michelangelo saw it as an organic multi-layered entity reflecting the structural stresses of the building. His aim was to combine architecture and sculpture in such a way that the whole interior of the chapel should form an integrated monument to the Medici, a kind of three-dimensional altarpiece.

To this end he rearranged the internal architecture so that the door from the church matched the position of the two doors leading into vestries on either side of the choir, and then created five more blind doors to form a symmetrical arrangement of two doors in each wall. Above each door is a tabernacle of greater size and complexity than the doorway itself, topped by a segmental pediment that seems to be barely prevented from overflowing by the gray Corinthian capitals of the basic framework. Between the pairs of doors on the side walls are the tombs of the Capitani, again barely con-

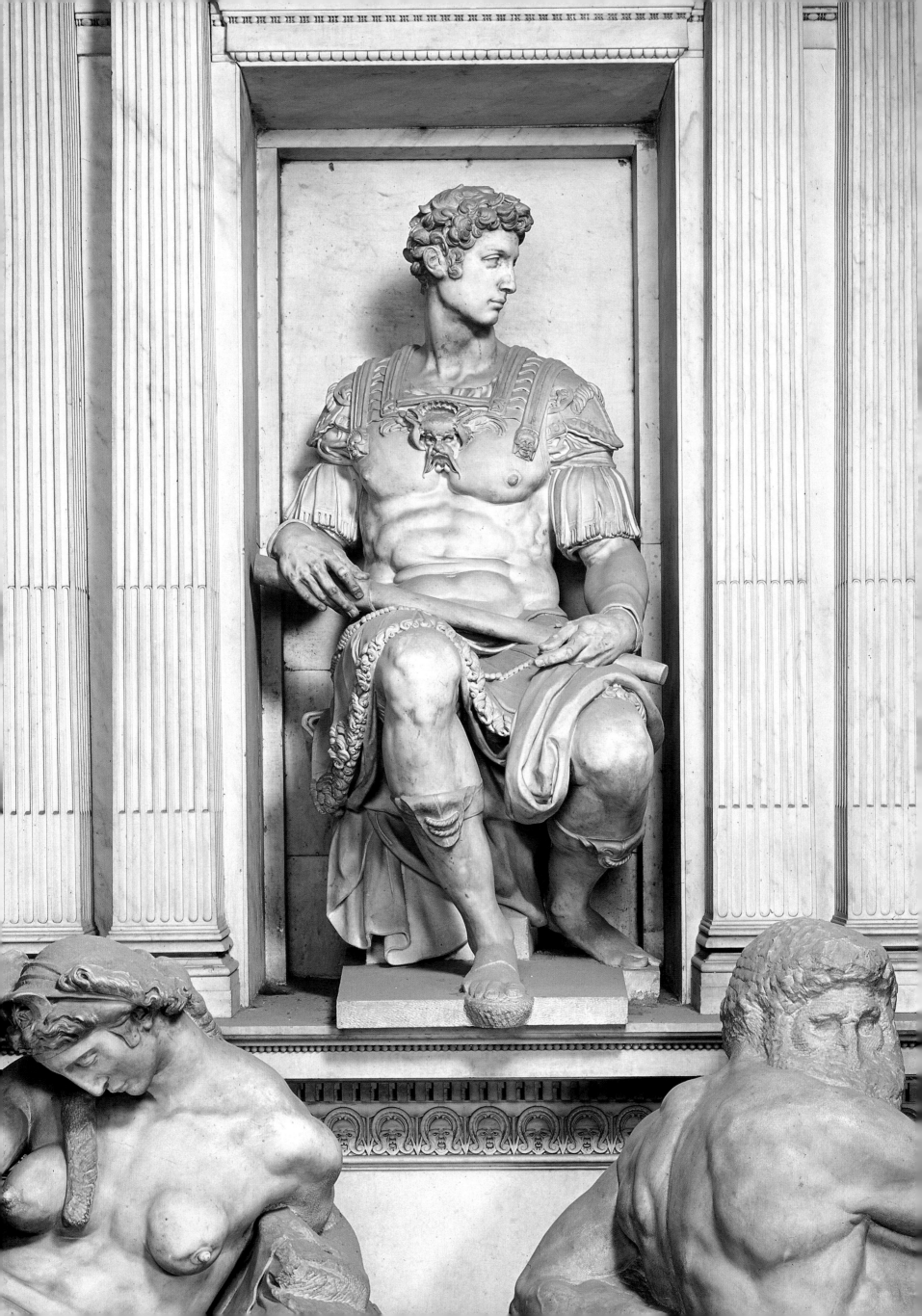

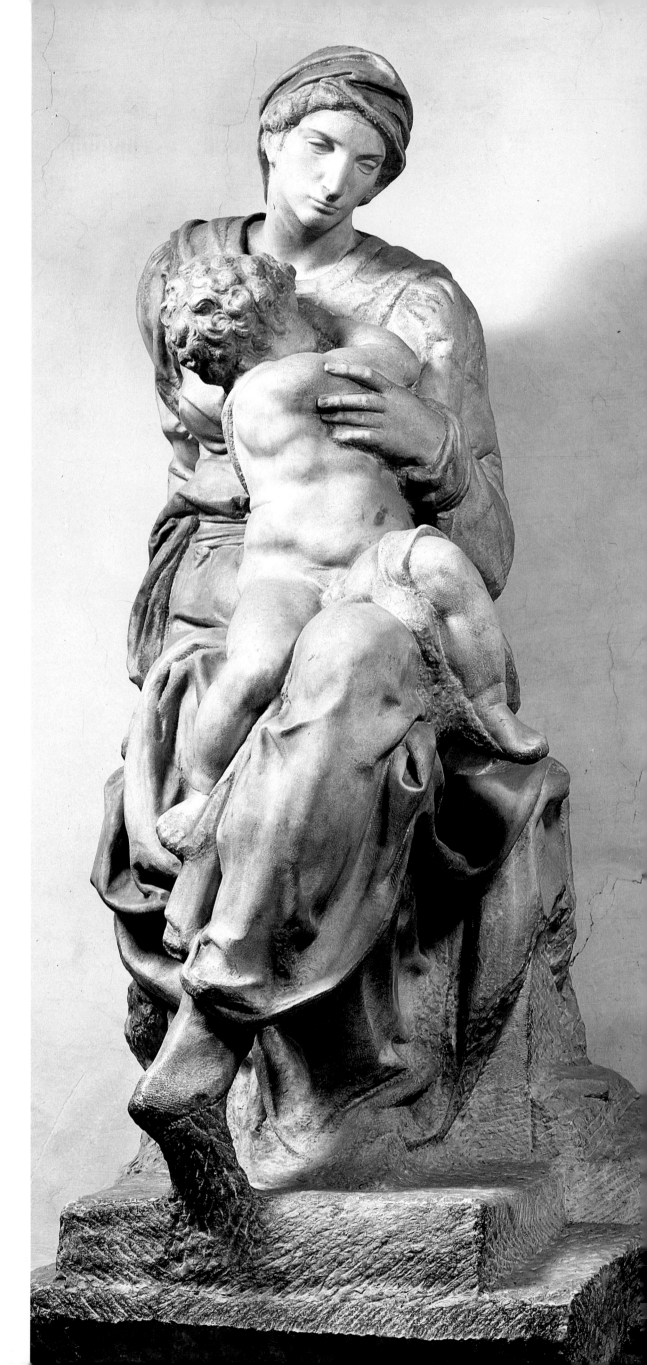

LEFT: *Giuliano de' Medici*, 1520-34, Medici Chapel, Florence. The figure is portrayed wearing antique body armor decorated with a grotesque head, one hand loosely clasping a military baton. The frieze of animal masks below the statue's feet contributes a macabre element.

RIGHT: *Medici Madonna*, 1521-34, marble, h. 98¾ inches (253 cm), Medici Chapel, Florence. Although intended for the chapel, this unfinished group was found in Michelangelo's studio. The last of his series of carvings of the Madonna and Child, this again shows the Virgin as preoccupied with the future and barely attending to her nursing child.

strained by the niches containing them. The white marble of tombs and doors and the gray *pietra serena* effectively form two inter-related decorative schemes which overlap in an extremely complex and multi-layered design which, while using elements inspired by classical architectural forms, creates a startlingly original combination.

Many drawings survive showing Michelangelo's various plans for the tombs; the final plan seems to have been for one on each side wall – the Capitani – and a double one for the Magnifici brothers, facing the altar. Of this, only the two side tombs were erected and they remain unfinished. Each of these is a complex sculptural program in its own right, with Giuliano, Duke of Nemours and Lorenzo, Duke of Urbino represented as idealized manifestations of the two strands of Christianity, the Active and Contemplative Life respectively. Giuliano as the Active Life is flanked by the figures of *Night* and *Day*, while the more pensive Lorenzo is attended by *Dawn* and *Evening*. To further complicate the symbolism, reclining figures of river gods were originally placed below each tomb, variously interpreted as the rivers of Hades and of Paradise.

The statue of Giuliano is the most fully finished of the tomb figures and was probably the first to be carved, as it is more compact than the massive, solid figure of Lorenzo, which seems rather cramped by the niche in which it sits; as on the Sistine ceiling, Michelangelo's later figures tended to outgrow their architectural setting. While Giuliano sits erect, bare head turned attentively and poised to rise from his seat, Lorenzo's pose is closed and relaxed, head bowed and face shadowed by his helmet. References to classical art abound: in the Capitani's antique body armor; in the decorative detailing of the tombs; in the supporting figures of *Night*, *Day*, *Dawn* and *Dusk*, the first of which is based on an antique state of *Leda and the Swan*.

RIGHT: Tomb of Giuligno de Medici, 1520-34, Medici Chapel, Florence. The figures of *Night* and *Day* are at the foot of Giuliano's tomb. *Night* (shown here) was derived from an antique statue of *Leda and the Swan* and was greatly admired. It clearly demonstrates, however, Michelangelo's lack of sympathy for the female form.

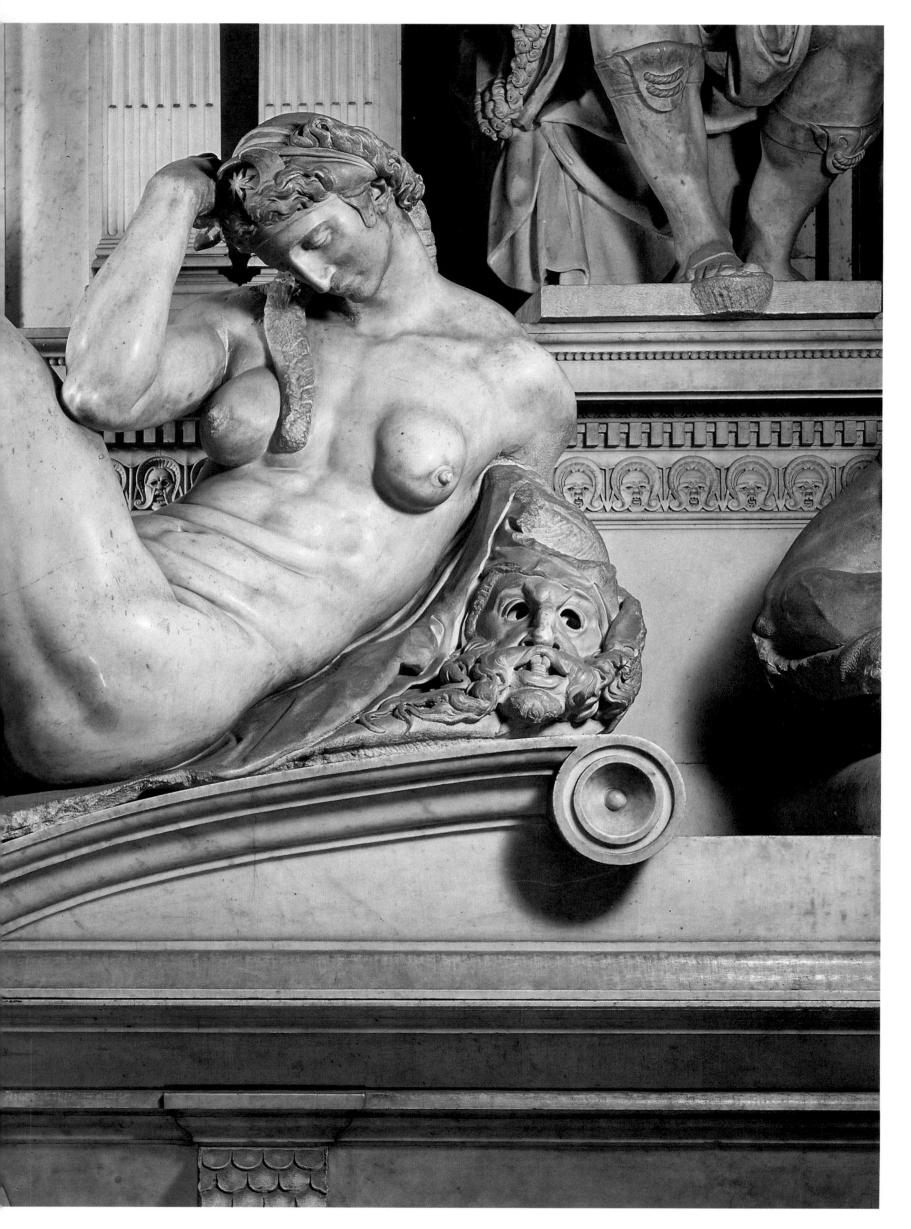

RIGHT: The interior of the Laurentian Library reading room, S Lorenzo, Florence. The existing walls of S Lorenzo had to support the weight of the new building, posing practical problems for the architect. Michelangelo defined the load-bearing part of the wall in gray *pietra serena*, and decoration was kept to a minimum. The Pope requested an 'unusual' ceiling and suggested designs for the floor decoration.

The unfinished *Madonna and Child* now on the entrance wall opposite the altar was intended as the central figure of the double tomb of the Magnifici, and the focus of intercessionary prayer. As with the much earlier *Madonna of the Steps*, the child twists round on his mother's lap, turning his back on the viewer. They are flanked by figures of the Medici patron saints, Cosmas and Damian, carved probably by Michelangelo's assistants. It seems that fresco decoration was also planned, and that the lunettes in the second storey over the tombs were to reflect the theme of Resurrection, but this came to nothing. Work on the chapel was interrupted in 1527, when Rome was sacked by the invading army of Charles V and a republican government gained power in Florence. After the restoration of the Medici in 1530, Michelangelo worked only spasmodically on the project. In 1534 he left Florence for Rome, never to return.

One other major architectural project occupied Michelangelo in Florence during the 1520s. Again it was a Medici commission, from Pope Clement VII, this time for a library to adjoin S Lorenzo and house the family's magnificent collection of books and manuscripts, begun by Cosimo de' Medici in the fifteenth century. The site chosen was above the existing refectory of the monastery of S Lorenzo, with access at one end through a vestibule from the cloister. This meant that the existing walls had to take the weight of another story, and Michelangelo therefore designed the library walls to be as thin and light as possible, with buttressing at key intervals. The design of the interior reflects this lightness and regularity in a novel linking of structure and decoration. *Pietra serena* pilasters define the load-bearing areas of the wall, while white stucco covers the light infill and the decoration, too, is lighter and more delicate than the heavy, crowded forms used in the Medici Chapel.

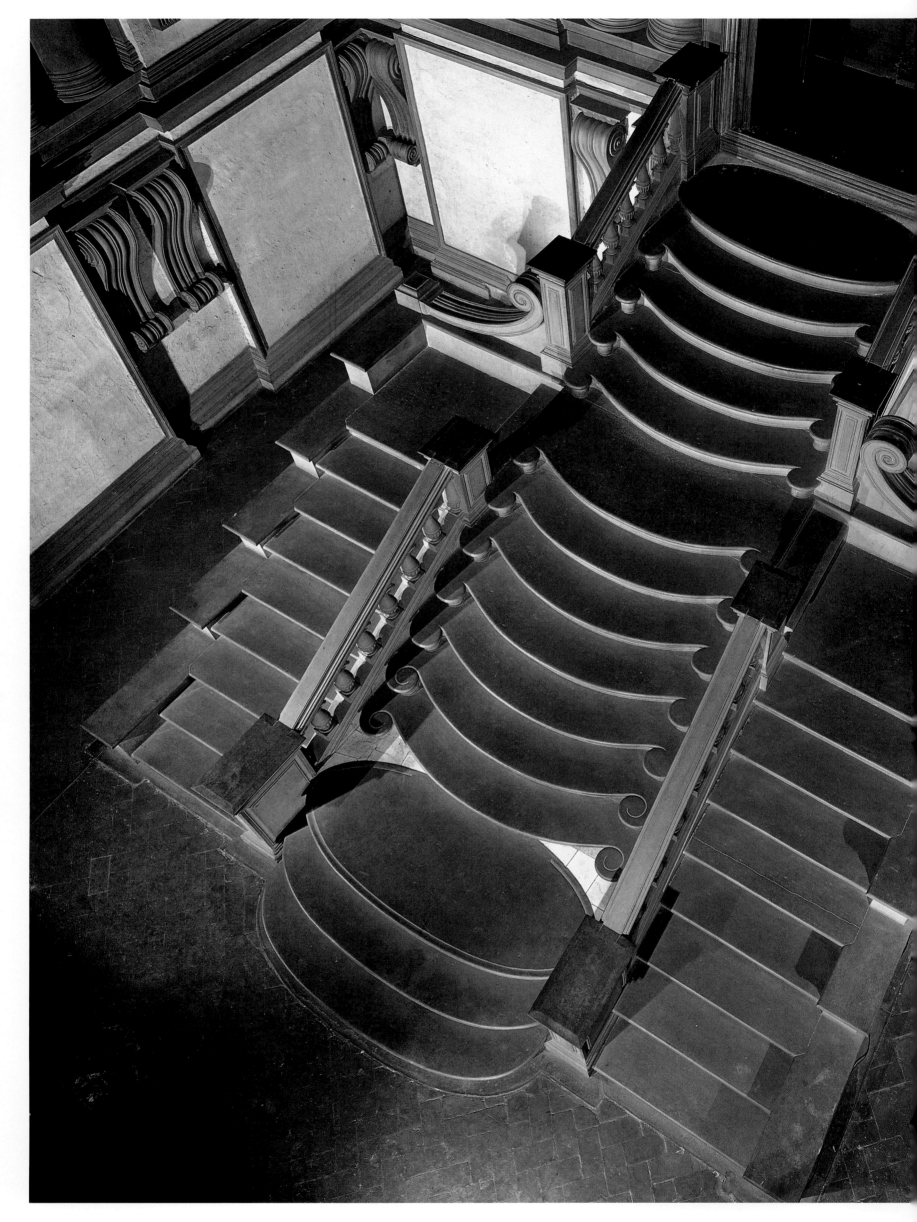

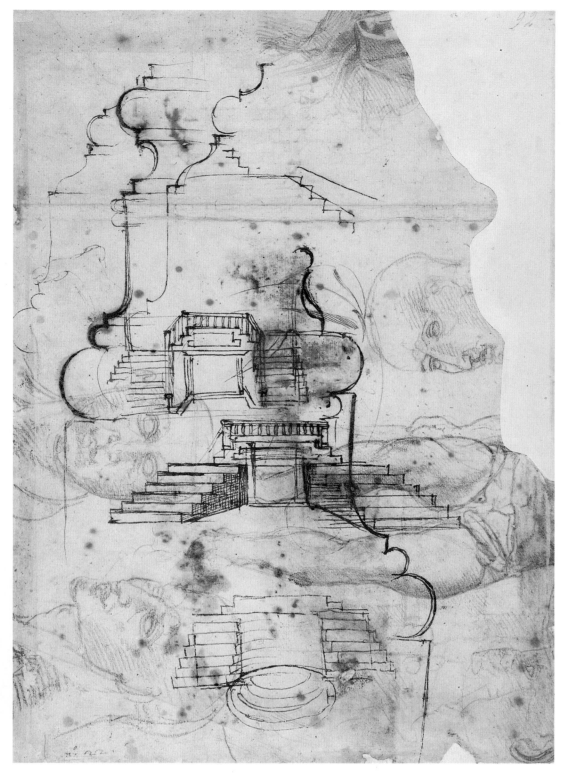

LEFT: Laurentian Library, S Lorenzo, Florence, stairs. This aerial view shows how the triple flight designed by Michelangelo spills out from the library entrance and flows down into the vestibule. Contemporaries apparently regarded it as unique; Vasari says 'nothing so graceful and vigorous in every part was ever seen . . . convenient staircase with its curious divisions, so different from the common treatment as to excite wonder.'

ABOVE: These studies show how Michelangelo moved away from his original idea of steps flanking the side walls of the vestibule, and began to experiment with a central curvilinear form.

The vestibule also presented problems. Michelangelo's first proposal was to light it from above, but the Pope insisted on normal windows, which meant adding a story to accommodate them and creating an awkwardly tall and narrow space. Instead of trying to disguise this, Michelangelo emphasized the verticality of the vestibule, in contrast to the longitudinal quality of the library, by embedding paired columns in niches in the walls. This was in fact dictated by necessity; the decorative-seeming columns actually carried the roof and had to stand on the existing foundation wall in order to be adequately load-bearing, but the effect is deliberately perverse. This perversity can be seen again in much of the rest of the decoration, including the blind window-frames with pilasters tapering toward the base rather than the top, and the consoles which support nothing. The most extraordinary feature of the vestibule, how-

RIGHT: *Pietà*, 1538-40, black chalk, 11¼ × 7½ inches (29 × 19 cm), Isabella Stewart Gardner Museum, Boston. This is one of a number of presentation drawings on religious subjects that Michelangelo made for his one female friend, the pious and intellectual Vittoria Colonna, Marchesa of Pescara. She spent considerable periods of time on retreat in convents outside Rome, and many of Michelangelo's surviving sonnets were composed for and sent to her. She was described by a contemporary as having the ability 'to show to the most serious and celebrated men the light which is a guide to the harbor of salvation'; Michelangelo's Christian faith deepened and strengthened during the course of their association.

BELOW: *Drawing for the Head of Leda, c.*1530, red chalk, Casa Buonarroti, Florence. This is a preparatory study from the male model for Michelangelo's lost painting of *Leda and the Swan*, commissioned by Alfonso d'Este, Duke of Ferrara, in letters which are remarkably deferential in tone, indicating the new higher status of major artists.

ever, is the great triple stairway which occupies the central part. Freestanding like a piece of sculpture, this has curved steps on its central flight, giving the impression that it is flowing down from the library door and spreading out across the floor space.

During the brief return of the Florentine Republic at the end of the 1520s, Michelangelo accepted a commission from the Duke of Ferrara for a painting on the theme of Leda and the Swan. The painting was finished but never delivered, instead being sold by one of Michelangelo's assistants to Francis I of France and later lost. A finely finished study for the head survives, drawn from a male model, as was the norm at this time. Also dating from this period is an unfinished sculpture of a male nude known variously as *David* and *Apollo*, which was begun after the Medici regained control of Florence for Baccio Valori, a Medici appointee. This continues the theme, begun in the *Doni Tondo* and further explored in some of the figures of the Sistine ceiling, of a figure in suppressed movement, with one arm raised and the head turning in the opposite direction to the body.

Most of Michelangelo's drawings are, like the *Head of Leda*, preparatory sketches for works in other media, but a few are more highly finished and intended for close friends as works of art in their own right. These are known as the 'presentation drawings', and mostly date from soon after his return to Rome in 1534. A series of classical subjects and ideal heads was made for a young Roman nobleman, Tommaso Cavalieri, with whom Michelangelo seems to have developed a close and passionate relationship. The drawings made for Vittoria Colonna, Marchesa of Pescara, seem to be slightly later in date and reflect the mood of pessimism that afflicted the Church after the sack of Rome in 1527, with their emphasis on redemption and salvation. This new mood of piety

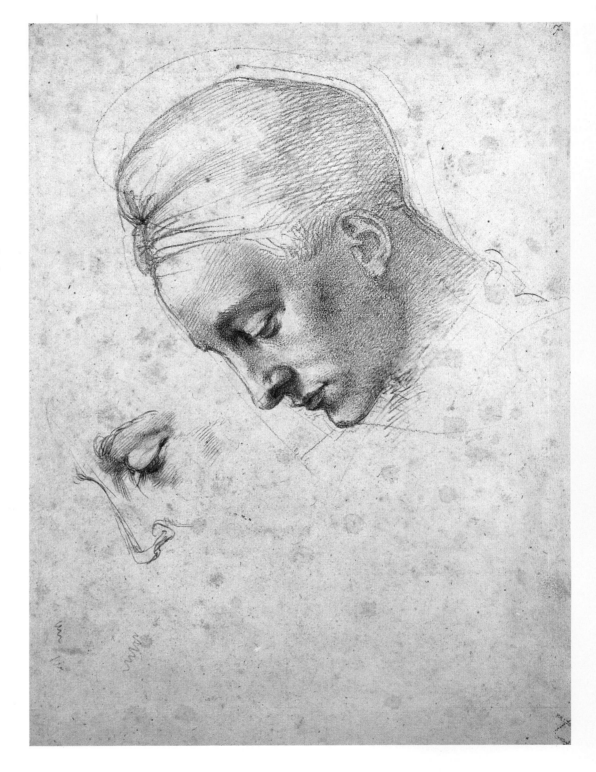

becomes an increasingly significant factor in Michelangelo's work during his last 30 years, as the crusading zeal of the Counter-Reformation took hold of the Catholic Church.

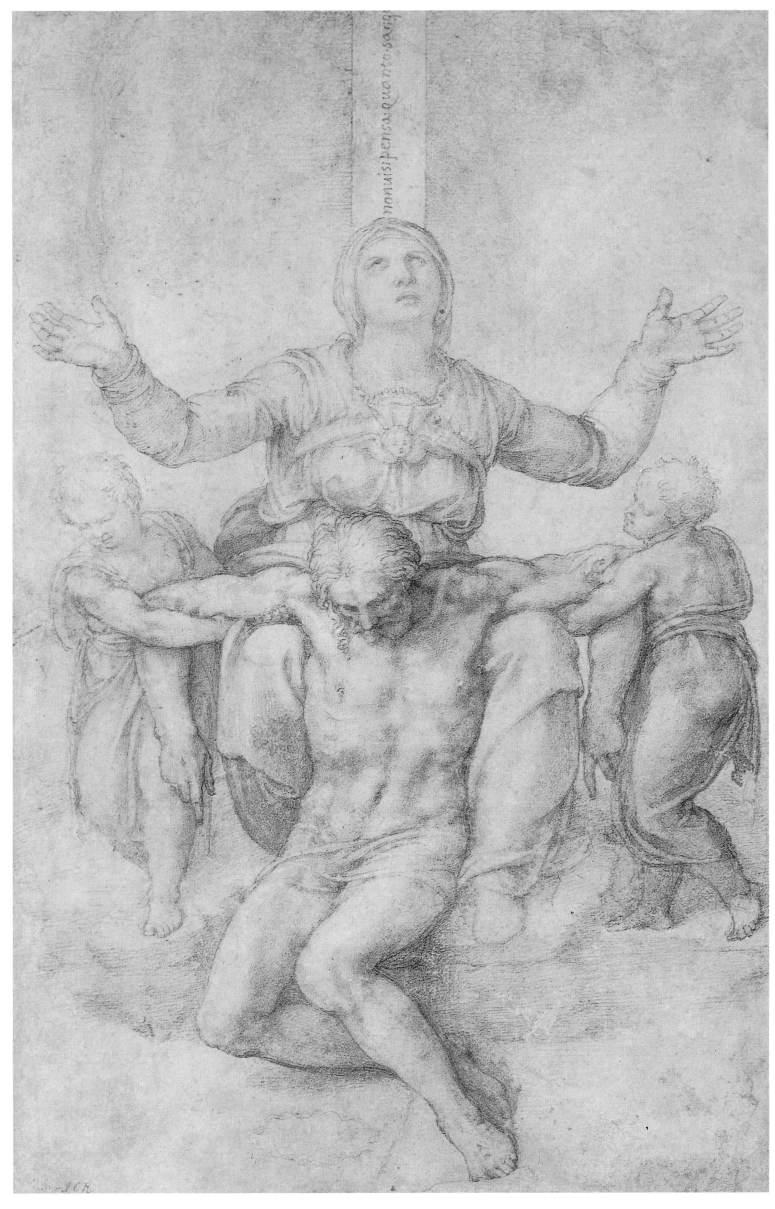

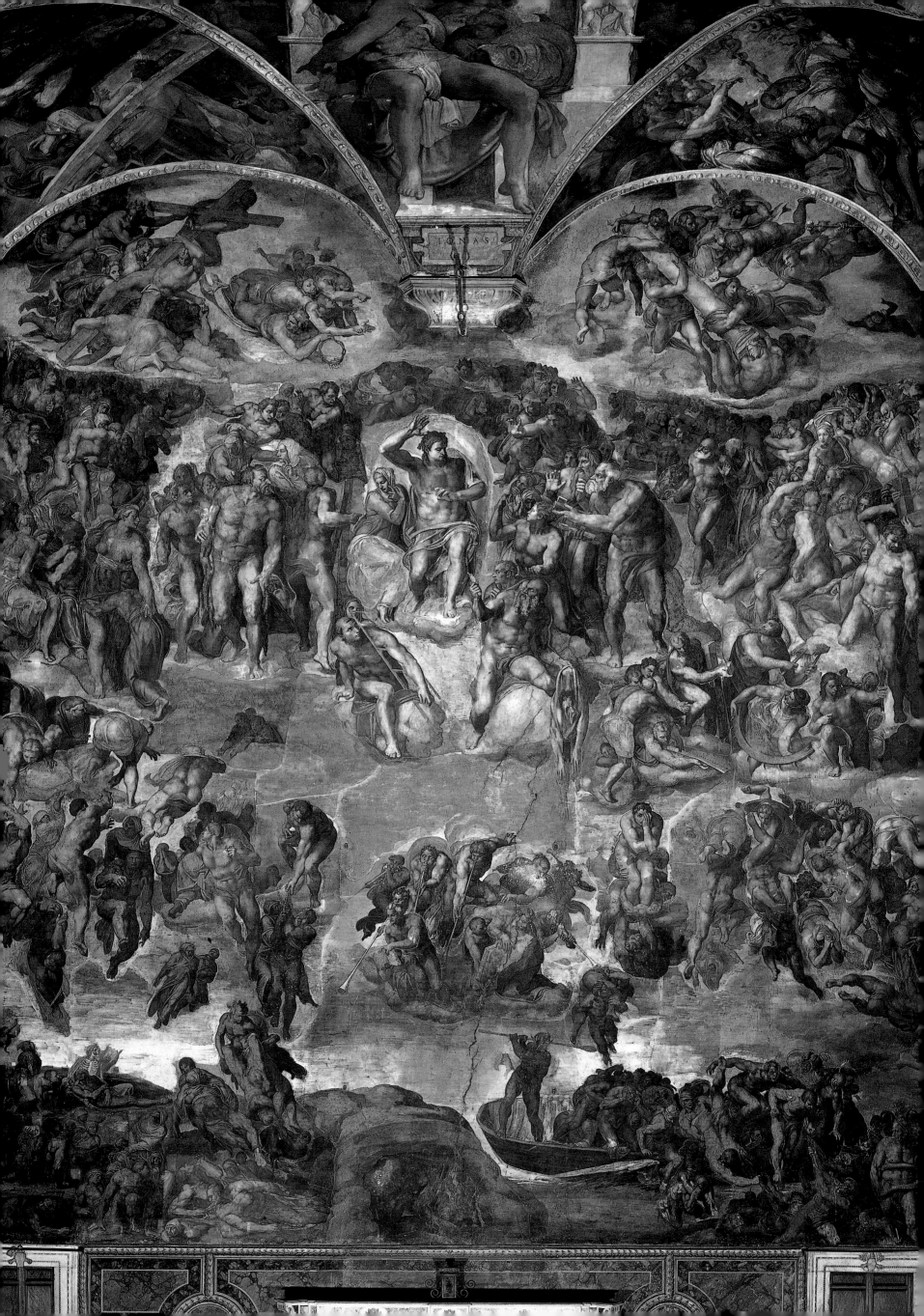

CHAPTER FOUR

Painting, Sculpture, Architecture: Rome, 1534–64

Yet again it was due to papal intervention that Michelangelo embarked on his next major project. The painting on the altar wall of the Sistine Chapel, Perugino's *Assumption*, was damaged by fire in 1525. This led to a revival of Julius II's original plan for a new altarpiece representing the Resurrection, as a fitting conclusion to the decoration of the chapel, which began with the Creation. At some point before Michelangelo started work, the subject became the *Last Judgment* that we see today, a change probably inspired by the reforming pope, Paul III (1534-49), who convened the Council of Trent and set on course the Counter-Reformation. Paul III had long admired Michelangelo, and in 1535 he took the unprecedented step of making him chief painter, sculptor and architect to the Vatican Palace.

Both the scale and the subject matter of this altar wall reflect the newly pious and militant mood of the Church. In order to make the whole wall the field for his apocalyptic vision, Michelangelo eliminated all of the existing decoration, including the frescoes at the beginning of the *Moses* and *Christ* cycles, and two ancestor lunettes that he himself had painted. The area to be covered, some 45 × 40 ft, was the largest that an artist had ever tackled for a single work without any kind of subdividing framework, as he had used on the ceiling. The resulting fresco was finally unveiled in 1541, and the story goes that when Paul III first saw it he fell on his knees in awe.

The theme is not a common one in Italian art, the closest comparison being Luca Signorelli's series of frescoes dating from 1500-04 in the cathedral at Orvieto. From these Michelangelo took the idea of the gesturing Christ, arm raised in condemnation, and the skeletal dead being clothed with flesh as they rise from their graves. Other traditional features include the blessed on Christ's right and the damned on his left. Quite new, however, is the swirling sense of movement that envelops the whole fresco and gives it an extraordinary energy and unity. The dead rise from the lower left, summoned by the trumpets of the angels in the center, and rise toward Christ to be judged. The

righteous continue upward to join the ranks of the blessed, while the damned fall away to the lower right, pursued by demons and all too clearly conscious that they are the authors of their own fate. Christ himself is shown young, vigorous and nude, like a classical god, half rising from his seat to separate the just from the fallen. Above him in the lunettes, groups of angels seem to struggle with the instruments of the Passion, and are as imbued with action and tension as all the other figures.

This fearsome vision of the end of the world provoked instant controversy, which focused initially on the nudity of the vast majority of the figures as being

PREVIOUS PAGES, LEFT: *Last Judgment*, 1534-41, fresco, 534 inches × 476 inches (13.7 × 12.2 m), Sistine Chapel, Vatican. Over 20 years after he had completed the Sistine Chapel ceiling, Michelangelo was commissioned by the reforming Pope Paul III to paint the altar wall. The largest space tackled by a single artist without any kind of subdividing framework, this awesome vision of the Day of Judgment seems to explode into the orderly decorative scheme of the chapel.

PREVIOUS PAGES, RIGHT: Luca Signorelli, *Last Judgment: The Damned*, 1500-04, fresco, Orvieto Cathedral. One of the few earlier representations of the subject, Signorelli's vision of the damned as a mass of seething and fully-fleshed bodies undoubtedly influenced Michelangelo.

RIGHT *Last Judgment*, detail, St Bartholomew. The upward struggle of the blessed seems as fraught with tension and danger as the fall of the damned. There is no area of calm and content; even the saints who surround Christ, holding the instruments of their martyrdom, seem defensive and unsure of their salvation. St Bartholomew here brandishes the knife that was used to flay him, while holding his discarded skin, the distorted features of which, like the victim in the *Victory* intended for the Julius tomb (page 72) have been identified as an ironic self-portrait.

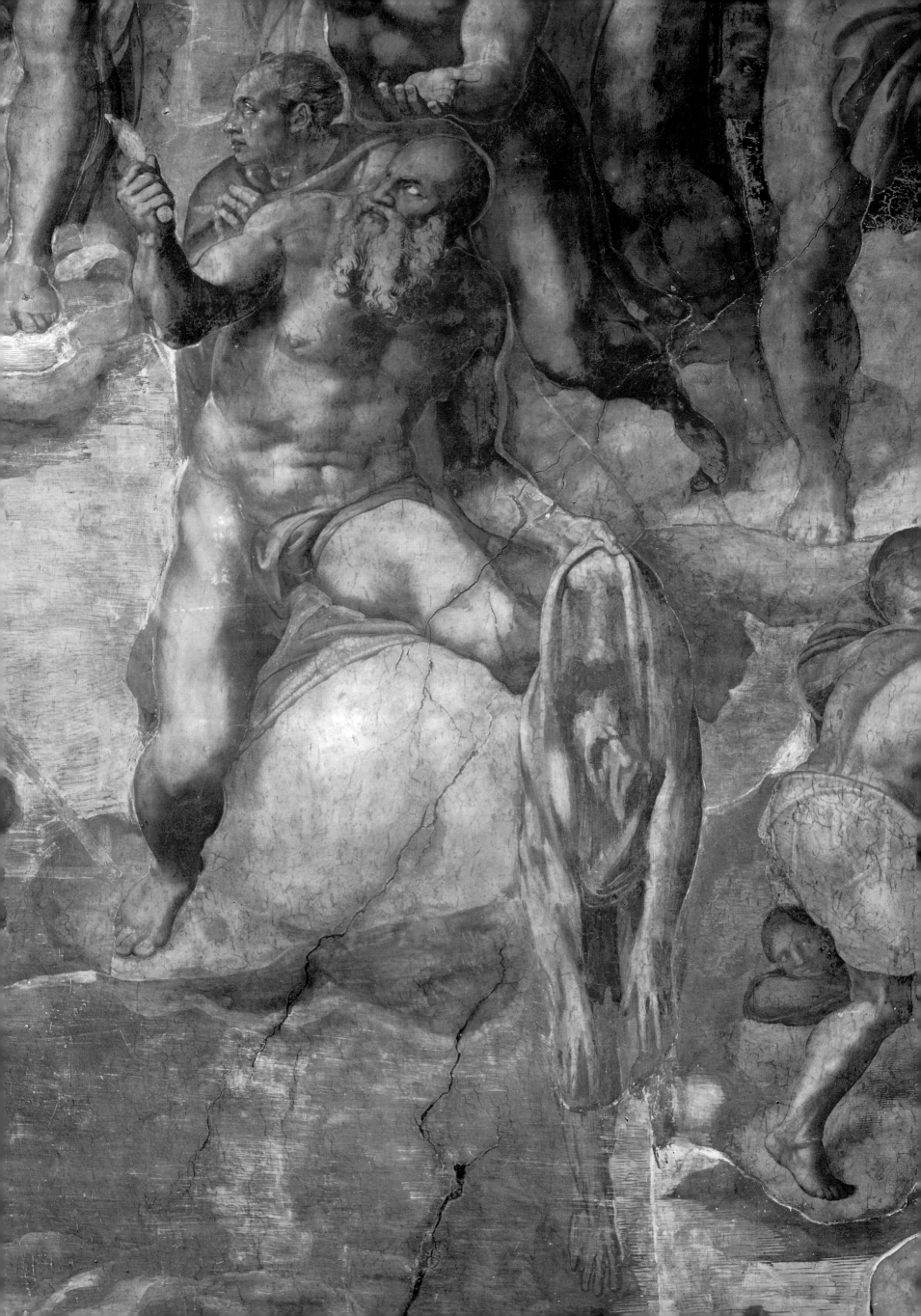

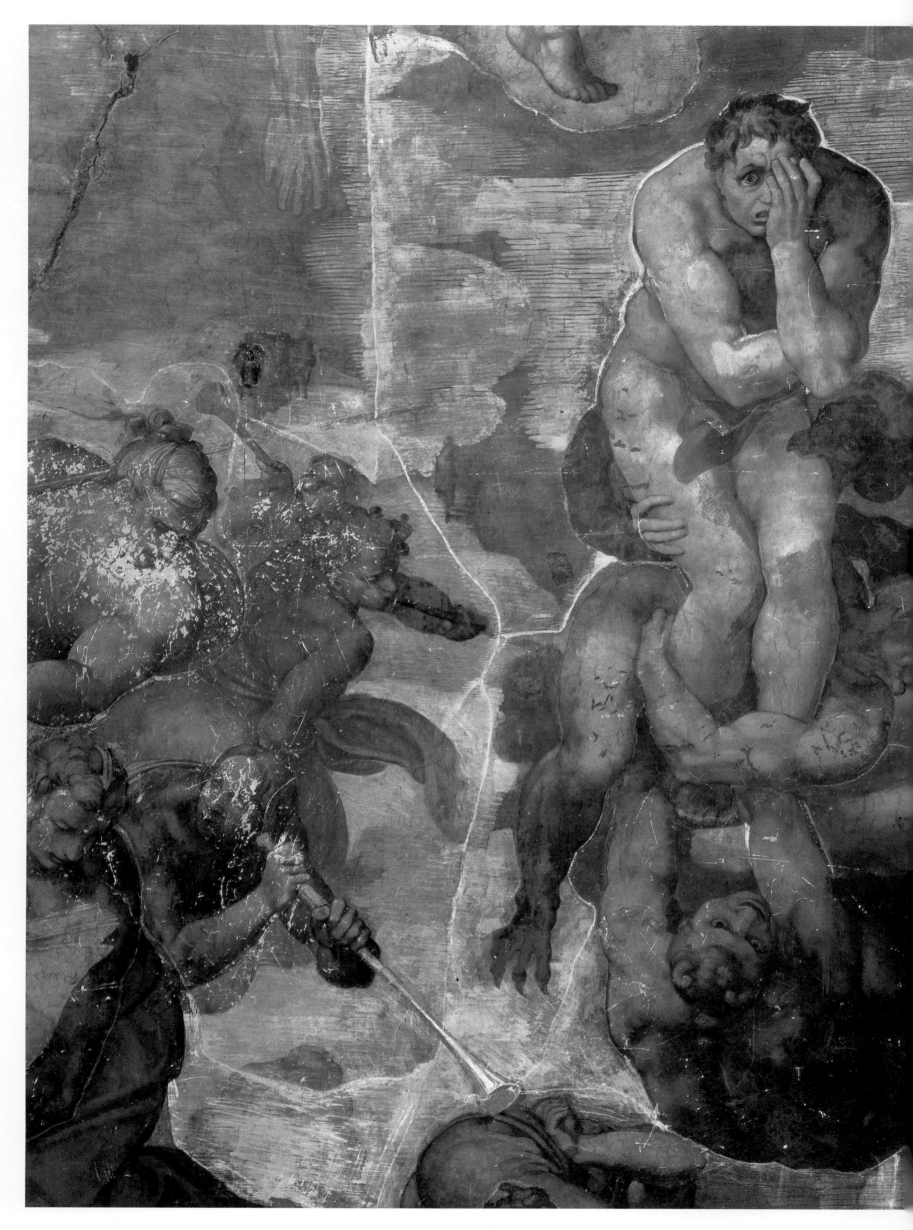

LEFT: *Last Judgment*, detail, one of the damned. This despairing figure, being dragged down by clawed and beaked but horribly corporeal demons, and even by other sinners, half covers his face in recognition of what he has brought on himself. The nude figures, with their discreet drapery provided by Michelangelo's pupil at the insistence of a later pope, no longer have the slender idealized bodies of earlier nudes; they are heavy and ungainly, the work of an artist now more concerned with spiritual than physical perfection.

deemed unsuitable for a religious subject and in such a situation. Pope Paul IV (1555-59) urged Michelangelo to 'tidy up' the fresco, which provoked the memorable reply that the pontiff should first tidy up the world and painting would follow suit. Finally Daniele da Volterra was commissioned, shortly before Michelangelo's death, to provide draperies for the principal nudes. While restoration is undoing some of the damage that time and smoke have wreaked on the *Last Judgment*, this deliberate vandalism is proving more difficult to rectify, as the underlying layers of fresco painted by Michelangelo seem first to have been removed.

A second major commission planned by Paul III for Michelangelo, two frescoes for the side walls of the private papal chapel built by Antonio da Sangallo from 1537, was delayed while yet another stage in the Julius Tomb was completed, and it was not until 1542, when he was nearly 70, that Michelangelo began work on *The Conversion of St Paul* and *The Crucifixion of St Peter*. The *Conversion* is the earlier of the two, and has the same swirling sense of unified movement as the *Last Judgment*, finished shortly before, but the light, clear color is closer to that of the Sistine ceiling than to the *Last Judgment*'s darker, more turgid tones. The fresco contains two spheres of action, the heavenly throng clustering round Christ and lit by the luminous warmth of his golden aura, and the earthly group which recoils in fear from the smitten Paul (or Saul, as he then was). These two are linked by the bolt of lightning that blinds Saul, and by Saul's rearing horse. The *Crucifixion* focuses on a single group, with the fierce, muscular Peter already nailed to his cross, which is about to be erected. His body cuts at an angle across the picture space, and he turns to glare accusingly at the viewer, reminding us that he is dying for our sins and reinforcing the Counter-Reformation message that salvation comes only

RIGHT: *The Conversion of St Paul*, 1542-45, fresco, 242 × 260 inches (620 × 666 cm), Pauline Chapel, Vatican. The two paintings for the private chapel of Paul III, which Michelangelo began when he was almost 70, reflect themes of vocation, martyrdom and salvation which were of particular relevance to the Counter-Reformation church. Shocked by the loss of much of northern Europe to Protestantism, the Catholic Church in the mid-sixteenth century was determined to put its house in order and reaffirm its sanctity as the direct descendant of the church of Christ. The subject of the two works also served to confirm papal authority, as they concerned Pope Paul's namesake, originally Saul of Tarsus, who took the Christian name of Paul, and St Peter, his earliest predecessor as head of the church. The *Conversion* gives further evidence of Michelangelo's loss of interest in formal beauty, already suggested in the *Last Judgment*. The landscape setting is only summarily executed, the human figures stiff and graceless; in contrast to the movement and energy of the almost contemporaneous *Last Judgment*, the action seems fixed and frozen, although the color is generally lighter and richer.

through the Church. The treatment of the individual figures in both these works is indicative of the major change that had taken place in Michelangelo's attitude to the male nude, and his increasing indifference to formal beauty. Most of the figures are clothed, and their bodies are clumsy and muscular, with none of the interest in virtuoso poses demonstrated on the Sistine ceiling or the sculpture of the Medici Chapel.

The increasing pessimism and piety of Michelangelo's last years is reflected in his late sculptural work. During the 1540s and 1550s, when he was principally concerned with architectural projects, he also worked on two *Pietà* groups, neither of them finished and both damaged by their creator in frustration over faults in the stone. The earlier of the two, more accurately known as *The Deposition of Christ* and now in Florence Cathedral, was only saved from total destruction by Michelangelo's servant. It was then repaired and altered by his pupil, Tiberio Calcagni, who added the bland and disproportionately small figure of the Magdalen on the left. The *Rondanini Pietà*, on which Michelangelo was working until a few days before his death in February 1564, has been described as the artist's 'symbolic act of suicide', its skeletal and attenuated forms suggesting a tragic repudiation of the artistic ideals to which his life had been devoted. A similar development can be seen in the group of drawings, nearly all of religious subjects, made at the end of his life. Technically these are less finished than the group made for Vittoria Colonna; rather than conscious works of art, they are the medium for expressing Michelangelo's deepening faith, his loneliness and his profound pessimism. In a late sonnet he wrote:

. . . No painting or sculpture now quiets the soul, which turns toward that holy Love that on the cross opened its arms to take us.

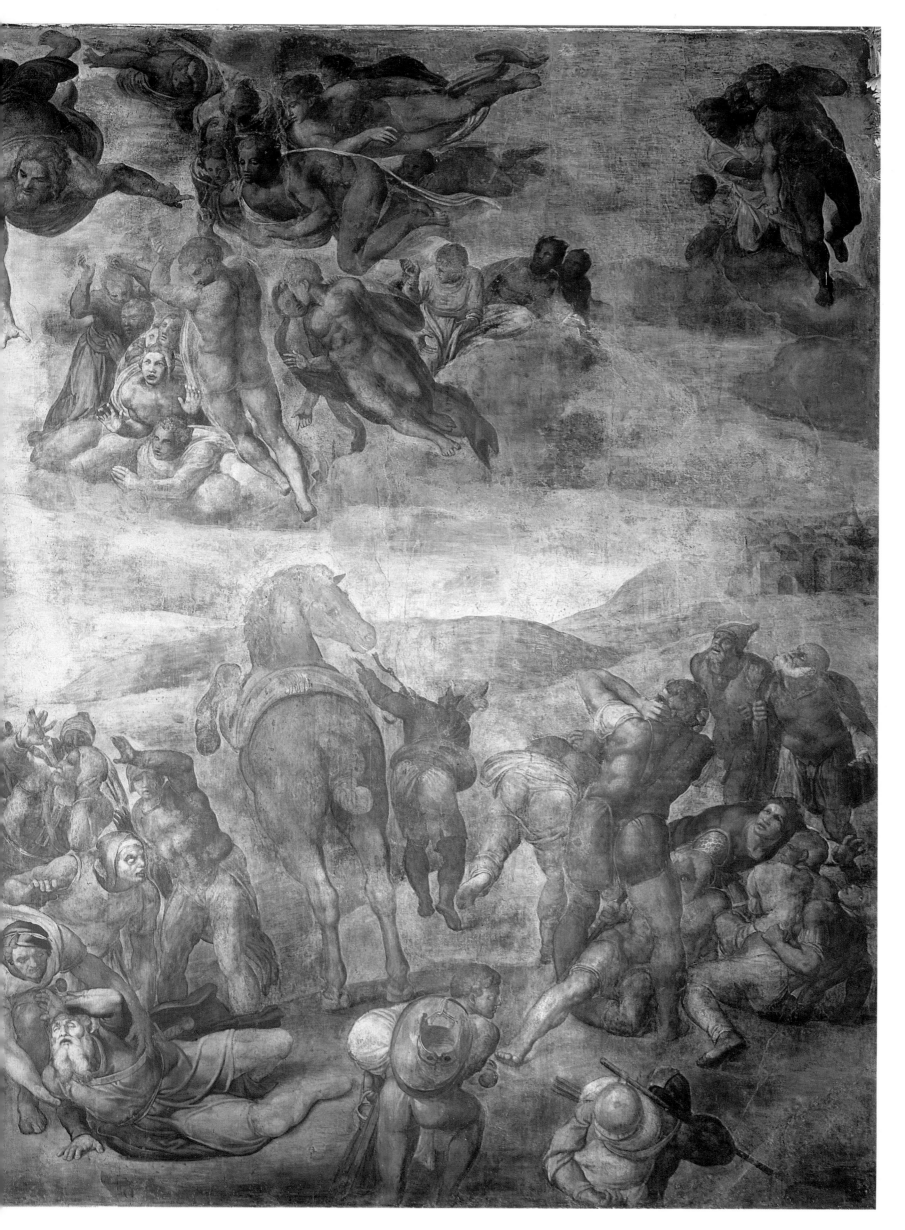

RIGHT: *The Crucifixion of St Peter*, 1546-50, fresco, 242 × 260 inches (620 × 660 cm), Pauline Chapel, Vatican. Peter is thought to have chosen to be crucified upside down in order to avoid comparison with Christ, making this a difficult subject to portray. Michelangelo finds an effective solution by showing the cross to which Peter is nailed as not yet erected; his body cuts across the picture space as he turns to glare directly at the viewer, reinforcing the message that salvation comes only through the Church, in the person of Peter, the first father of the Church. The convincing physique and steely conviction of the apostle are not, however, reflected in the bystanders, who are represented as awkward and inert. The fascination with physical variety and perfectability has become subsumed within an all-embracing spirituality.

BELOW: *Christ on the Cross between the Virgin and St John*, c.1550, black chalk with white paint, 16 × 11 inches (41.2 × 27.9.cm), British Museum, London. The drawings of Michelangelo's last 15 years were not presentation works but private devotional studies, and are far less technically assured than the highly finished earlier works. Here the tentative outlines have been repeatedly reworked, and yet the whole has a spiritual intensity that reflects the artist's slow painful journey from Neoplatonist optimism and certainty to Counter-Reformation quiescence.

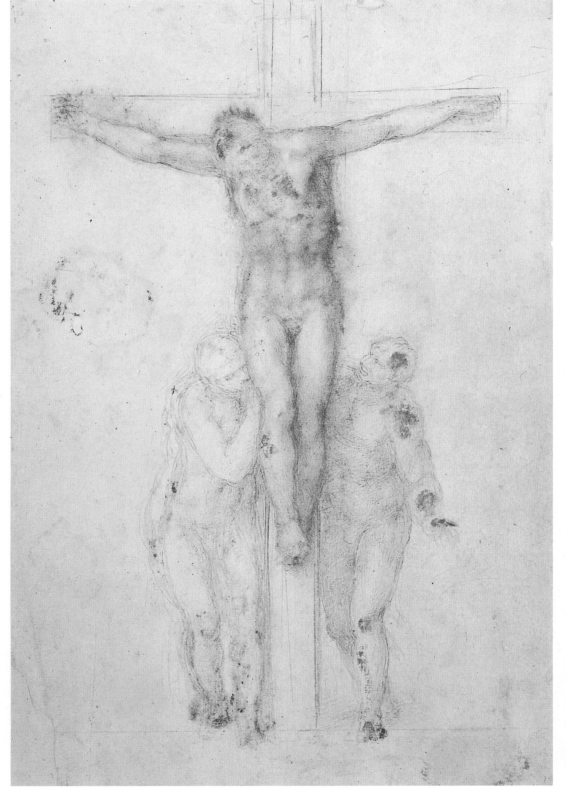

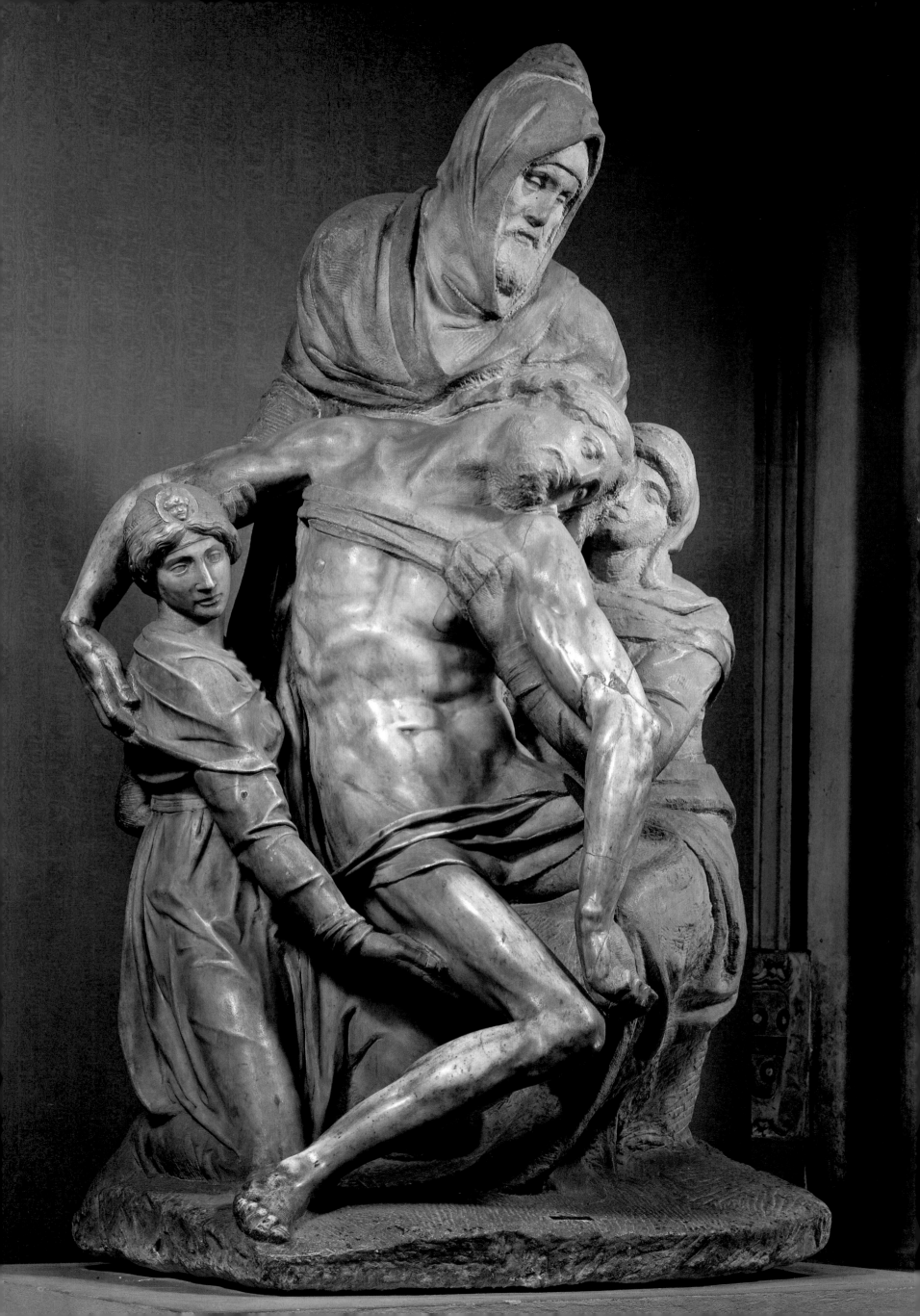

RIGHT: Etienne Dupérac, engraving of Michelangelo's design for the Capitoline Hill, 1568. The oval piazza, with its patterned and very slightly domed pavement, focuses on the vast equestrian statue of Marcus Aurelius in the center. Michelangelo refaced the two existing palaces and designed a third to close off the third side of the piazza, while the fourth and narrowest side gave access to a monumental stair up the hillside from the city. This largescale and symmetrical conception was a wholly new development in town planning.

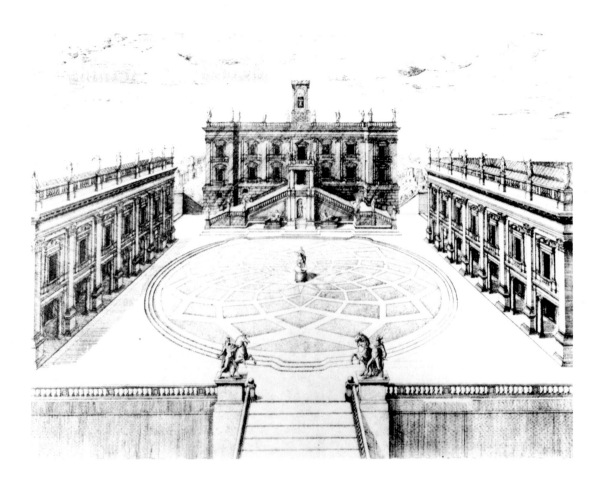

LEFT: Detail of the Palazzo dei Conservatori, showing the giant Corinthian pilasters flanking the much smaller columns and entablature which weave their way between. Work on the matching palace only began in 1603 and was not finished until the mid-1650s, and yet remains suprisingly true to Michelangelo's intentions.

BELOW: Palazzo dei Conservatori; the effect is one of controlled monumentality.

Michelangelo's last years, from 1546 until his death, were largely devoted to the new St Peter's, a project begun in 1506 by Julius II. Although he had arrived in Rome in 1534 with 15 years experience as an architect, the only architectural commission he received in his first ten years there was the redevelopment of the Capitol, now known as the Campidoglio. This was the ancient civic center of Rome, as opposed to the papal center of the Vatican on the other side of the Tiber. When the Emperor Charles V visited Rome in 1535, his ceremonial pro-

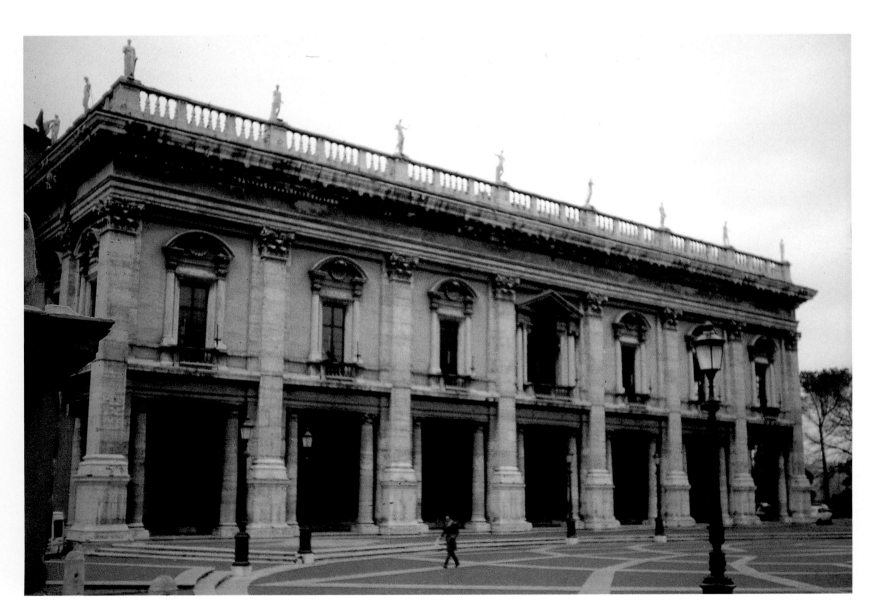

cession had to skirt the Capitol, which was little more than a jumble of buildings and scrubby hillsides. Michelangelo's design, commissioned by Pope Paul III some time after 1537, represented a novel development in town planning, with its symmetrical arrangement of oval piazza and three surrounding palaces, approached by a great ceremonial stair. The focal point was a huge equestrian statue of Marcus Aurelius which Paul III had moved from in front of the Lateran Palace. Two existing buildings, the Roman Tabularium used as the city's senate and the fifteenth-century Conservatori palace which served as the civic offices, formed the back and one side of the new Capitol. Michelangelo designed a new palace to form the other side, on the same alignment as the Conservatori, and gave both palaces, the existing and the new, colonnaded fronts articulated by a dramatic series of giant columns reaching up through two storys. This first venture into largescale architectural planning set the standard for monumental squares all over Europe.

His next architectural commission, the already partly built Farnese Palace begun by Antonio da Sangallo in 1517, was less radical in its realized form, although again Michelangelo's plans for it were both novel and imposing. The facade was more or less complete when Michelangelo took over on Sangallo's death in 1546, and only the cornice is his, but in the courtyard he was able to modify the second story and add a top story which is much more freely and decoratively designed than Sangallo's soberly monumental lower level. Although the basic structure of alternating columns and windows is retained, the columns have become double pilasters and the pediments over the window frames have become detached from the windows and rest on their own separate capitals. Using purely classical motifs, Michelangelo nonetheless achieved a quirkily non-classical effect.

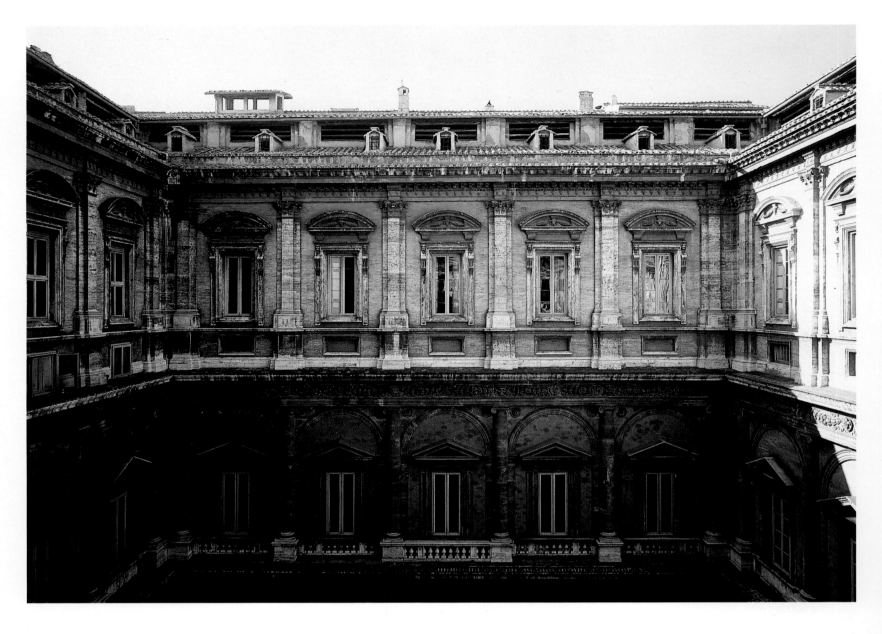

Sangallo had planned the Farnese Palace as a conventional courtyard block, but Michelangelo proposed to open out the rear of the palace into a carefully arranged garden vista, focusing on an immense classical statue of Hercules and the Bull, known as the *Farnese Bull* and found in the Baths of Caracalla. His plan entailed converting the rear block into a two-story loggia only one room deep, giving an open view through the garden and across the river to Trastavere and another garden. This combination of palatial residence with vistas of the countryside would have created something similar to the classical type of *villa suburbana*. It seems, however, that the resulting loss of room space told against the plan, as it was never carried out.

By far the most important architectural project in which Michelangelo was involved during his Rome years, and which came to dominate the last years of his life, was the continuation of building work on the new St Peter's. Old St Peter's, an early Christian basilica dating from the fourth century AD, was in an extremely decrepit state by the early sixteenth century, but it seems that the original plan, formulated by Pope Julius II and his architect Donato Bramante, was to restore rather than replace it. The building history is very complicated and

documentation is lacking for the early years, but it would appear that by about 1506 Bramante was thinking in terms of a new building, domed and centrally planned rather than the more traditional structure. On his death in 1514 he left no definitive design, however, and his successors Raphael, Peruzzi and Antonio da Sangallo the Younger all worked on variants of his original, Sangallo trying to effect a compromise by combining a central plan with the longitudinal form more suited to liturgical requirements.

It does not seem that Michelangelo was the automatic choice to succeed Sangallo on the latter's death in 1546, and according to Vasari he was reluctant to accept the commission, making the usual protest that architecture was not his métier. Certainly it was a very different project from any other he had undertaken. The vast scale of the building meant a large workforce and inevitable organizational problems with which Michelangelo was ill-equipped to cope. The building was also already half-constructed, thus limiting the options open to him. In fact he took the radical step of demolishing the outer walls which Sangallo had added to the design, enabling him to integrate the remaining spaces into a unified whole.

The present St Peter's is only partly Michelangelo's work. Although he

ABOVE: In the interior of the Palazzo Farnese Michelangelo had a freer hand; he modified the second story, adding sharply jutting window pediments and a festively garlanded entablature, and designed the top story in a thoroughly anti-classical vein, with curved window pediments completely separated from the rest of the window.

RIGHT: In Vasari's view of St Peter's, dated 1546, Sangallo's outer wall can be seen standing up to first-story level. Michelangelo had this demolished.

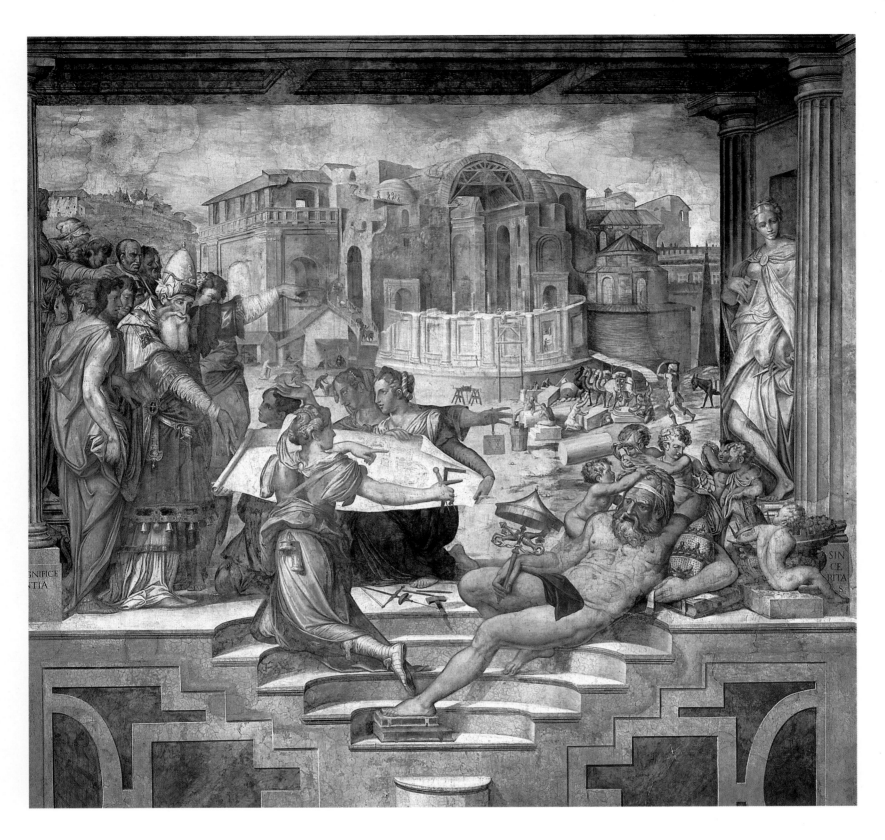

advanced the building work considerably in the 17 years before his death, and what he completed set the style for all later continuations and modifications, his plans were considerably altered. The most major change was the transformation of the church into a Latin cross shape, with a new façade, effected in the first half of the seventeenth century by Carlo Maderno. This was in response to clerical pressure for a longitudinal plan, with a choir separating clergy from laity, a broad nave for processions, and side chapels for individual dedications. The central portion of St Peter's, however, retains the simplified diamond-shaped ground plan that Michelangelo gave it, with its four great piers, which he reinforced to support the dome.

As regards the façade he had a freer hand, because the great church had been built from the center outward and the outer surface remained undefined. Where Sangallo had proposed superimposed rows of columns, Michelangelo again used a single giant order, as on the Capitol, to give a sense of coherence to the whole monumental, undulating façade. These provided a framework not dissimilar to the would-be architectural framework the much younger Michelangelo had used to divide up the vast space of the Sistine ceiling. Within the discipline provided by these giant 90-foot pilasters, the layered wall surface, reminiscent of the Medici Chapel, and the richly varied detailing of the windows and tabernacles, give ample testimony to the fertile imagination of their 70-year-old creator. Little is known of Michelangelo's plans for the main entrance façade, which was not begun until after his death and was soon demolished again for Carlo Maderno's nave extension. The dome was only finally erected by Giacomo della Porta, again after Michelangelo's death. His original plans followed those of Bramante in envisaging a simple hemispherical dome, but surviving drawings show that he had also considered the more pointed (and therefore more stable) form that della Porta chose.

Although he seems to have undertaken the task reluctantly, the building of St Peter's became the final great artistic commitment of Michelangelo's life, the perfect expression of the intense spirituality of his last years. Painting and sculpture might not quiet the soul that yearned toward God, but the completion of the greatest architectural monument of Christianity, the resting place of the first disciple and father of the church, might render that soul worthy of redemption. Despite his age and the immense difficulties of the project, he made

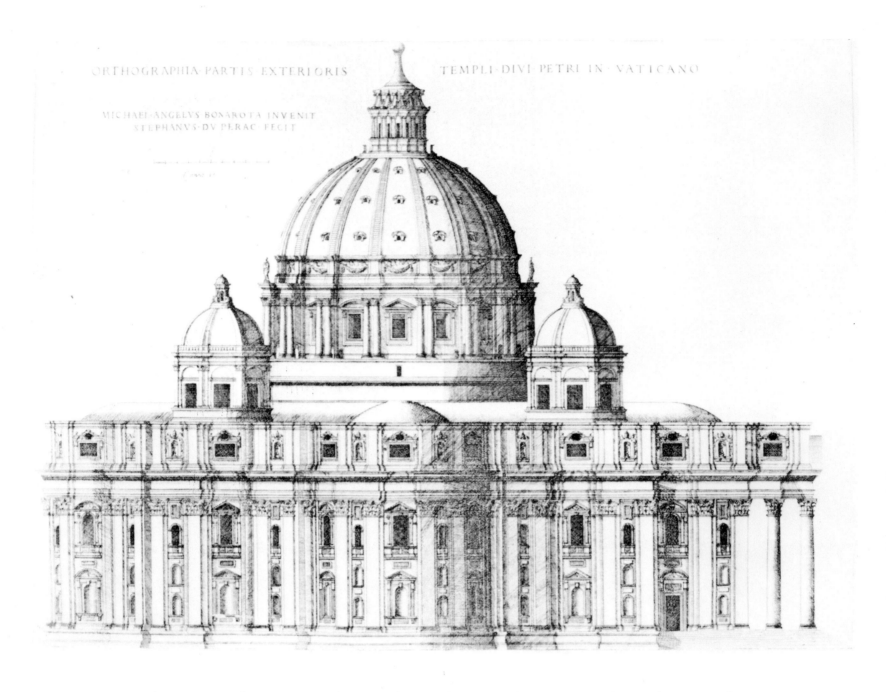

ORTHOGRAPHIA PARTIS EXTERIORIS TEMPLI·DIVI·PETRI·IN·VATICANO

MICHAEL·ANGELVS·BONAROTA·INVENIT
STEPHANVS·DV·PERAC·FECIT

more progress in the 17 years that remained to him than had been achieved in the previous 40, so that when he died much of the building as we see it today was standing, and the drum had been completed as far as the springing of the dome. When he was threatened with removal from the task in his eighties, as a result of political maneuverings, Vasari records his outraged reaction:

To abandon it now that we have come to the most difficult part would be shameful, and I should lose the fruit of labors of the last ten years which I have endured for the love of God.

Michelangelo died on 18 February 1564, at the formidable age of 88. His contemporaries had long recognized him as a genius, *il divino*, and it was clear to them that he had given a new direction to all the spheres in which he worked, painting, sculpture and architecture. The early *Pietà* was hailed at the time as a turning point in Italian sculpture, the culmination of a quest to reconcile fidelity to the natural world with the classical ideals of harmony and proportion. Michelangelo's subsequent exploration of the subject of the male nude in action, in both painting and sculpture, was taken up by artists later in the sixteenth century and developed into the exaggerated spiralling poses that became one of the hallmarks of Mannerism. In architecture his use of classical components, new and more sculptural vocabulary of ornament, and integrated approach to internal space, bypasses a generation and links with the buildings of Baroque architects such as Gianlorenzo Bernini (1598-1680) and Francesco Borromini (1599-1667), in the period of Catholic resurgence.

One of the principal themes running through much of Michelangelo's work throughout his career is that of redemption: whether through devotion and suffering, as in the *Pietà* and the Crucifixion drawings; through valor and probity as in the *David*; or through divine grace despite man's unworthiness, as gloriously encapsulated on the Sistine ceiling. In his mature work, notably the *Last Judgment* and the late sonnets, a new mood of piety and pessimism becomes apparent, reflecting the Catholic reaction to the Reformation and the sense of chaos after the Sack of Rome, but also the artist's own darker vision. In this context his devoted years of labor, from the age of 72 to 89, on the building of St Peter's seems a final and affirmative act of faith.

ABOVE: This engraving by Etienne Dupérac shows Michelangelo's design for the south elevation of St Peter's, with his giant pilasters, over 90 foot high, imposing a firm discipline on the undulating form of this most rhythmical of buildings.

RIGHT: The dome of St Peter's as built is from a design by the seventeenth-century architect Giacomo della Porta, but surviving drawings show that Michelangelo played with the possibility of a pointed dome, as well as with the more traditional hemispherical form.

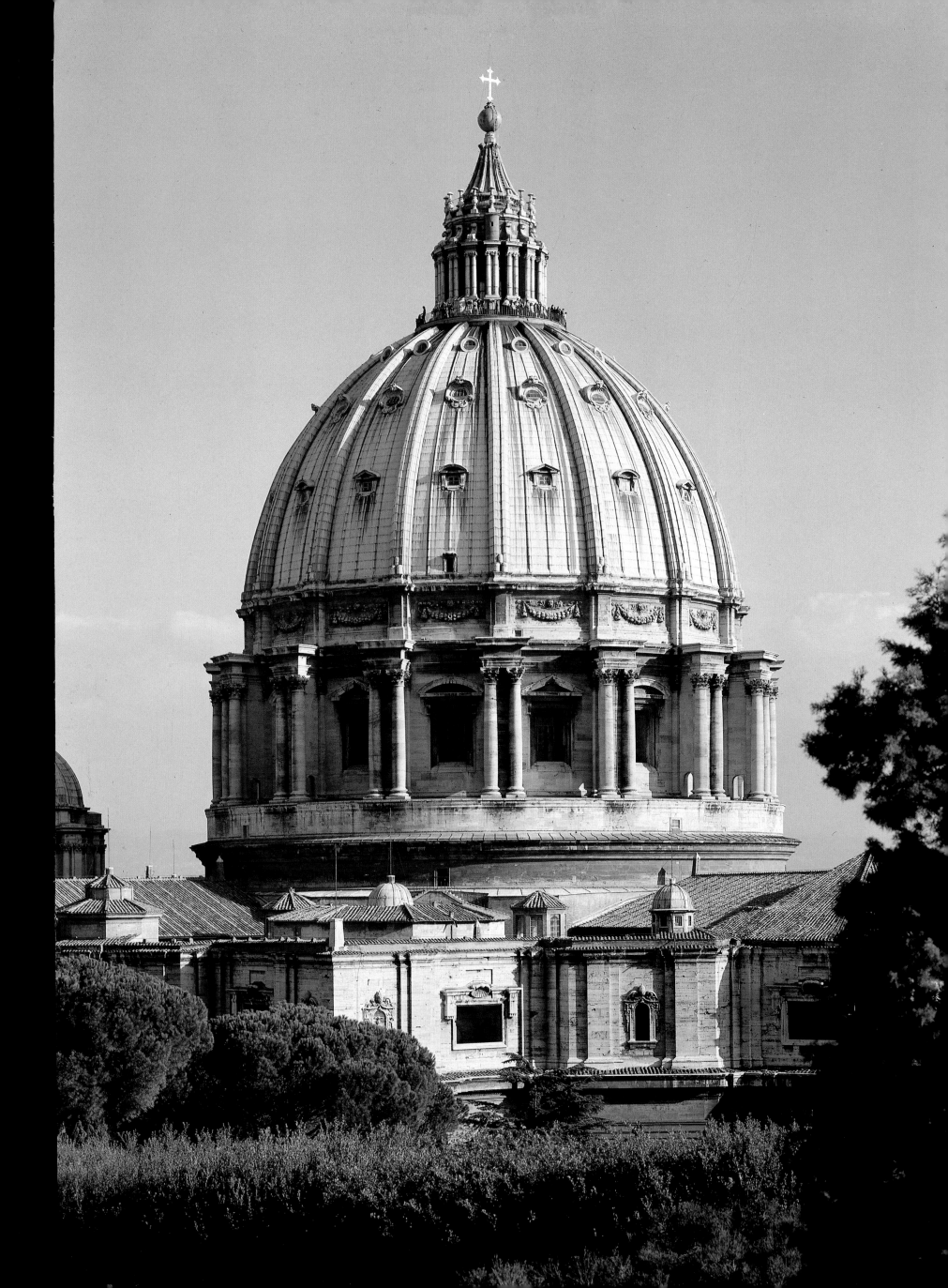

Index

Acknowledgments

The author and publisher would like to thank the following for their help in the preparation of this book: Martin Bristow, the designer; Ron Watson, the indexer; and Judith Millidge, the editor. We are also grateful to the following individuals and agencies for use of the illustrations on the pages noted below.

Ashmolean Museum, Oxford: page 1
Bargello Museum, Florence/Scala, Florence: pages 4, 9, 21, 29
Brancacci Chapel, S Maria del Carmine, Florence/Scala, Florence: page 8
British Museum, courtesy of the Trustees: pages 10, 32, 45, 61, 98
Casa Buonarroti, Florence/Scala, Florence: pages 15, 16, 17, 26, 27, 74
Courtesy of Viscount Coke, Holkham Hall, Norfolk: page 30
Florence Cathedral/Scala, Florence: page 100
Gabinetto dei Disegni e delle Stampe, Florence/Scala, Florence: page 88
Galleria dell' Accademia, Florence/Scala, Florence: pages 23, 31, 70
Isabella Stewart Gardner Museum, Boston: page 89
Dr Sally Jeffery: pages 102, 103 (bottom)
Metropolitan Museum, New York/Scala, Florence: page 54
Musée du Louvre, photo RMN: pages 68, 69
Museo Nazionale, Florence/Scala, Florence: pages 4, 10, 21, 29
National Gallery, London: page 33
Nippon Television Network Corporation: pages 44, 53
Notre Dame, Bruges/Scala, Florence: page 25
Orvieto Cathedral/Scala, Florence: page 91
Royal Academy of Arts, London: page 28
S Domenico Bologna/Scala, Florence: pages 18, 19
S Pietro in Vincoli, Rome/Scala, Florence: page 72
Scala, Florence: pages 11, 20, 73, 74, 75, 76-77, 78, 79, 80, 81, 86-87, 101, 104-
 105, 106, 107, 109
Staatliche Graphische Sammlung, Munich: page 12
Staatliche Museen, Berlin: pages 14, 20 (top), 67
Teyler Museum, Harlem: page 6
Tornabuoni Chapel, S Maria Novella, Florence/Scala, Florence: page 13
Trustees of the National Museums and Galleries on Merseyside, Walker Art
 Gallery, Liverpool: page 20
Uffizi Gallery, Florence/Scala, Florence: page 27
Vatican Museum, Rome/Scala, Florence: pages 2, 22, 23, 34, 36-37, 38-39,
 40-41, 42-43, 44, 46-47, 48-49, 50-51, 52, 53, 56-57, 58, 59, 60-61, 62-63,
 64, 65, 90, 93, 94-95, 96-97, 98-99